50 Years of
British Pop
Twentieth Century in Pictures

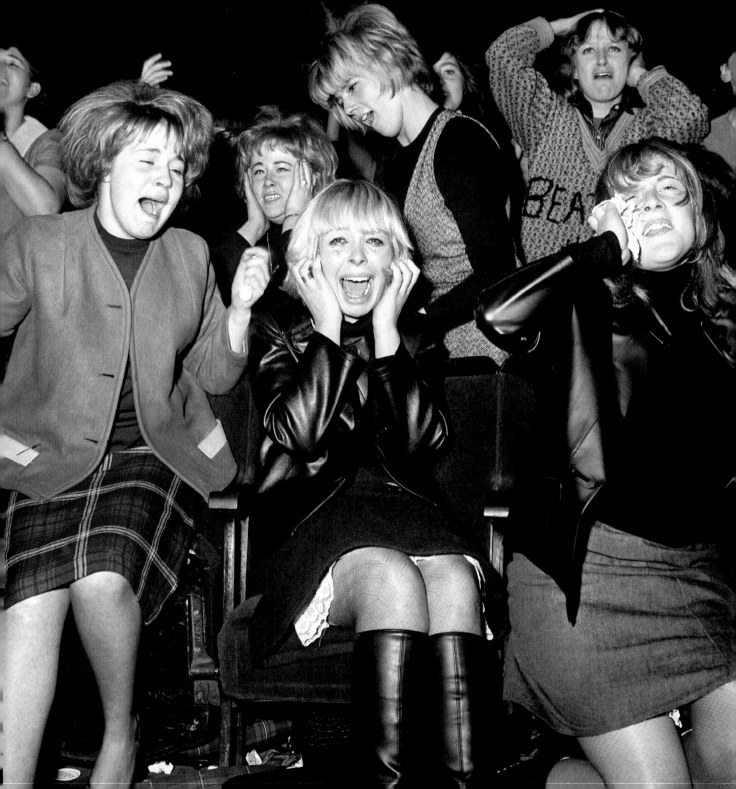

50 Years of
British Pop
Twentieth Century in Pictures

AMMONITE
PRESS

PRESS
ASSOCIATION
Images

First Published 2009 by
Ammonite Press
an imprint of AE Publications Ltd,
166 High Street, Lewes, East Sussex BN7 1XU

Text copyright Ammonite Press
Images copyright Press Association Images
Copyright in the work Ammonite Press

ISBN 978-1-906672-28-7

British Cataloguing in Publication Data. A catalogue
record of this book is available from the British Library.

Editor: Huw Pryce
Series Editor: Paul Richardson
Picture research: Press Association Images
Design: Gravemaker + Scott

Colour reproduction by GMC Reprographics
Printed by Kyodo Nation Printing, Thailand

Page 2: The 'Beatles effect'
in Manchester.
21st November, 1963

Page 5: Eli, a baby elephant,
joins The Who, Nicola
Austine (L) and Toni Lee
on the *Magic Bus* at
the BBC's Lime Grove
studios. (L–R) Roger
Daltrey, Keith Moon, Peter
Townshend and John
Entwistle.
9th October, 1968

Page 6: Busted
at the Capital Radio
Party in the Park,
in Hyde Park, London.
6th July, 2003

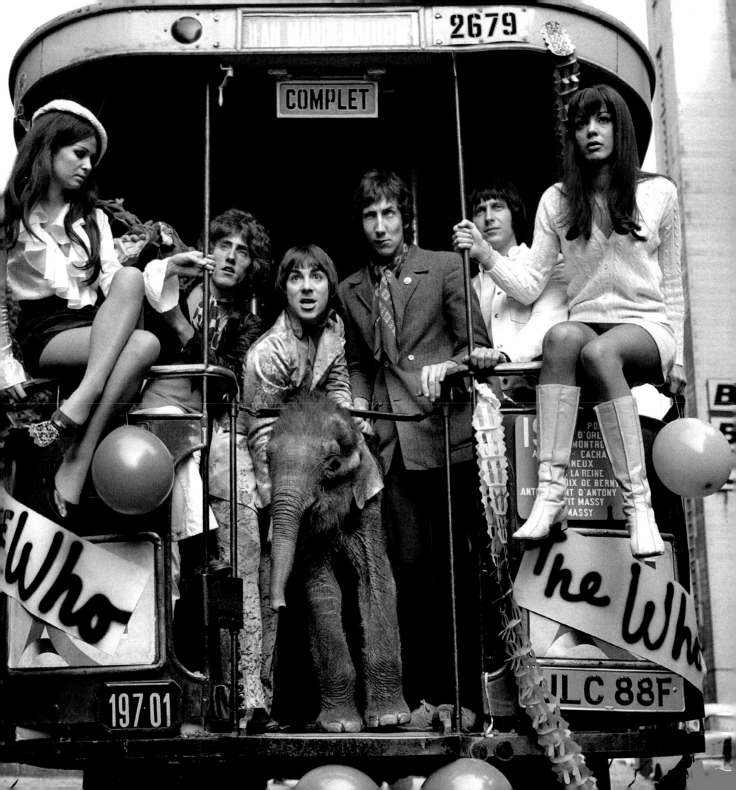

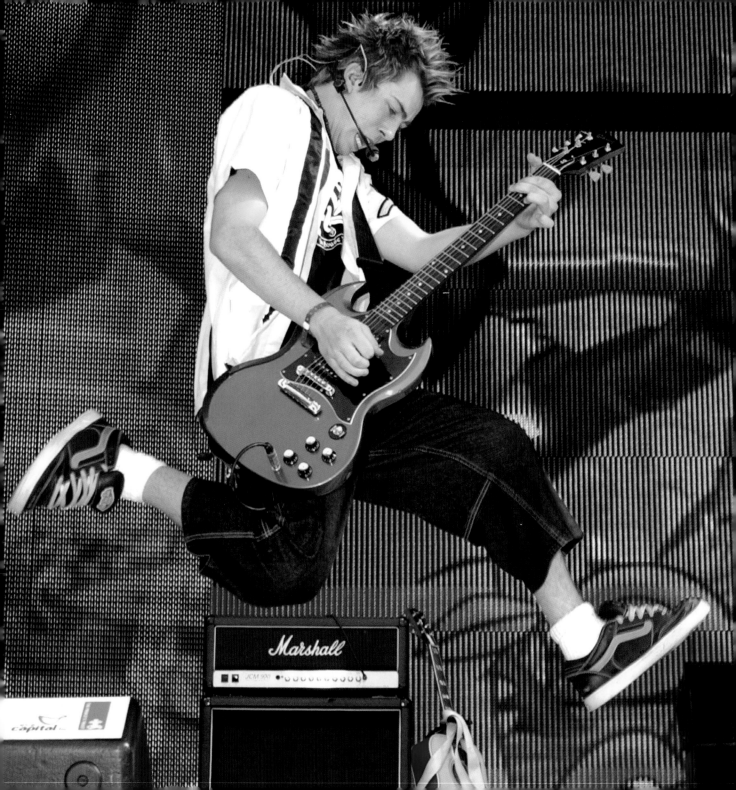

Introduction

What we consider to be 'pop music' came into being in the post-war years, but 'popular music' has always been with us under one name or another. What changed? Teenagers. The '50s saw teenage culture begin to struggle free from that twilight zone between childhood and adulthood: before then everybody, young and old, did the *Hokey Cokey* and *The Lambeth Walk*, they all wanted to know *How Much is that Doggie in the Window?* After a decade of pulling together to get Britain through the war and the austerity that followed, everything was safe; filtered by, and full of, the establishment. Musicians wore formal clothes and spoke with cut-glass RP accents or not at all. The media, such as it was, reflected the paternalism of Lord Reith and the authoritarianism of Churchill and Attlee. Something had to give.

Although rock and roll blew in from America on a cloud of imported testosterone, Britain grew its own Elvis Presleys and Pat Boones. The earliest picture here is of Petula Clarke, whose career began before 'pop' was born and who belongs to that first generation of rock and roll fans. Dame Vera Lynn, also pictured here, could have been pop's mum. The emergent sub-cultures of the 50s were skiffle outfits, beatniks and folkies, cooler and more radical than the mainstream, utterly different from the anodyne *Housewife's Choice* music and the *Ted Heath Orchestra* big band sound, more accessible than Benjamin Britten.

As that post-war generation began to spread its wings, magistrates, MPs, editors and churchmen moaned in melodramatic piety over the degeneracy of the young. They couldn't possibly have foreseen what was to follow the maelstrom of the '60s. *Lady Chatterley* was to give way to the pill, free love, pills, the *OZ* obscenity trial, androgynous boys in make-up, pins through noses, spitting, and political activism. A generation moved from the *Hokey Cokey* to the *Twist*, then teenagers charged inexorably on to the *Pogo* and ultimately *Acid House* with its drug fuelled raves. Fashions changed every year: hair was elaborately styled, next deliberately unkempt, then exaggeratedly overworked into spikes and the famous Mohican.

The '80s saw the UK pop scene re-enter the fold of respectability as it led the world in raising money for famine relief. In the '90s Britpop was a national brand endorsed by New Labour. Today the TV talent show is king. Six decades of popular history from the Beatles to Boy George to Pete Doherty and from Petula to Cilla to Duffy. The photographers of the Press Association were there to record it all.

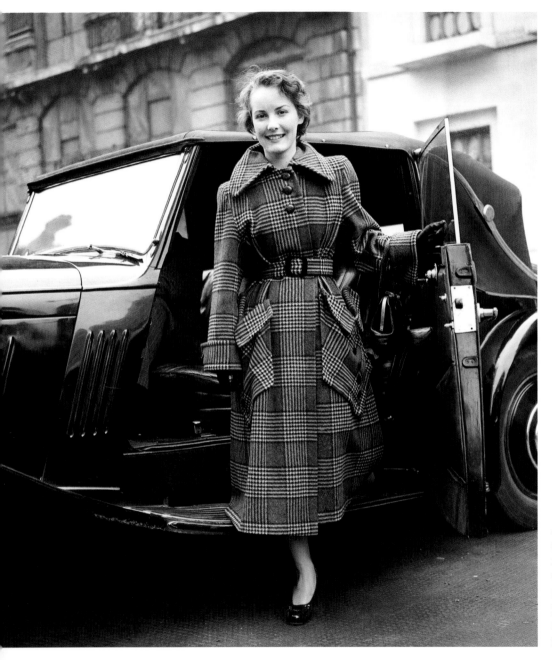

At 18 Petula Clarke is already a showbiz veteran. She first performed for the troops during the war and notched up an impressive 200 shows before the age of nine.
20th October, 1950

The Beverley Sisters, one of Britain's earliest girl groups, rehearse for the *Royal Variety Performance*.
3rd November, 1952

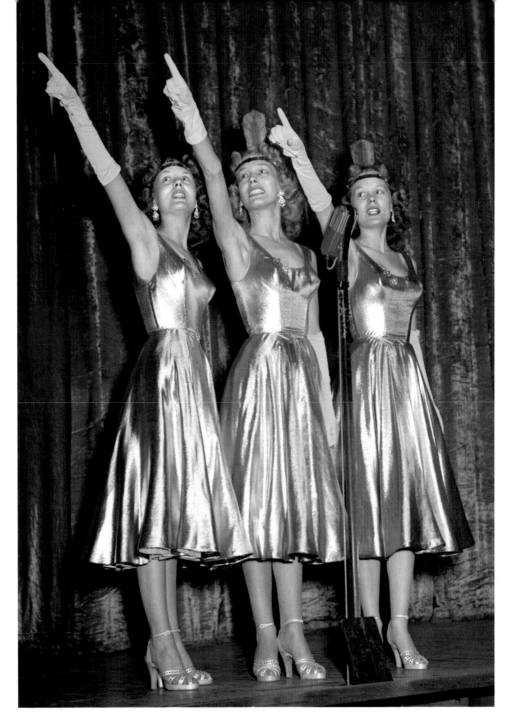

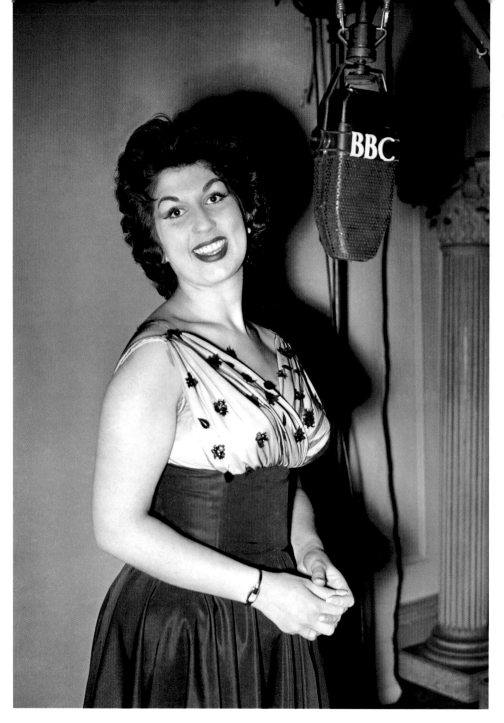

Alma Cogan, '*the girl with the laugh in her voice*' is to join June Whitfield on BBC radio show *Take It From Here*.
20th October, 1953

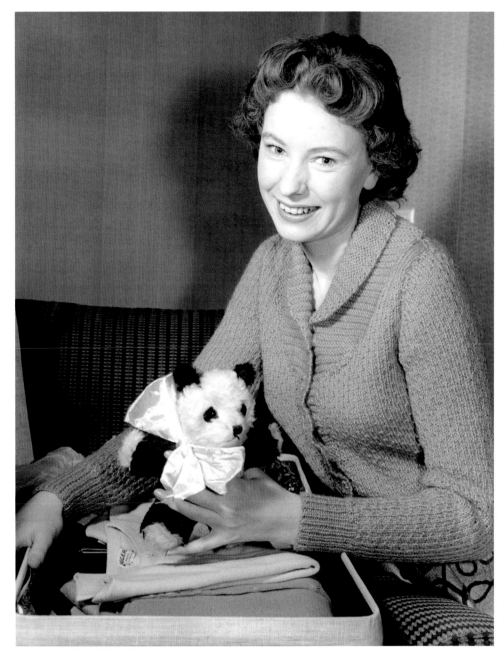

Belfast singer Ruby Murray packs for her first promotional trip to the United States. She gained a place in the record books in 1955, during which year she had at least one single in the top 20 for 52 weeks.

2nd March, 1956

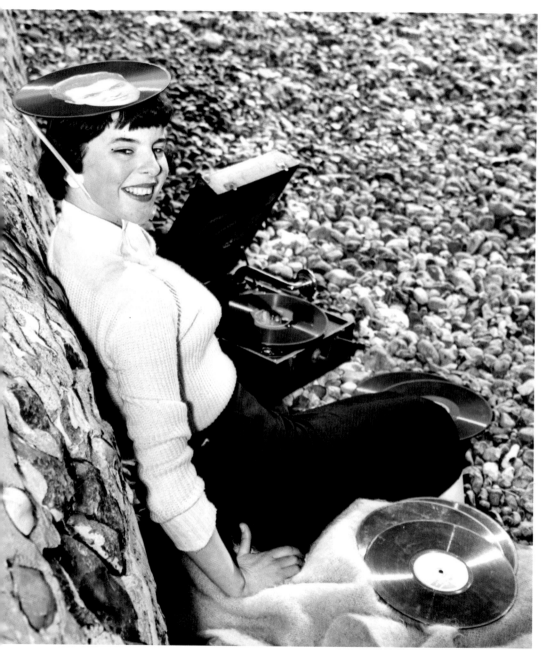

Suzanne Crowley describes herself, with some justification, as a *"raving mad Dickie Valentine fan"*. His voice goes everywhere with her on her portable gramophone. She even made a hat for herself out of one of his records.
11th May, 1956

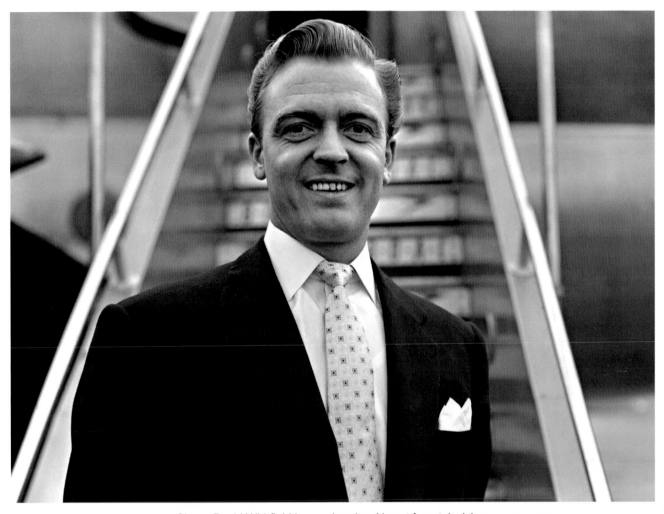

Singer David Whitfield leaves London Airport for a television engagement in New York. He was the most successful British male singer in the US during the pre-rock years, the first UK male vocalist to earn a gold disc and the first artist from Britain to sell over one million copies of a single disc in America.

15th May, 1956

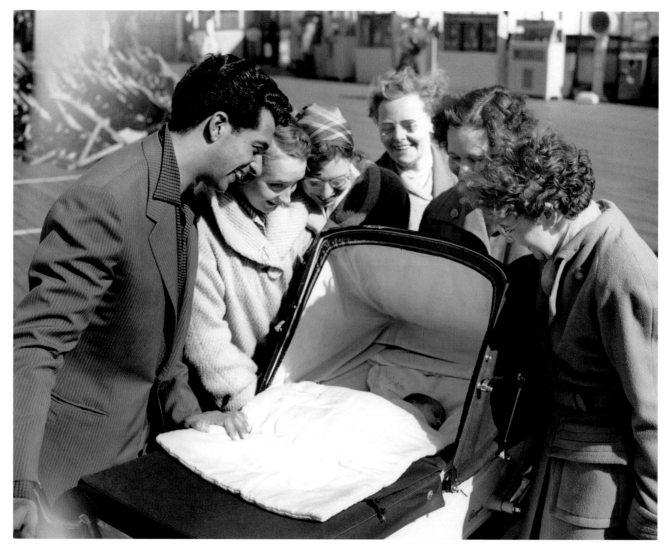

Singer Frankie Vaughan
happily relinquishes
the limelight to the
new star in his family,
his baby daughter Susan.
18th June, 1956

Vera Lynn rehearses for her new BBC radio show *Sincerely Yours*. As a wartime sweetheart of the forces, her signature tune was *Yours*. Born in 1917, Dame Vera's last official performance was at the 50th anniversary of VE Day at Buckingham Palace in 1995, when she was 78.

30th July, 1956

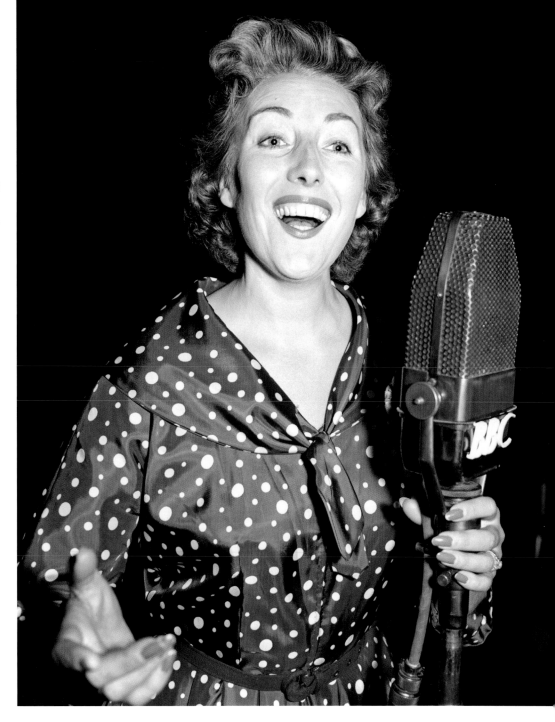

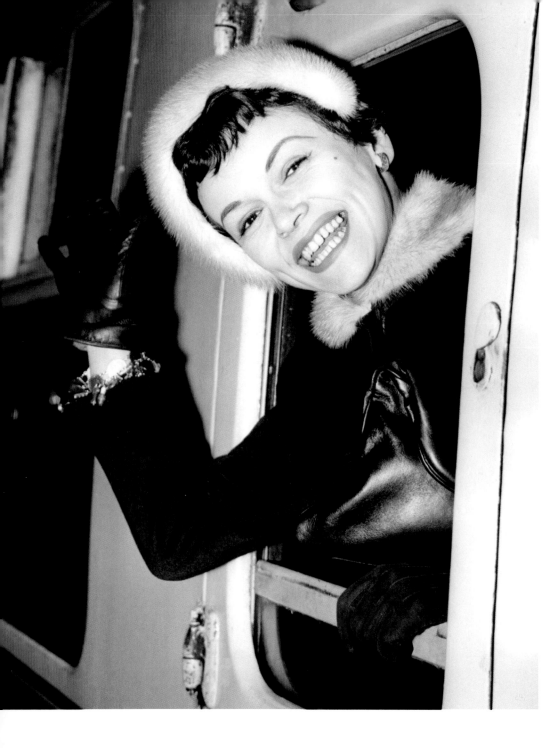

Facing page: Pioneering glamour model Sabrina with David Whitfield at the London Palladium during rehearsals for the *Royal Variety Performance*.
5th November, 1956

Hungarian born, South African star Eve Boswell at Waterloo Station on the *Ile de France* boat train.
24th October, 1956

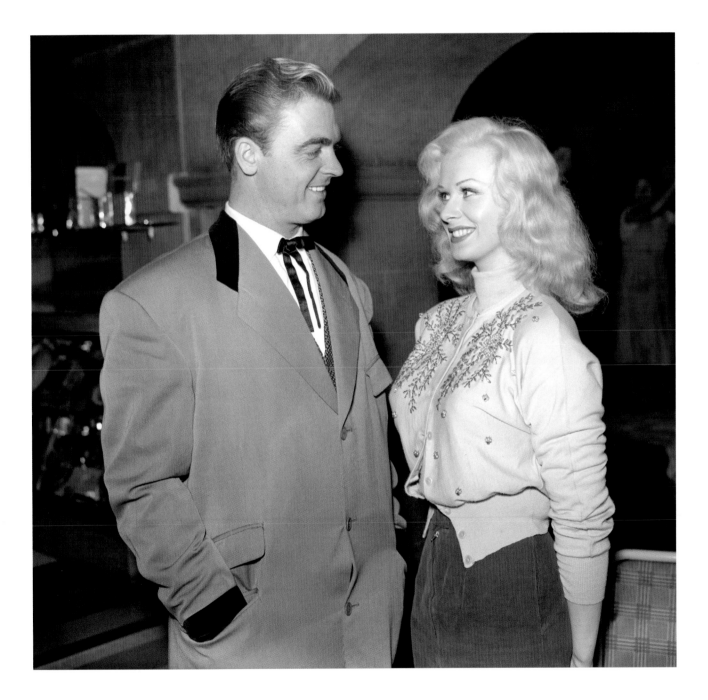

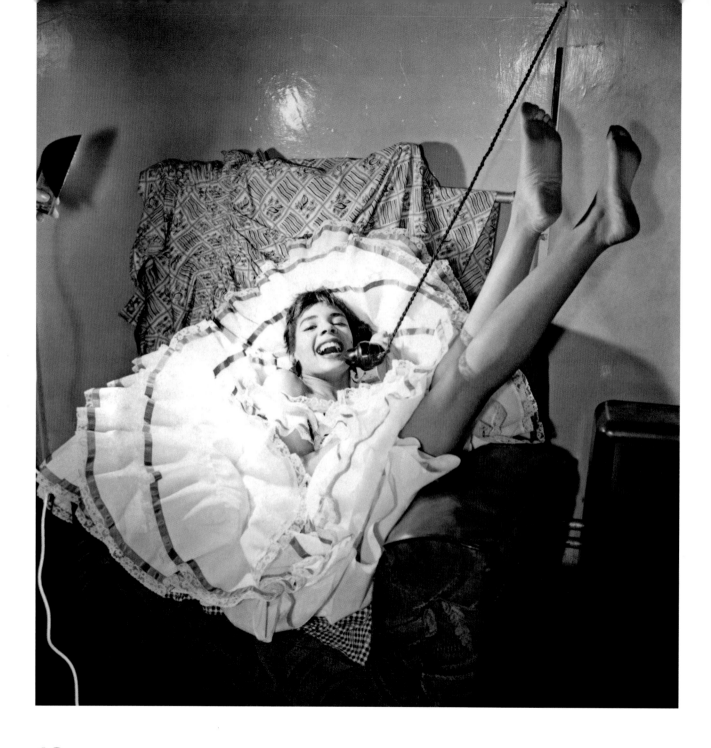

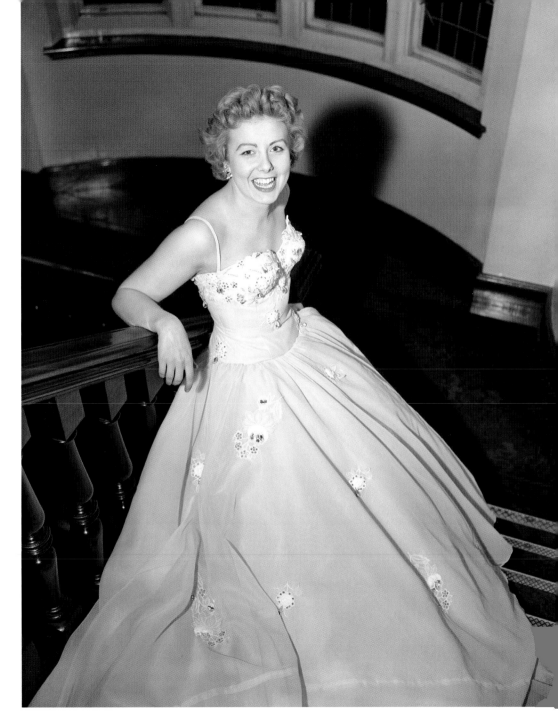

Facing page: 20 year old
Shirley Bassey,
'*The Tigress of Tiger Bay*'.
She was discovered singing
in working men's clubs
in her native Cardiff.
10th January, 1957

Edna Savage tries on
a new evening gown
before flying out to Cyprus
to spend a month
entertaining the troops.
5th February, 1957

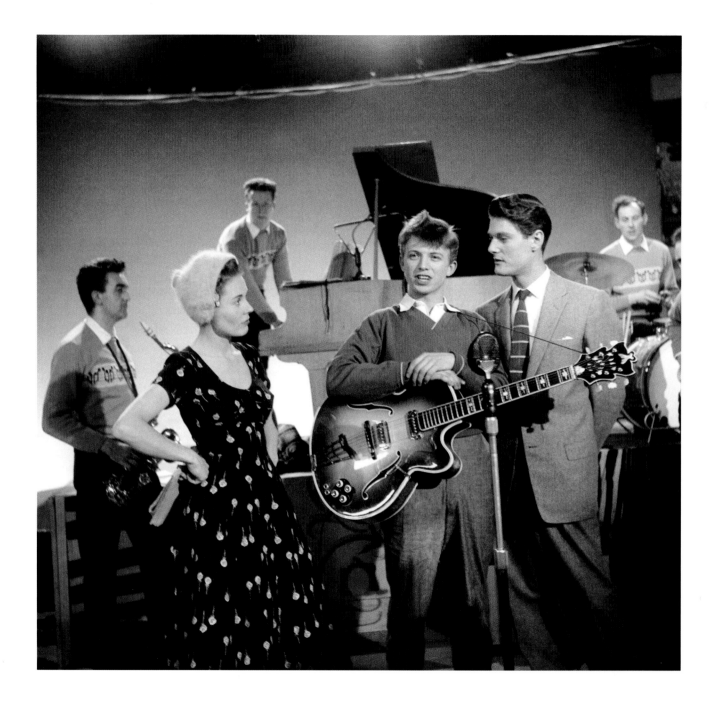

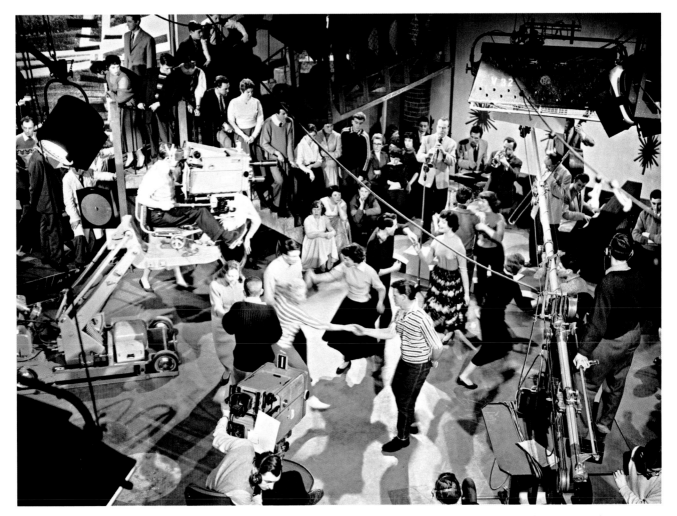

Facing page: (L–R)
Josephine Douglas
(compere and producer),
Tommy Steele and Pete
Murray (compere) on the
Six-Five Special.
2nd March, 1957

Filming *Six-Five Special,* the BBC's first pop music
oriented show, commissioned to replace the 'Toddler's
Truce', a TV blackout between six and seven PM intended
to allow children to be put to bed.
5th March, 1957

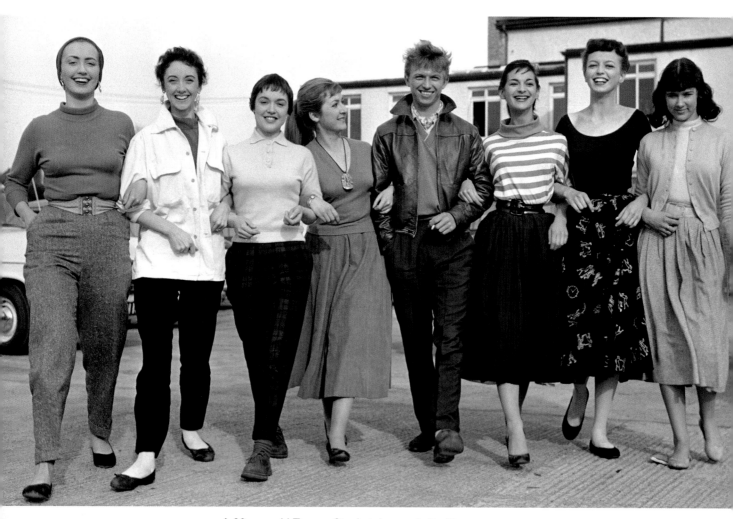

A 20 year old Tommy Steele takes a stroll with some
of the girls from the film *The Tommy Steele Story*. Tommy,
a former steward in the Merchant Navy, rocked his way right
to the top of British show business in about six months.
18th March, 1957

Dickie Valentine heads for Antwerp. He was voted Top UK Male Vocalist in 1952, while singing with the Ted Heath Orchestra, and again after going solo in 1954. He recorded two Number 1 hits, *Christmas Alphabet* and *Finger of Suspicion*.
5th April, 1957

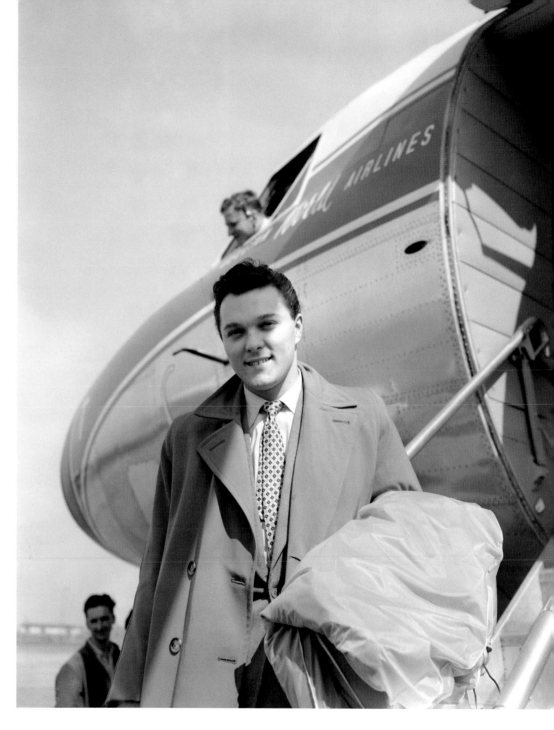

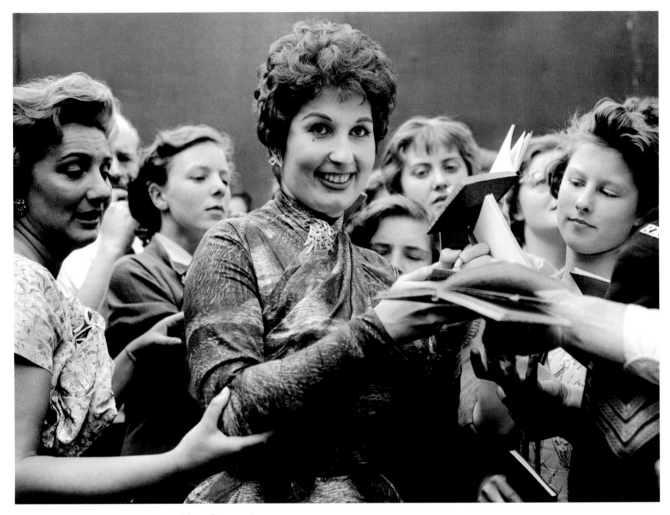

Alma Cogan signs
autographs for her fans at
the reopening of The Festival
Gardens in Battersea Park.
1st June, 1957

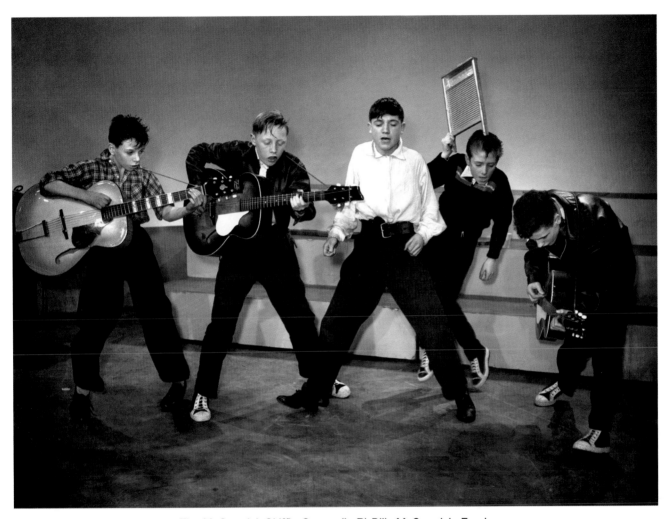

The McCormick Skiffle Group: (L–R) Billy McCormick, Frank Healy, Wesley McCausland, Edward McSherry and James McCartney. Skiffle gave an opportunity for small groups of untrained, poorly equipped musicians to compete with the established orchestras and big bands of the day, which led to the explosion of guitar bands in the 1960s.

2nd November, 1957

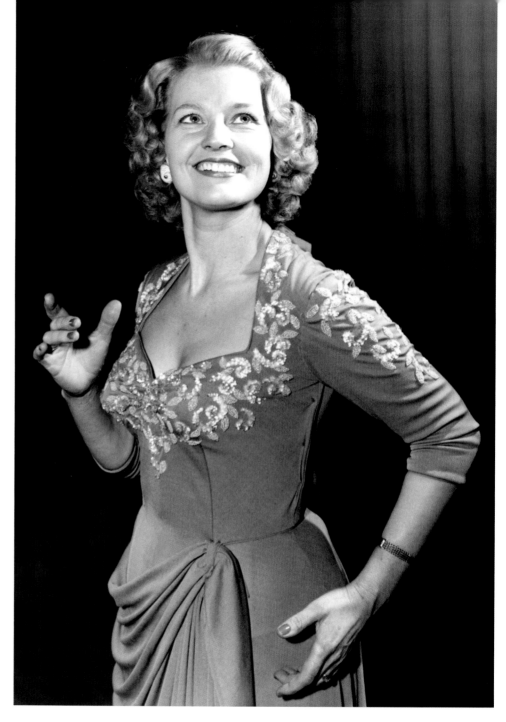

Singer and variety performer
Joan Regan at the *Royal
Variety Performance* at
the London Palladium.
16th November, 1957

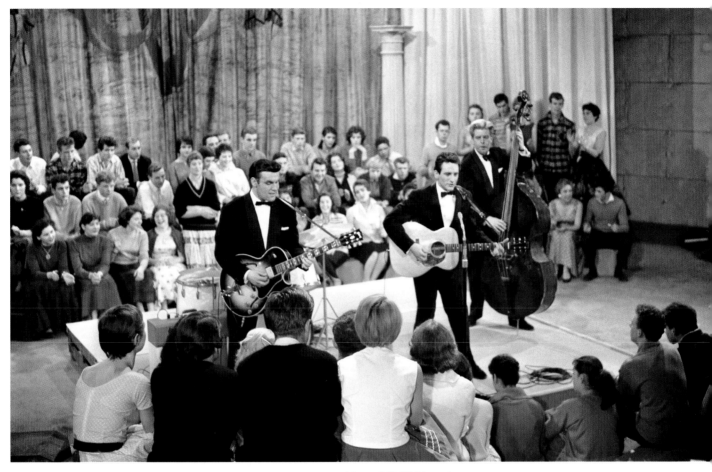

'*King of Skiffle*' Lonnie
Donegan and his skiffle
group during filming of
Six-Five Special.
20th November, 1957

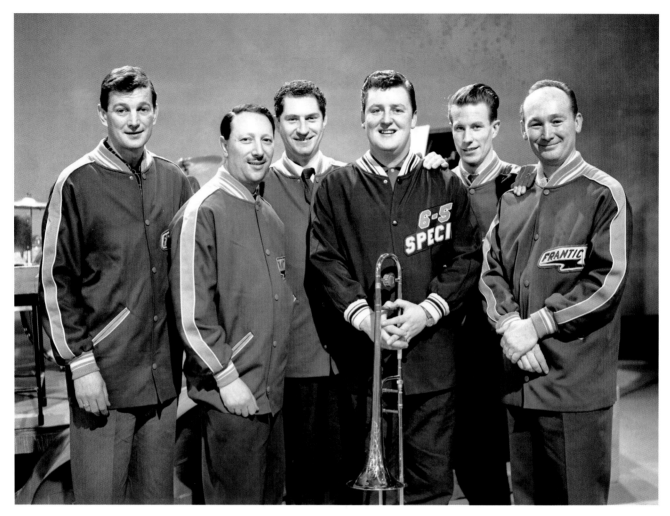

Six-Five Special house band, Don Lang and his Frantic Five.
(L–R), Martin Gilroy, Syd Delmonte, Reg Guest, Don Lang,
Ken Lack and Rex Bennett.
10th January, 1958

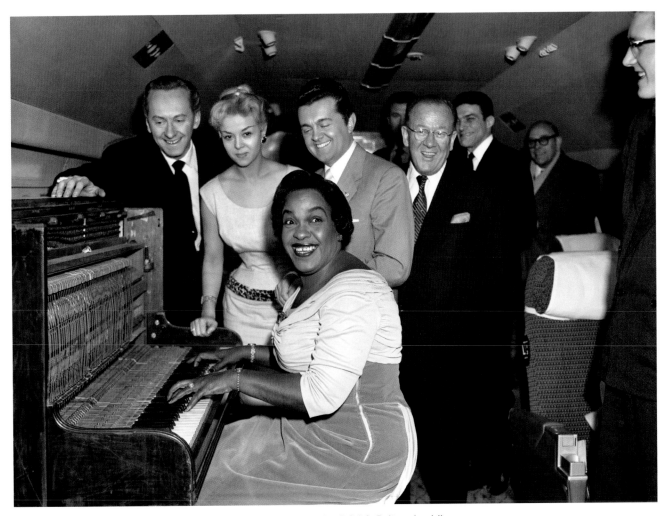

Winifred Atwell plays aboard a BOAC *Britannia* airliner
between London and New York. A recording of the
half-hour performance aboard the plane was flown back
from New York for screening in *Jack Hylton's Monday
Show* on ITV. (L–R) Hughie Green, Rosalina Neri from Milan,
Ronnie Ronalde and Jack Hylton.

6th February, 1958

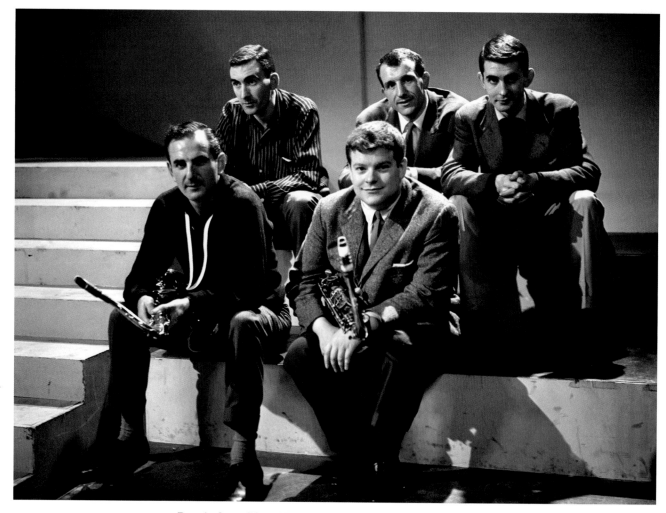

Ronnie Scott (L) and Tubbie
Hayes (R) with the Jazz
Couriers on *Six-Five Special*.
22nd May, 1958

Voted Best New Singer in 1959, Craig Douglas went on to record eight cover versions of former American hit songs and had a Number 1 single in 1959 with *Only Sixteen*, which easily outsold Sam Cooke's original in the UK.

15th November, 1958

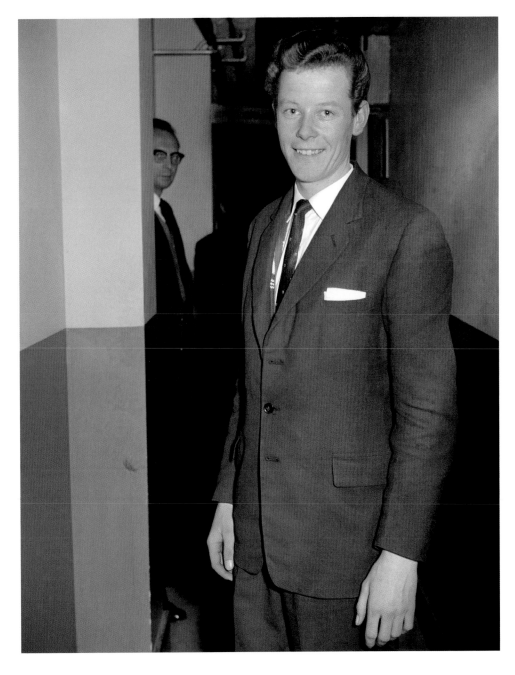

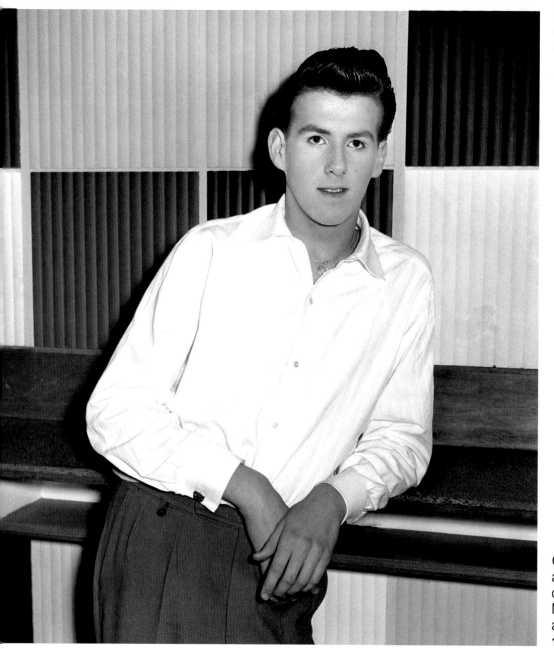

Facing page: Joan Regan at home in Kent.
26th November, 1958

Grantham boy Vince Eager, a Larry Parnes' stablemate of Tommy Steele, Marty Wilde, Billy Fury and Joe Brown.
15th November, 1958

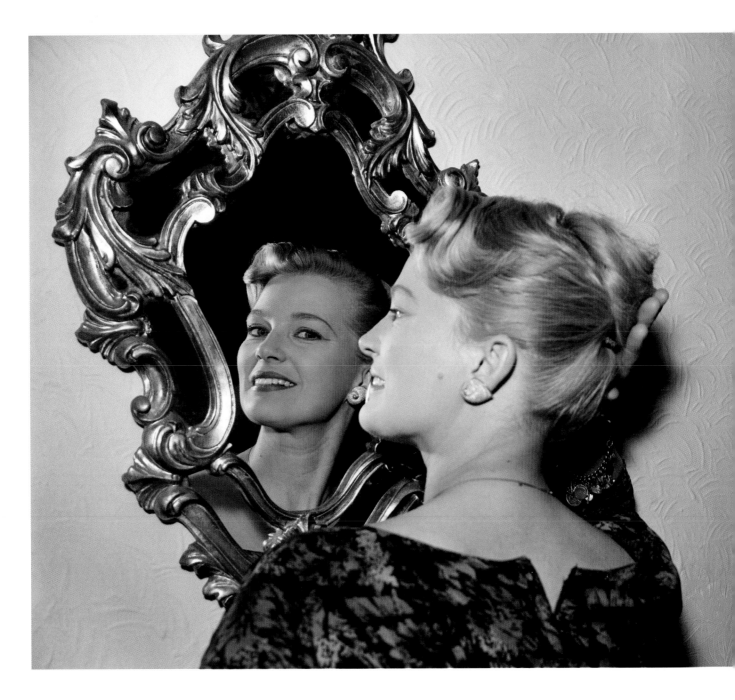

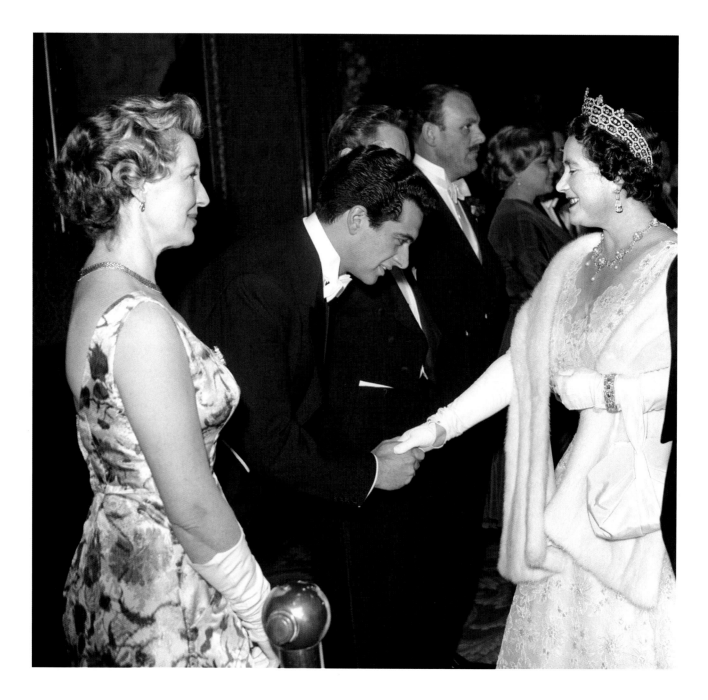

50 Years of British Pop • Twentieth Century in Pictures

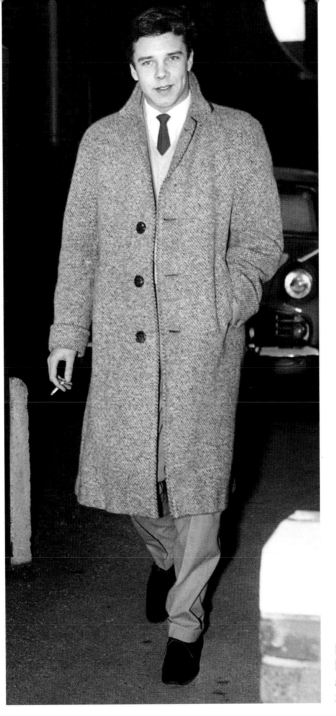

Facing page: Frankie Vaughan and actress Kay Walsh are presented to the Queen Mother at the Royal performance of the film *The Horse's Mouth* at the Empire Cinema in Leicester Square.
2nd February, 1959

Marty Wilde, 19, arrives for his National Service medical at Lee Road, South London.
3rd February, 1959

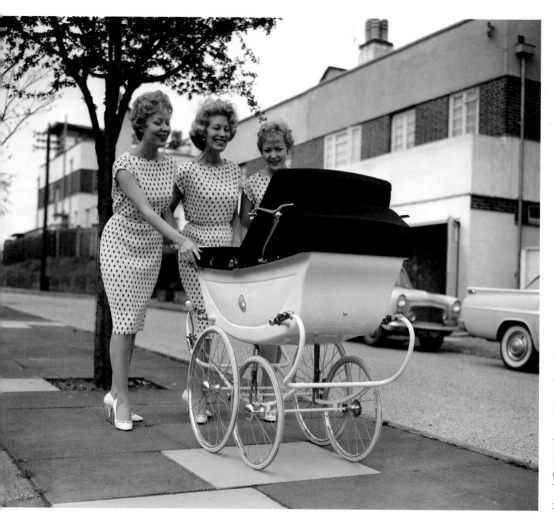

The Beverley Sisters take
Joy's baby Victoria for a
pram outing in Highgate.
(L–R) Babs, Joy and Teddie.
In later years Victoria
teamed up with her sister
Babette and Teddie's
daughter Sasha to form
The Little Foxes.
30th April, 1959

Former forces sweetheart Carole Carr takes over as disc jockey on the radio programme linking Britons with their relatives and friends in the forces overseas, *Two Way Family Favourites*.
16th October, 1959

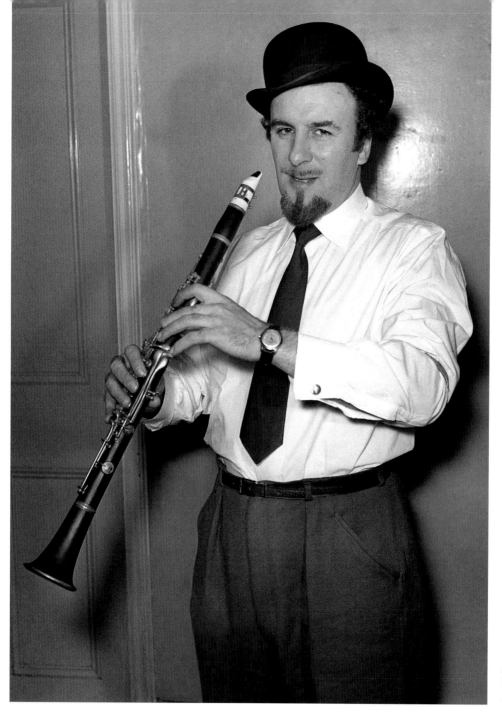

Facing page: Lonnie
Donegan receives his gold
disc for *My Old Man's
a Dustman* – from some
dustmen.
23rd October, 1960

Acker Bilk demonstrates
his clarinet technique.
1st March, 1960

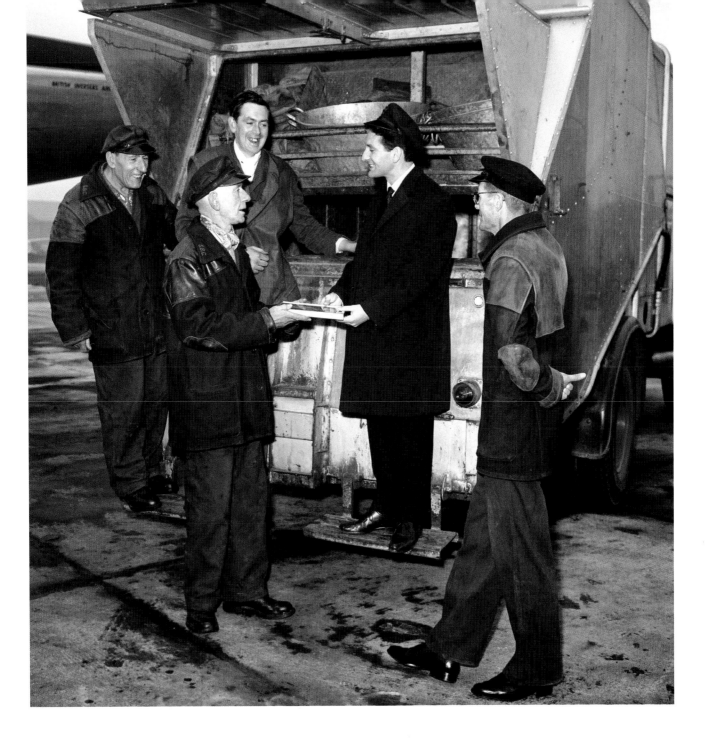

Facing page: Adam Faith celebrates his 21st birthday with actress Carole Lesley at Pinewood Studios, where they are starring in the film comedy *What a Whopper*.
23rd June, 1961

Billy Fury, another Larry Parnes signing. The shopkeeper turned impresario took him on when he arrived at the stage door in Birkenhead to sell his songs to Marty Wilde.
22nd December, 1960

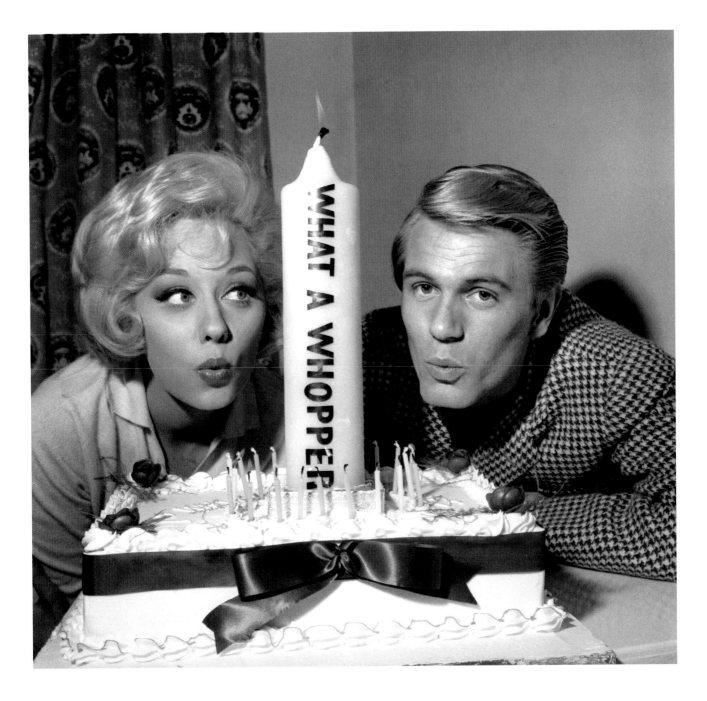

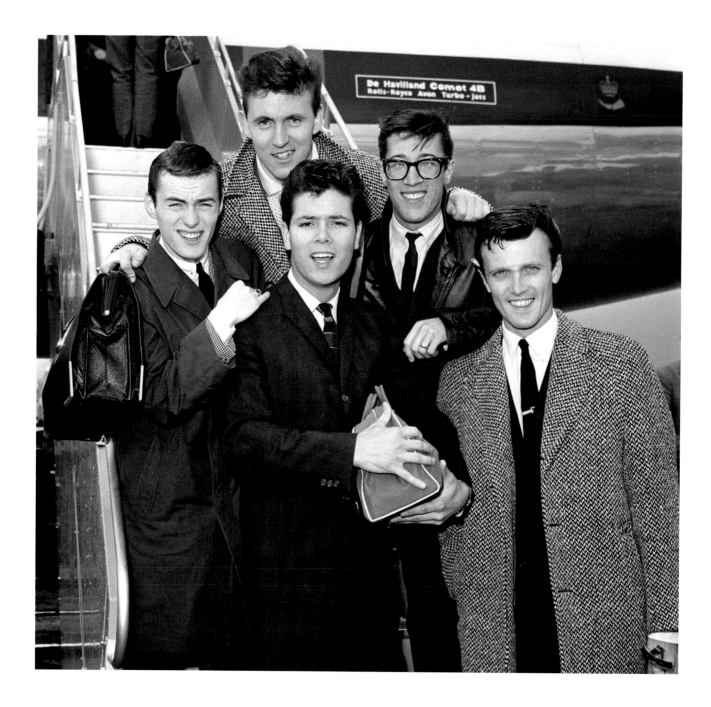

50 Years of British Pop • Twentieth Century in Pictures

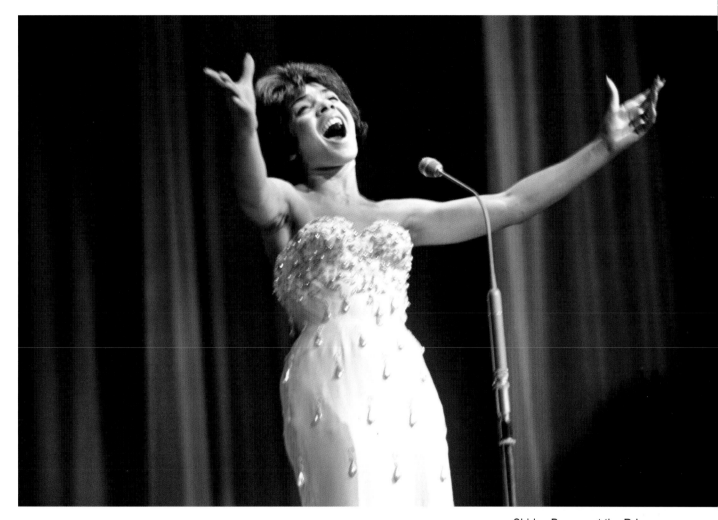

Shirley Bassey at the Prince
of Wales Theatre for the
Royal Variety Performance.
6th November, 1961

Facing page: Cliff Richard
and The Shadows leave
London Airport for
a Scandinavian tour.
15th August, 1961

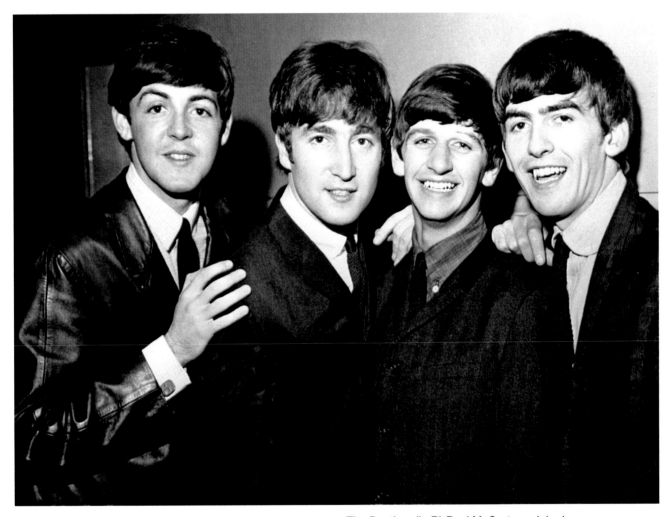

The Beatles: (L–R) Paul McCartney, John Lennon, Ringo Starr and George Harrison. Their first single *Love Me Do* peaked at Number 17 in the UK charts in October 1962 and topped the US Billboard 100 chart in 1964.
1st June, 1963

Facing page: Helen Shapiro and Acker Bilk share a moment of true showbiz glamour.
13th December, 1961

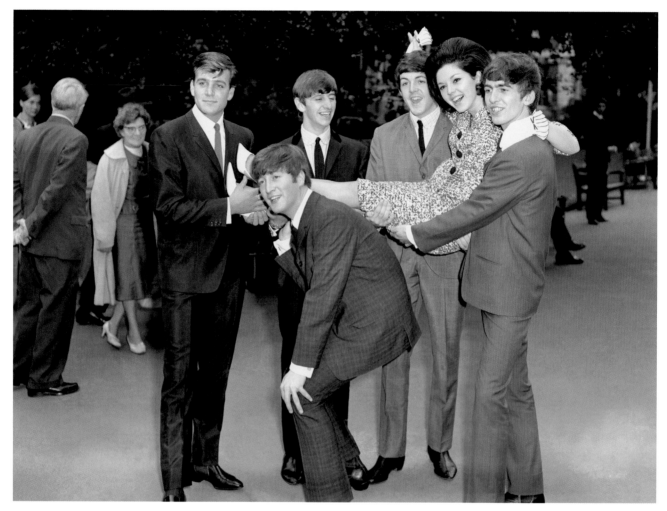

Bobby's Girl singer Susan Maughan gets a lift from
Billy J Kramer (L) and the Beatles after the Variety Club
Luncheon at the Savoy. All three acts won *Melody Maker*
awards – the Beatles won Top Vocal Group, Kramer was
voted 1964 Hope, and Maughan received the Top Female
Singer award.

10th September, 1963

Facing page: The Beatles
jump to it on stage: (L–R),
Paul McCartney,
John Lennon, Ringo Starr
and George Harrison.

4th November, 1963

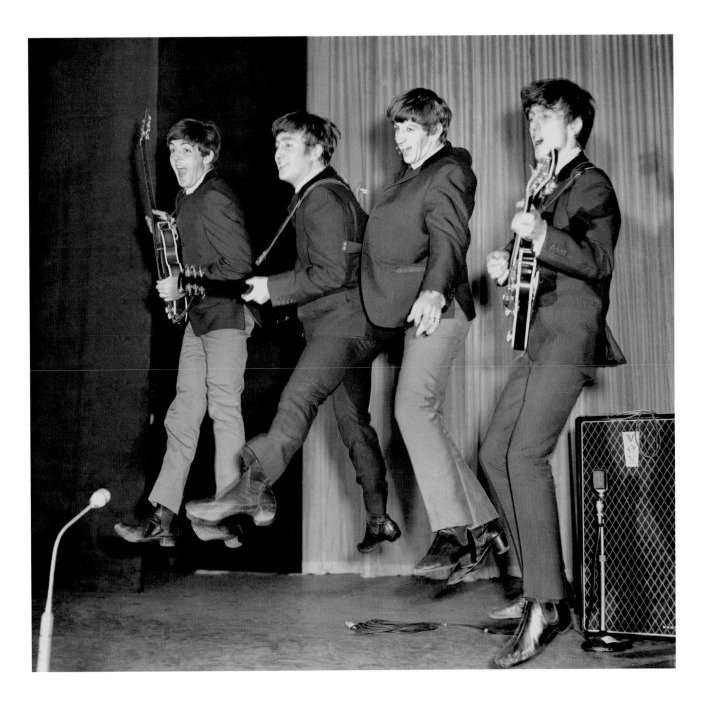

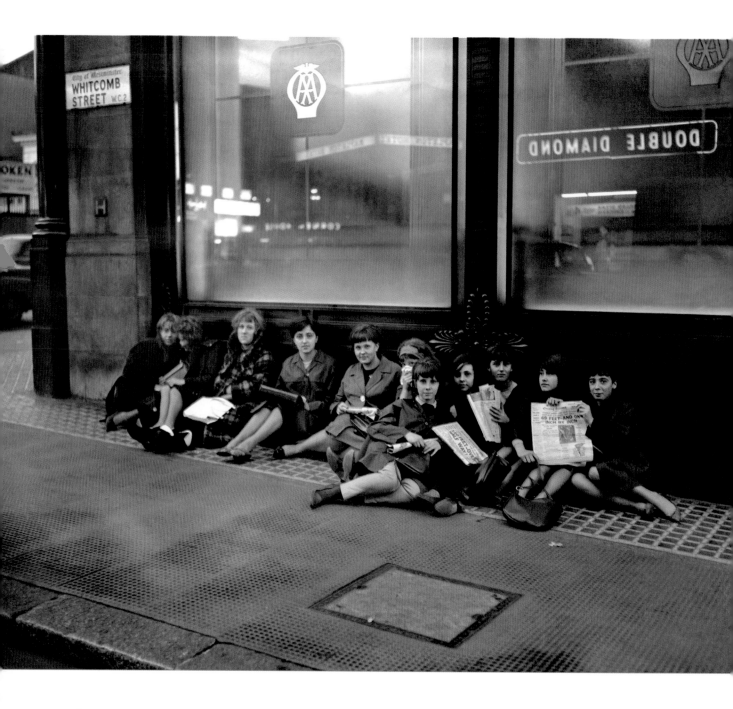

Facing page: Beatles fans wait outside the Prince of Wales Theatre before the *Royal Variety Performance.* The night was made famous by John Lennon's request; *"Would the people in the cheaper seats clap your hands? And the rest of you, if you'll just rattle your jewellery."*
4th November, 1963

Cilla Black (born Priscilla White), signed by Beatles manager Brian Epstein in September 1963. Her second single, Bacharach and David's *Anyone Who Had a Heart,* held the UK record for biggest selling single by a female artist until January 2009, when it was topped by Alexandra Burke's cover of Leonard Cohen's *Hallelujah.*
15th December, 1963

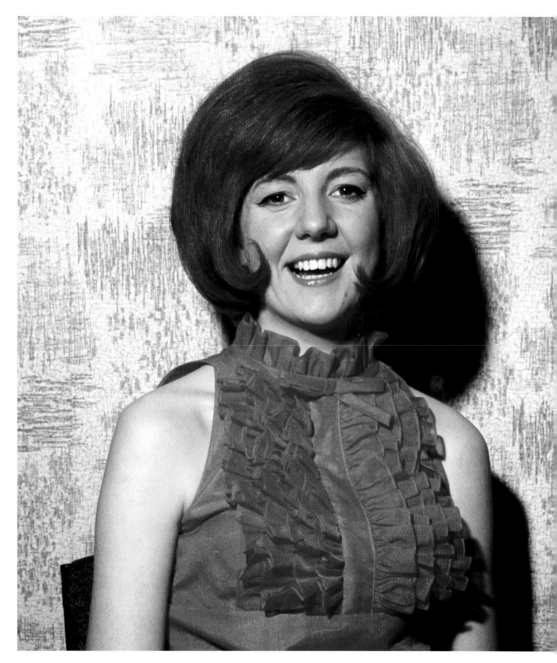

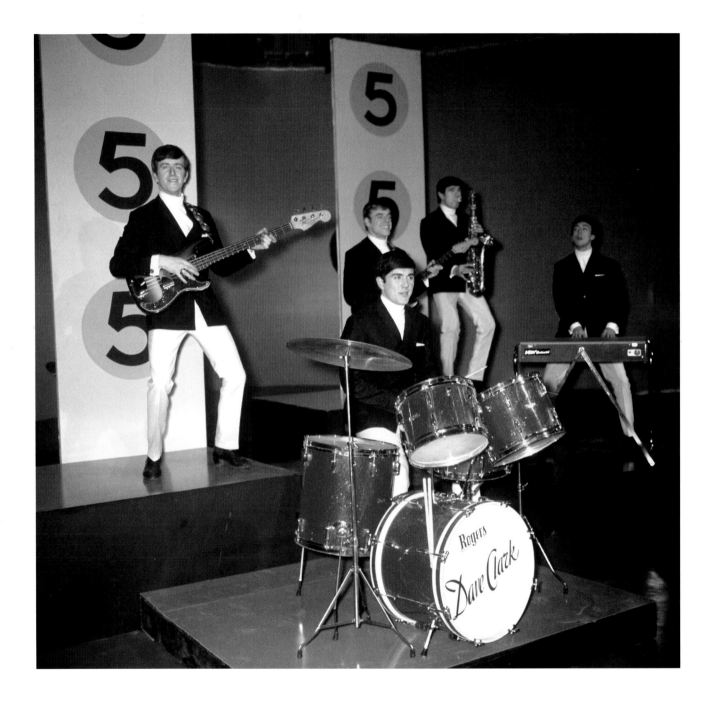

Facing page: The Dave Clark Five. With Dave Clark on drums the kit finds its way to the front of the line up.
6th January, 1964

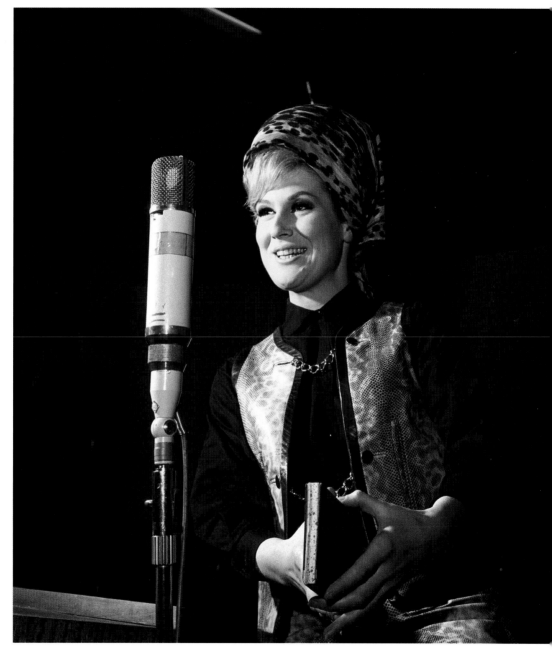

Dusty Springfield returns to work after a short illness. Later in 1964 she was deported from South Africa for performing to a mixed race audience.
21st January, 1964

Joe Brown, the star of Larry Parnes' first West End musical *For Love or Money*. Brown is the only member of the Parnes stable to refuse a name change. Allegedly Parnes wanted to call him Elmer Twitch.
13th February, 1964

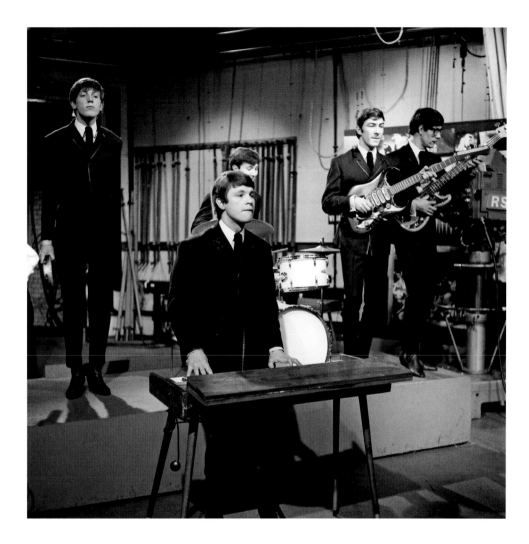

The Swinging Blue Jeans
on *Ready Steady Go!*
13th March, 1964

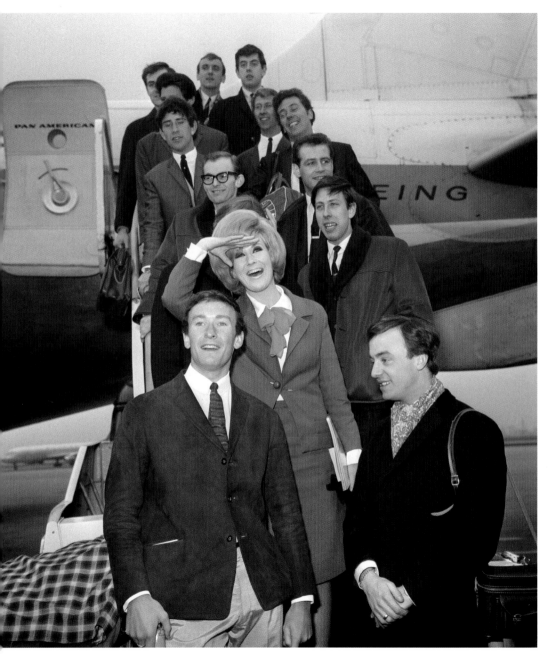

Facing page: Ringo Starr just makes the doorway in front of racing fans at Marylebone Station. This is a scene from the film *A Hard Day's Night,* but the fans are real.
5th April, 1964

Gerry and the Pacemakers, the Tremeloes, the Echoes and singer Dusty Springfield board a Pan American liner, bound for Australia, at London Airport.
31st March, 1964

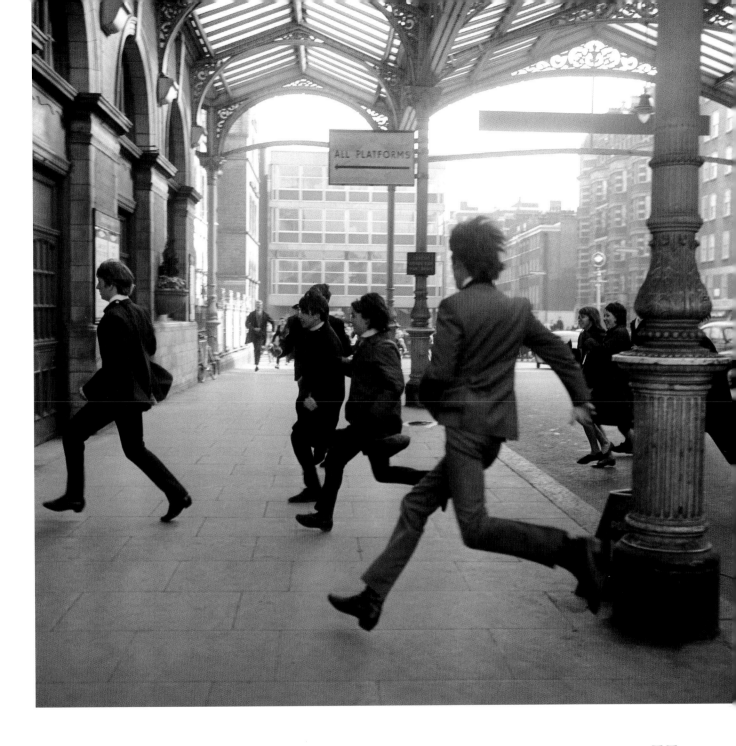

ALL PLATFORMS →

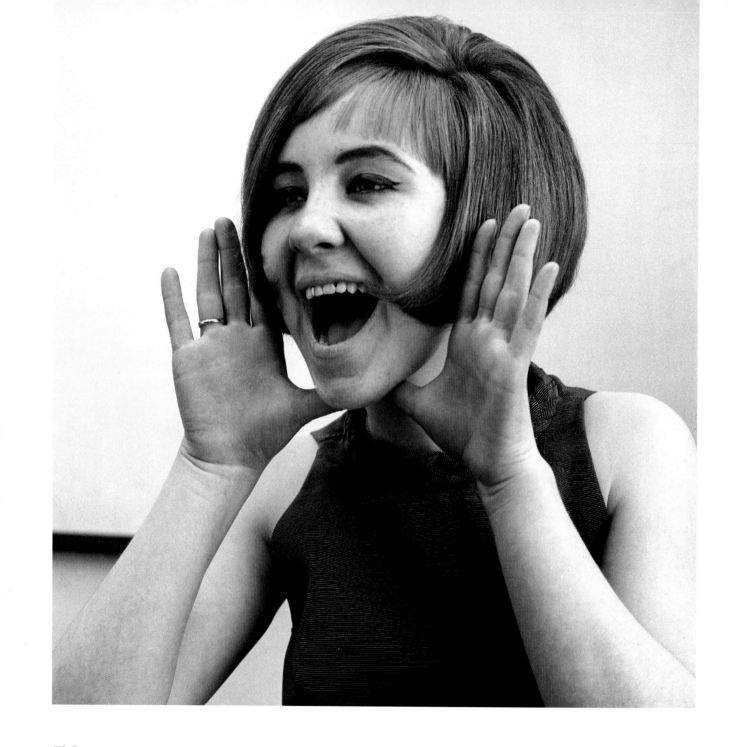

Facing page: 15 year old singer from Scotland, Lulu, made her debut with the song *Shout*.
14th April, 1964

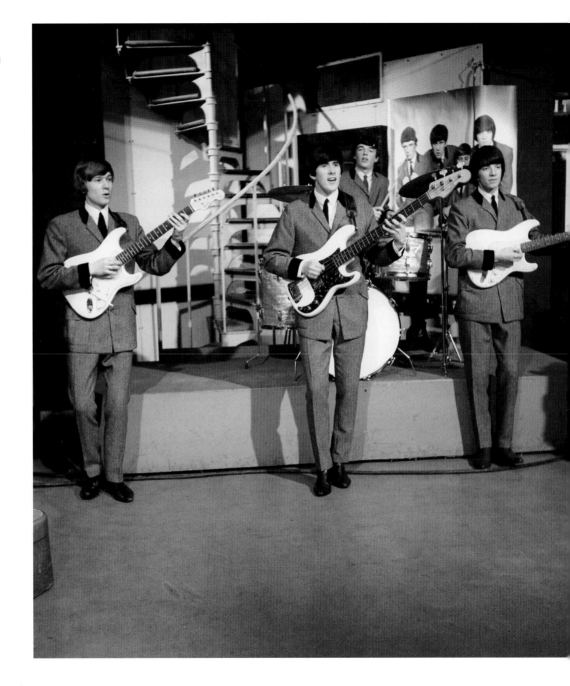

Mersey Beat band The Fourmost on *Ready Steady Go!*
17th April, 1964

Johnny Kidd (real name
Frederick Alfred Heath) and
The Pirates offer a future
echo of Adam and the Ants.
1st May, 1964

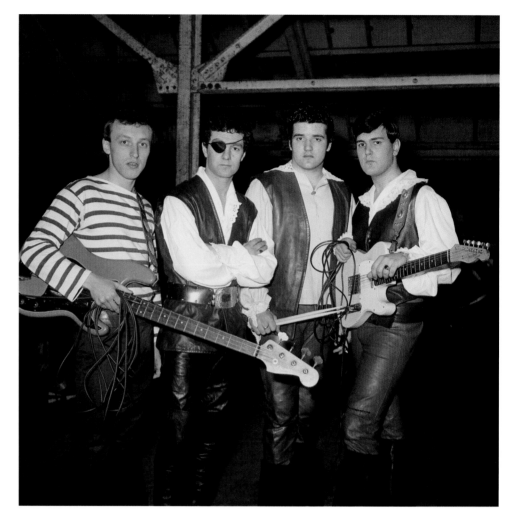

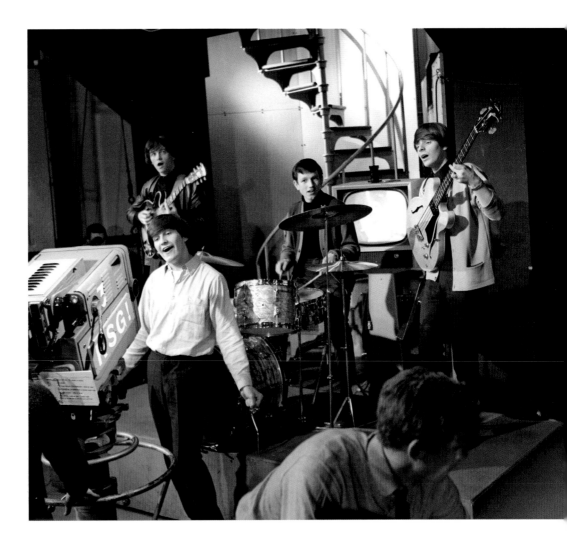

Wayne Fontana and
the Mindbenders
on *Ready Steady Go!*
9th May, 1964

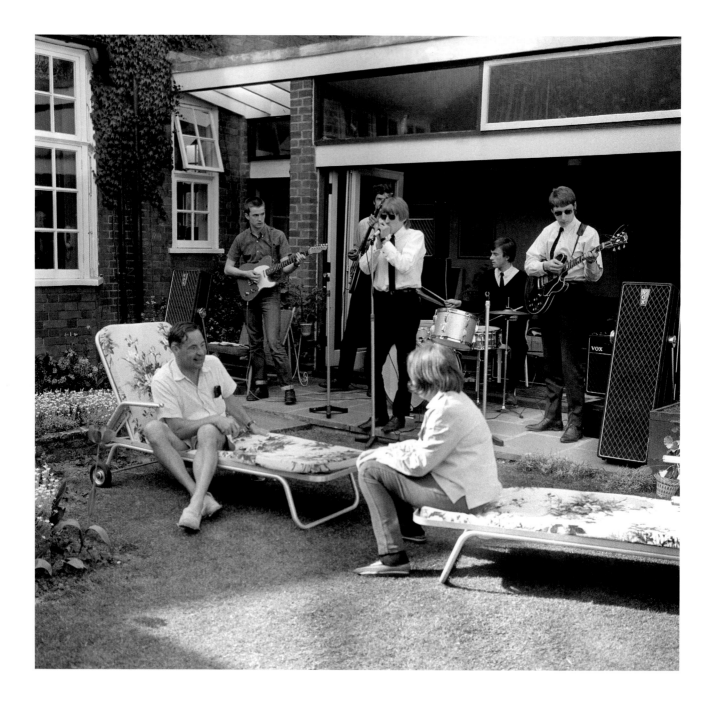

Facing page: The Yardbirds in the back yard of Lord Willis, who attacked the 'Beatle cult' in a House of Lords speech.
17th May, 1964

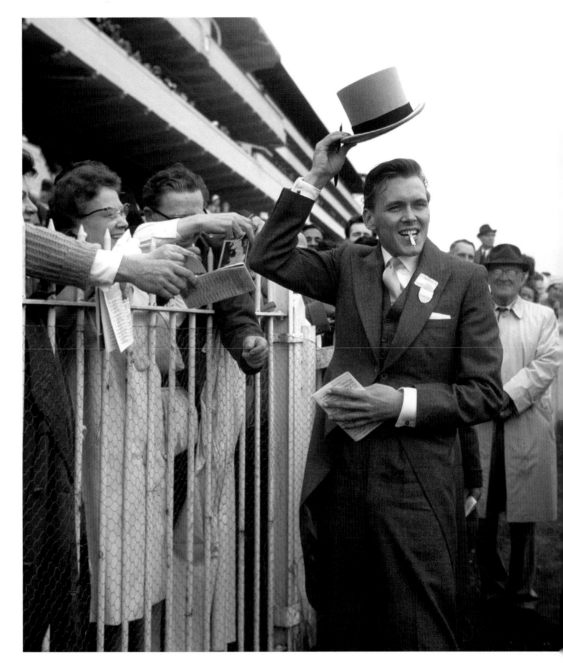

He's got a horse! Billy Fury, owner of racehorse *Anselmo*.
3rd June, 1964

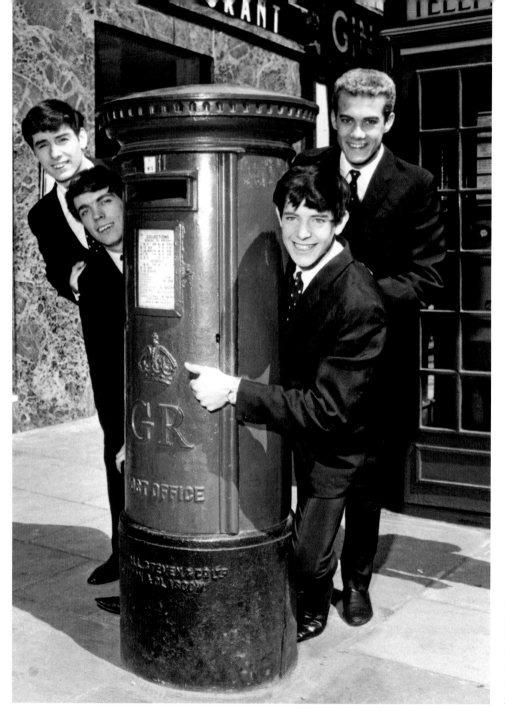

Facing page: "Are we doing *Stonehenge*?" The Rolling Stones at ABC's Teddington Studios, for *Thank Your Lucky Stars*. (L–R) Bill Wyman, Brian Jones, Charlie Watts, Mick Jagger and Keith Richards.
28th July, 1964

The Eagles, from Bristol. (L) Guitarists Terry Clarke and Mike Brice (front). (R) Rod Meacham, vocalist and drummer, and Johnny Payne, rhythm guitarist (front).
22nd June, 1964

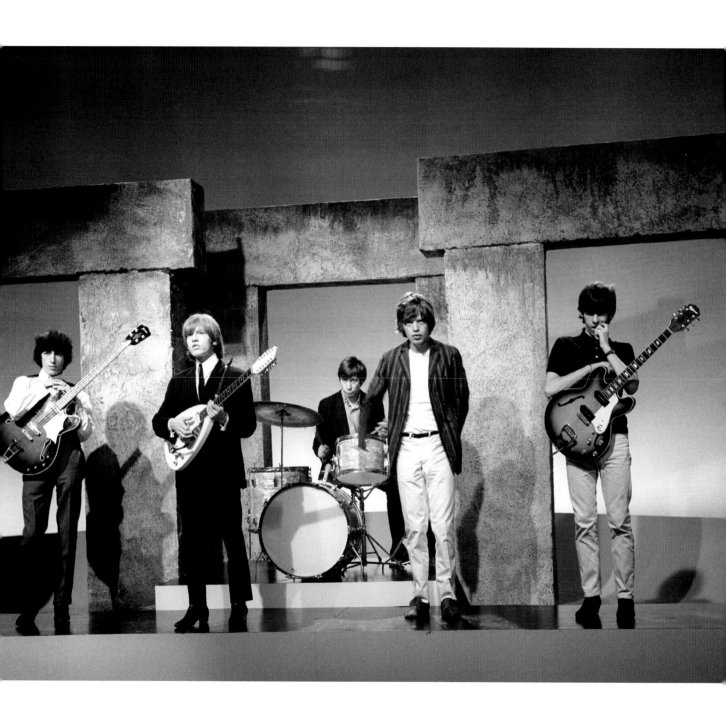

Facing page: Joe Cocker
(R) buys a copy of his own
record.
1st September, 1964

Juke box moment.
1st September, 1964

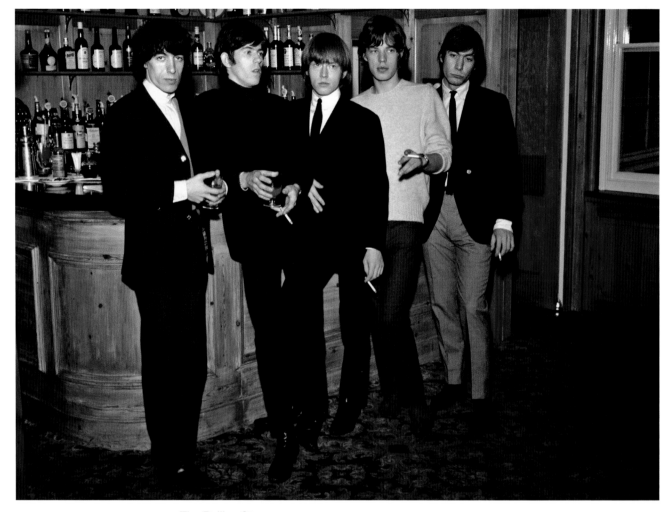

The Rolling Stones
in characteristic hell–raising
form.
12th September, 1964

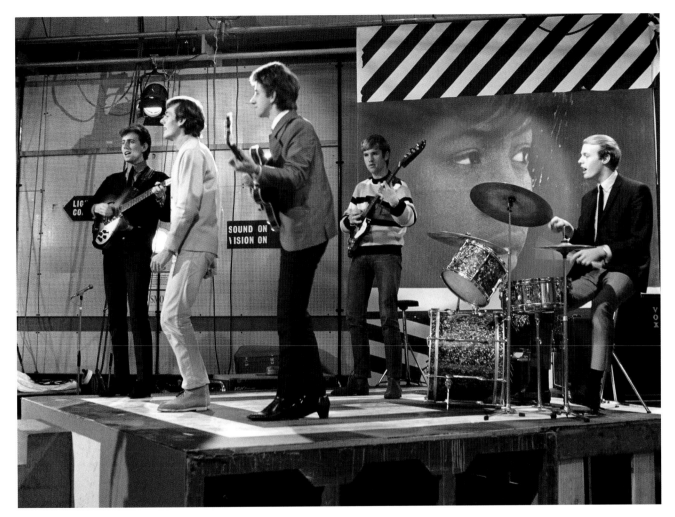

The Hollies on
Ready Steady Go!
18th September, 1964

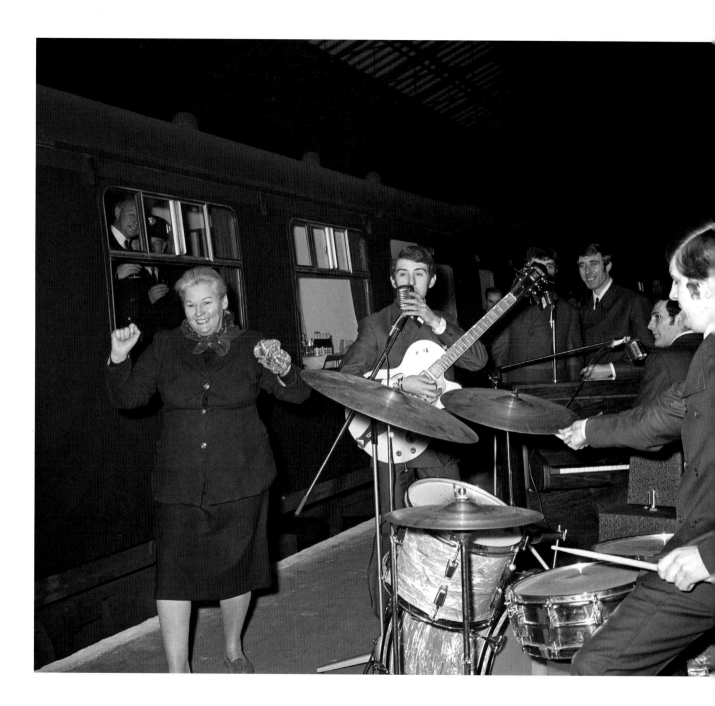

50 Years of British Pop • Twentieth Century in Pictures

Facing page: The Moody Blues serenade travellers and porter Alice Eades at Holborn Viaduct Station.
11th November, 1964

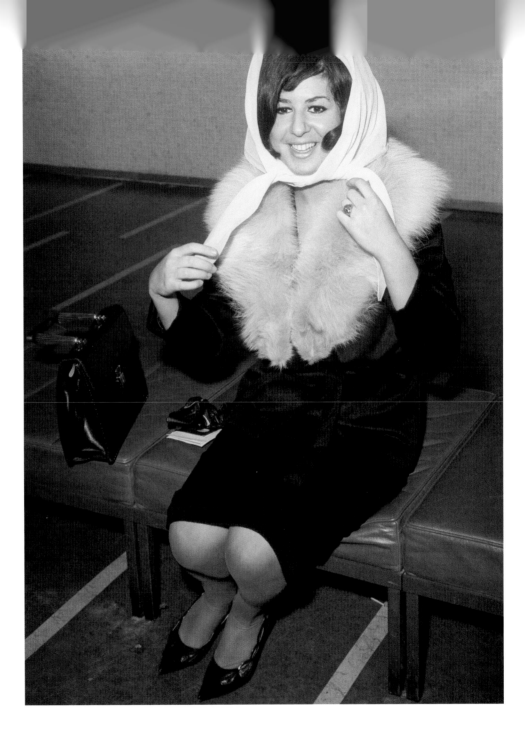

19 year old Elkie Brooks from Salford, on her way to Paris.
23rd November, 1964

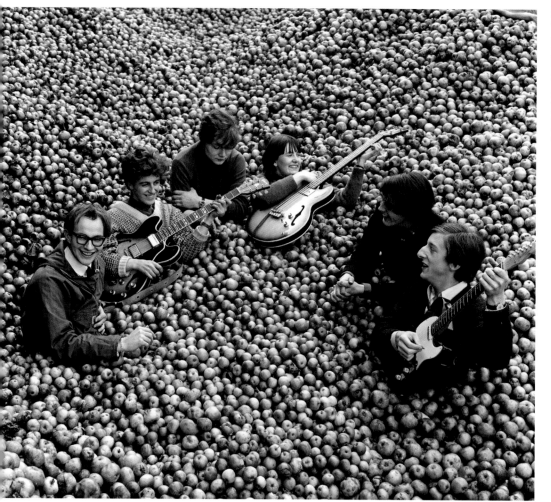

Solihull's finest: The Applejacks visit the world's largest cider factory at Hereford. (L–R) Gerry Freeman, Phil Cash, Al Jackson, Megan Davies, Don Gould and Martin Baggott.

17th December, 1964

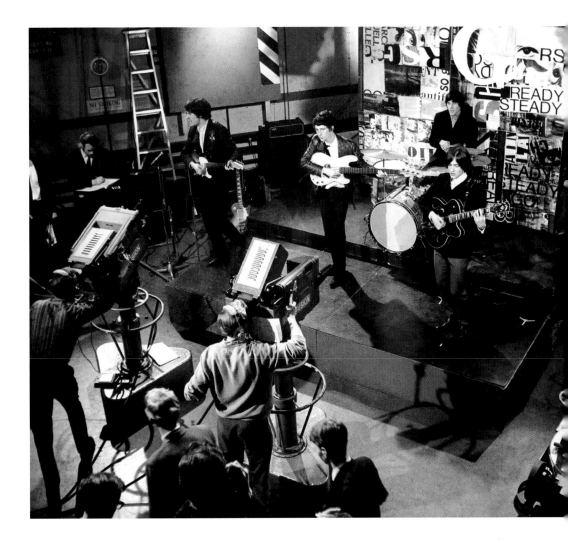

The Kinks on
Ready Steady Go!
5th January, 1965

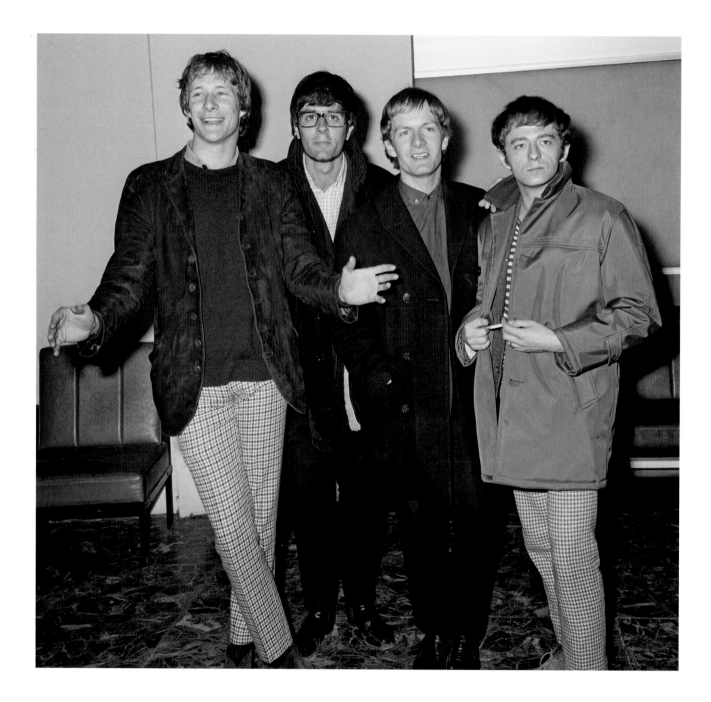

Facing page: Manfred Mann
return from Australia. (L–R)
Paul Jones, Manfred Mann,
Mike Vickers and Mike Hugg.
The fifth band member,
Tom McGuinness, is still
in customs.
10th February, 1965

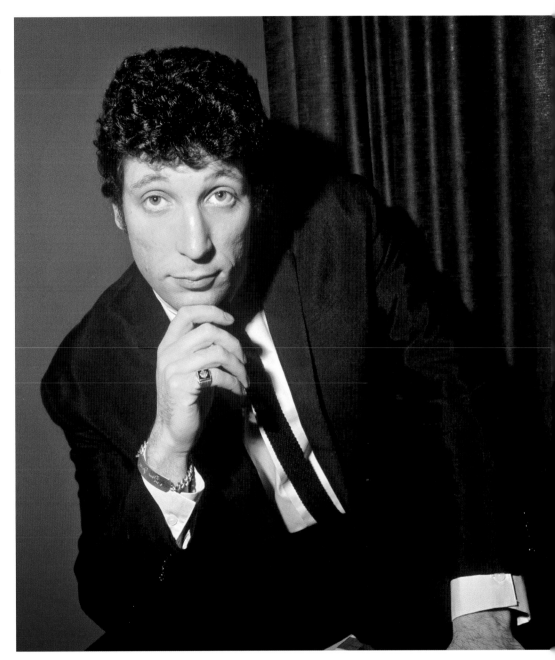

Fresh from the valleys:
Tom Jones.
25th February, 1965

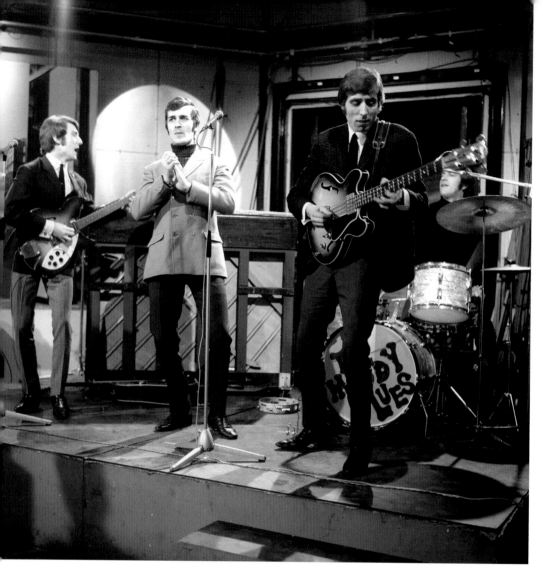

The Moody Blues on
Ready Steady Go!
5th March, 1965

At the height of their powers:
(L–R) Cilla Black, Petula
Clark and Sandie Shaw.
4th May, 1965

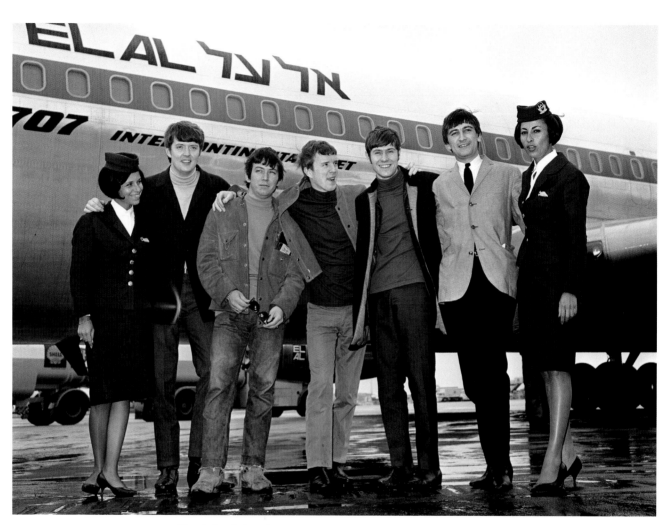

The Animals head
for the US.
27th May, 1965

Irish crooner Val Doonican
prepares for *The Val
Doonican Show.*
16th September, 1965

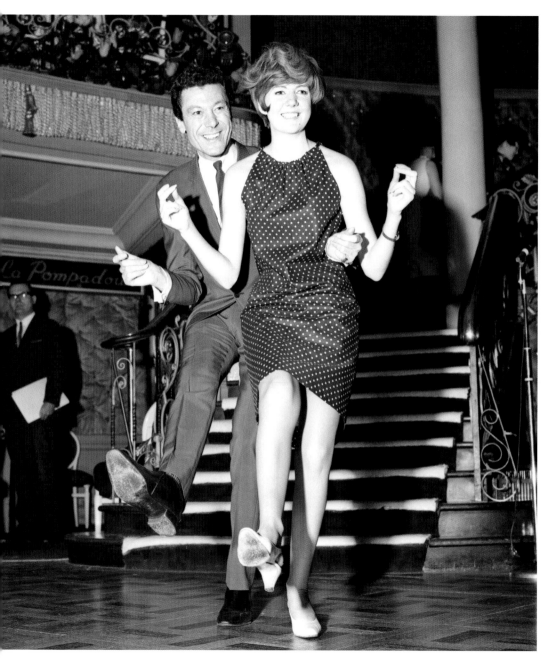

Cilla Black and Lionel Blair take a turn around the floor.
29th September, 1965

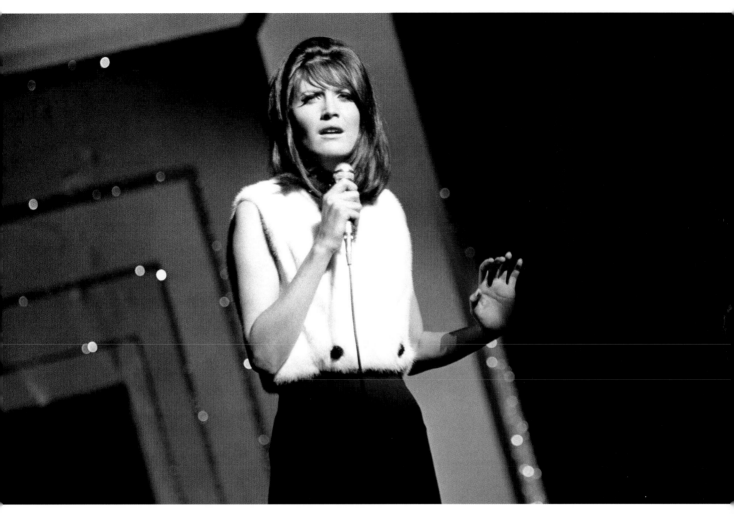

Sandie Shaw.
January, 1966

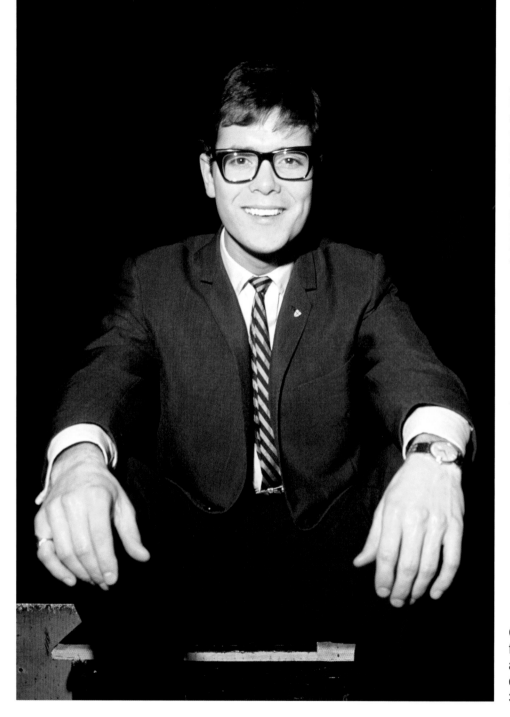

Facing page: Disc jockey Jimmy Savile hands out fruit in Brixton Market where he auctioned 20 autographed tickets for the opening of the Ram Jam club in Brixton. The Ram Jam was hugely influential in the '60s; in the '70s and '80s it underwent a number of name changes before reopening as The Fridge in 1981.
11th February, 1966

Cliff Richard takes a break from rehearsals for his appearance at The Talk of the Town.
30th January, 1966

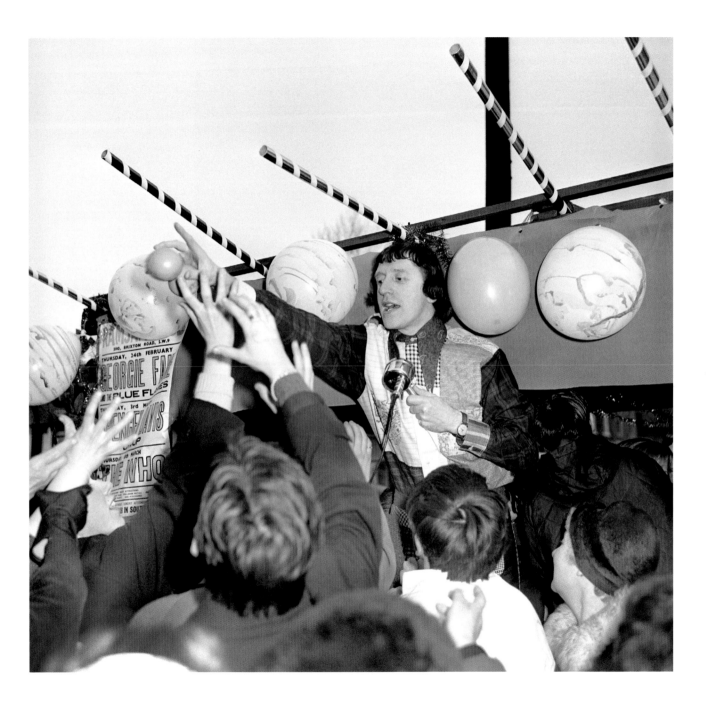

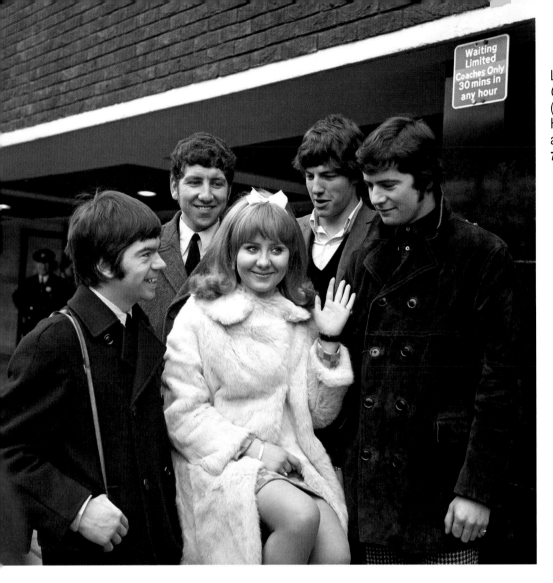

Lulu, *'The wee lass from Glasgow'*, with The Luvvers (L–R) Tony Tierney, H Wright, D Wenels and Alec Bell.
7th March, 1966

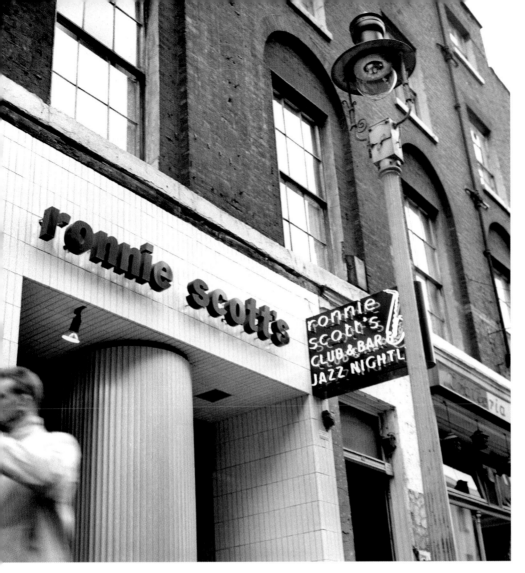

Ronnie Scott's jazz club
on Frith Street, Soho.
15th March, 1966

Donovan appeared at Marylebone Magistrates Court
charged with possession of cannabis. His musical director
David John Mills, known as 'Gypsy Dave', was also charged.
10th June, 1966

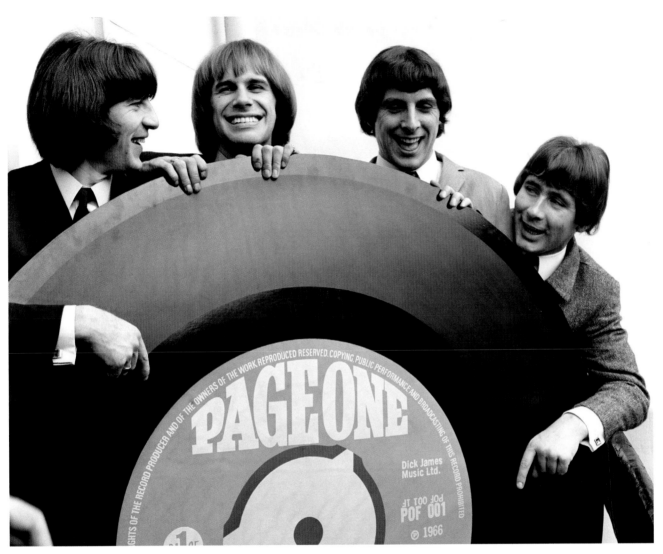

The Troggs with a giant copy of their single *I Can't Control Myself:* (L–R) Chris Britton, Pete Staples, Ronnie Bond and Reg Presley.
29th September, 1966

Sandie Shaw, Britain's entry for the 1967 *Eurovision Song Contest* with *Puppet on a String*. She won with more than twice as many votes as the runner-up.
29th September, 1966

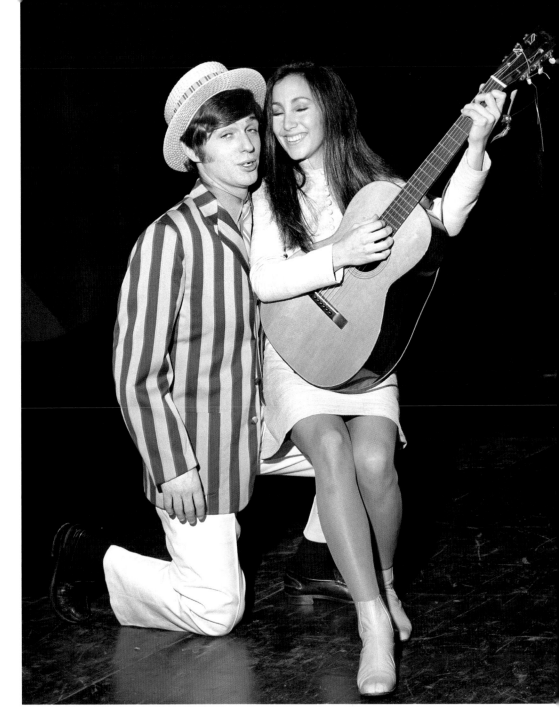

Georgie Fame and Julie Felix at the Saville Theatre, London, for his show *Fame in '67*, which also featured Cat Stevens.
23rd December, 1966

Engelbert Humperdinck
(real name Gerry Dorsey).
1st March, 1967

Pink Floyd: (L–R) Roger
Waters, Nick Mason,
Syd Barrett and Rick
Wright. Barrett was later
remembered in the group's
song, *Shine On You Crazy
Diamond*.
3rd March, 1967

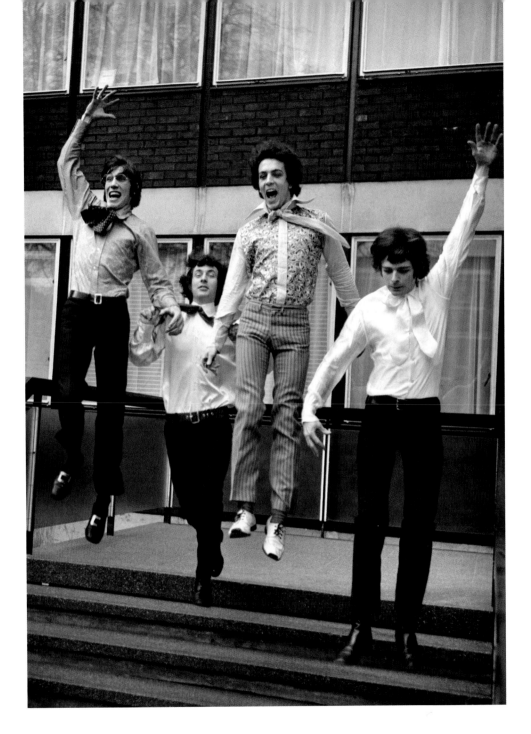

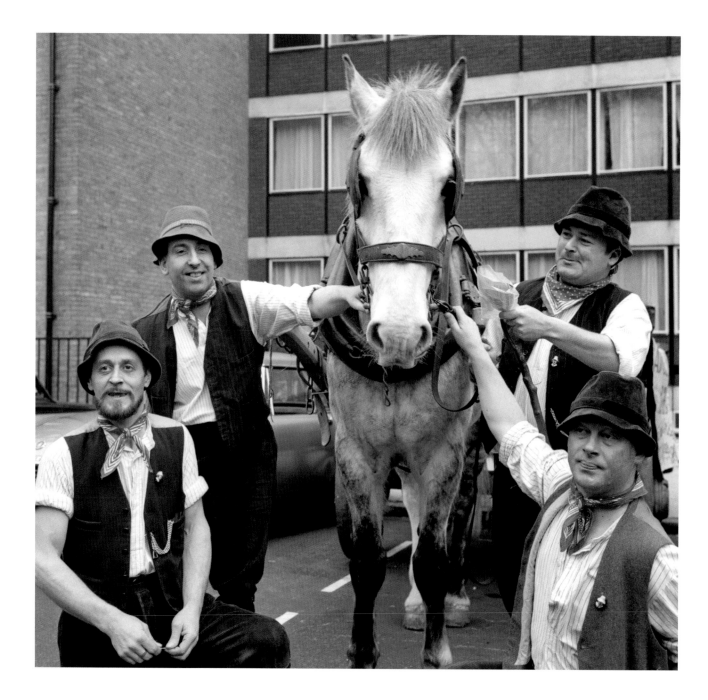

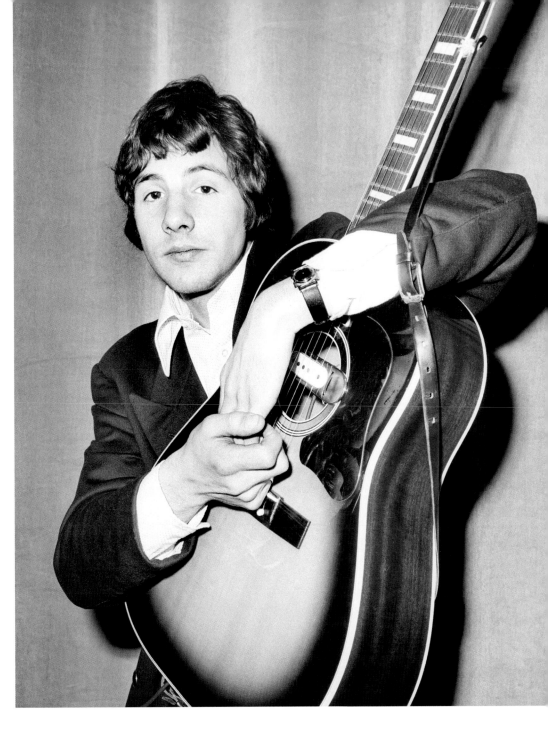

Facing page: The *'Zummerset Zound'* or possibly *'Scrumpy and Western'* comes to London; Adge Cutler and the Wurzels visit EMI House. Their songs and ditties originated as musical accompaniments to cider drinking in Somerset pubs. (L–R) Johnny Macey, Reg Chant, Adge Cutler and Reg Quantrell.
13th March, 1967

Cat Stevens backstage at the Finsbury Park Astoria.
31st March, 1967

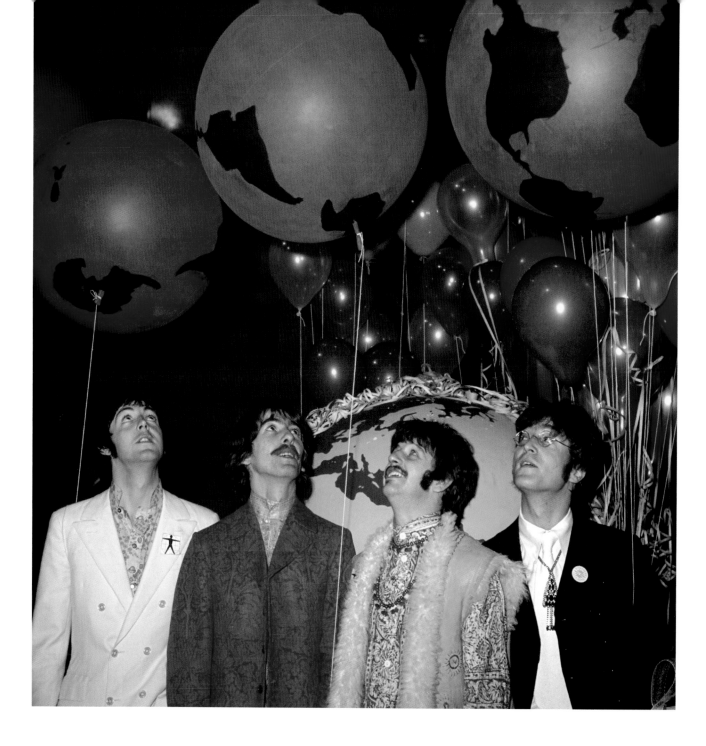

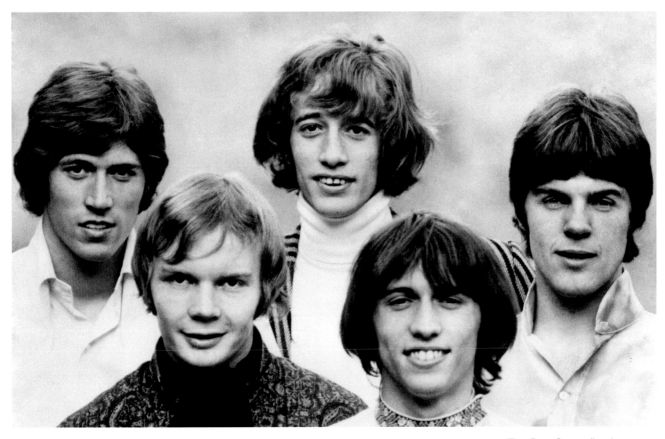

The Bee Gees: (back row, L–R): Barry Gibb, Robin Gibb and Vince Melouney. (front row, L–R): Dennis Bryon and Maurice Gibb.
1st August, 1967

Facing page: The Beatles launch the *Sergeant Pepper* album in the UK.
1st June, 1967

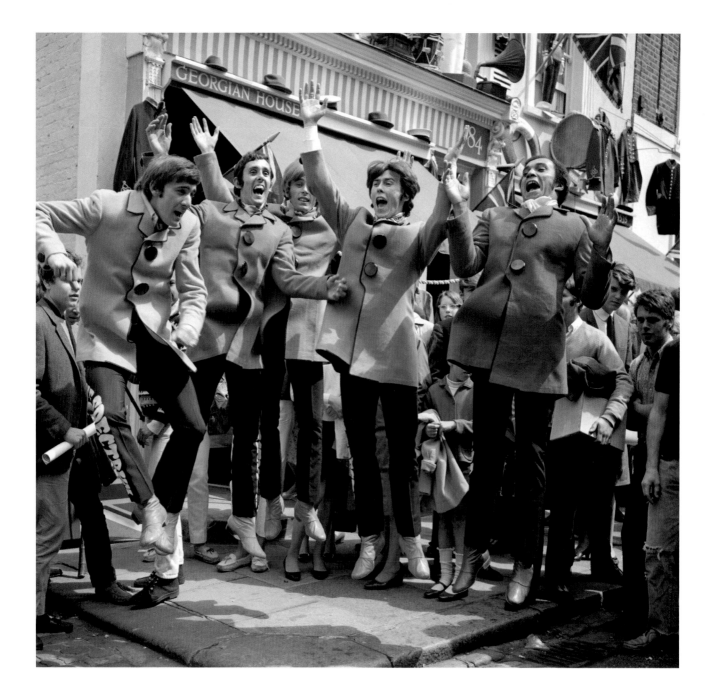

Facing page: The Spectrum take to the air in Portobello Road. Signed to a £100,000 TV and film contract by producers Gerry and Sylvia Anderson, they recorded the theme tune to *Captain Scarlet*: (L–R) Colin Forsey, Keith Forsey, Anthony Judd, Tony Atkins and Bill Chambers. Keith went on to produce Billy Idol's records and Georgio Morodor's film scores, collecting an Oscar for *What a Feeling* from *Flashdance*.

5th August, 1967

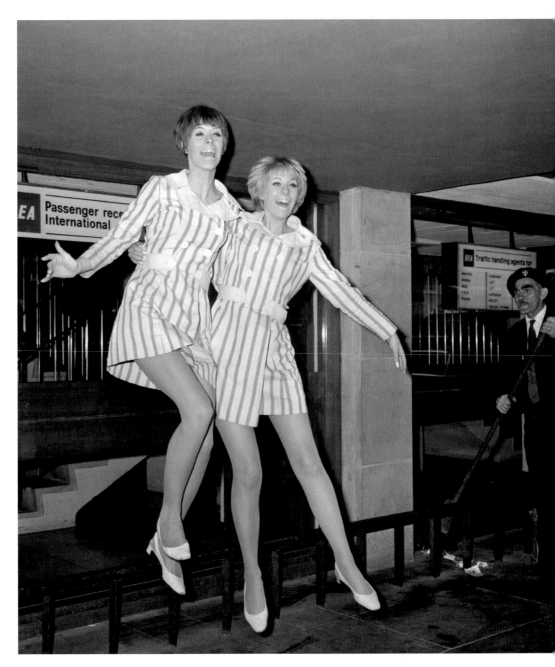

Heathrow Airport, and The Caravelles head for the carousel: Andrea Simpson (L) and Lynne Gibson.
15th August, 1967

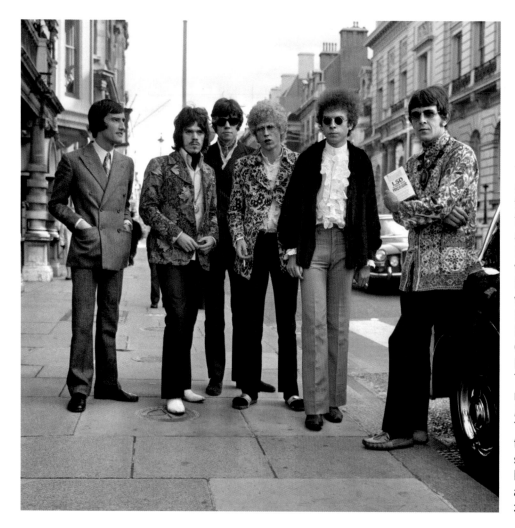

The Move leave the offices of their solicitor in Pall Mall, for the second hearing of the case in which they are accused of libelling Prime Minister Harold Wilson with a cartoon depicting him *in flagrante delicto* with his secretary. (L–R) Manager Anthony Secunda, Roy Wood, Bev Bevan, Christopher Kefford, Trevor Burton and Carl Wayne. They lost, forfeiting the royalties for their hit single *Blackberry Way* to charity. The subsequent split led to the creation of two supergroups, The Electric Light Orchestra and Wizzard.

3rd September, 1967

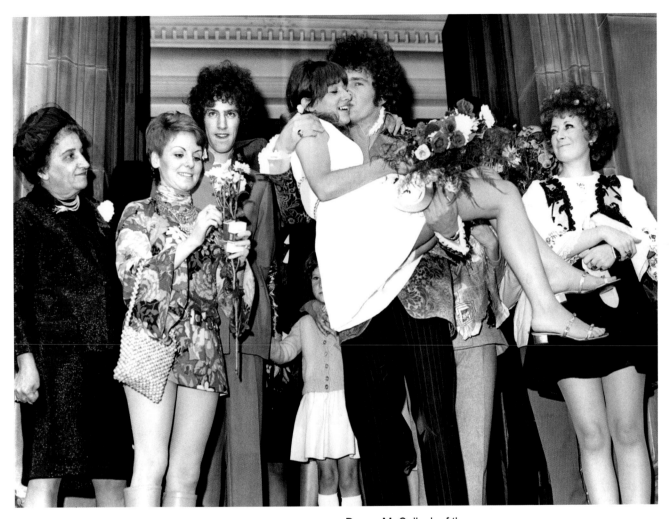

Danny McCullock of the
Animals holds his bride
Carol Fielder in his arms at
Paddington Register office.
15th September, 1967

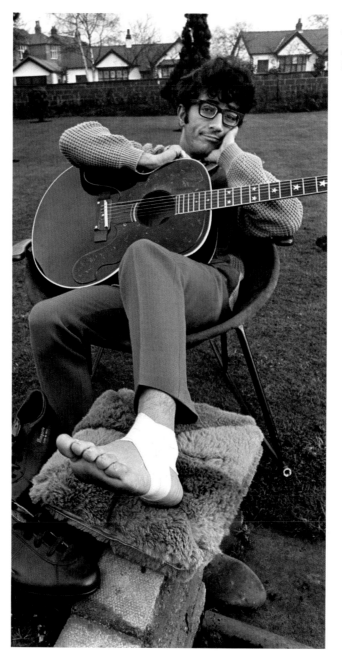

Facing page: Tony Blackburn with Anita Harris and her dog Albert at the Waldorf Hotel.
3rd January, 1968

Freddie Garrity of Freddie and the Dreamers nurses an injured ankle at his home in Gatley, Cheshire.
21st December, 1967

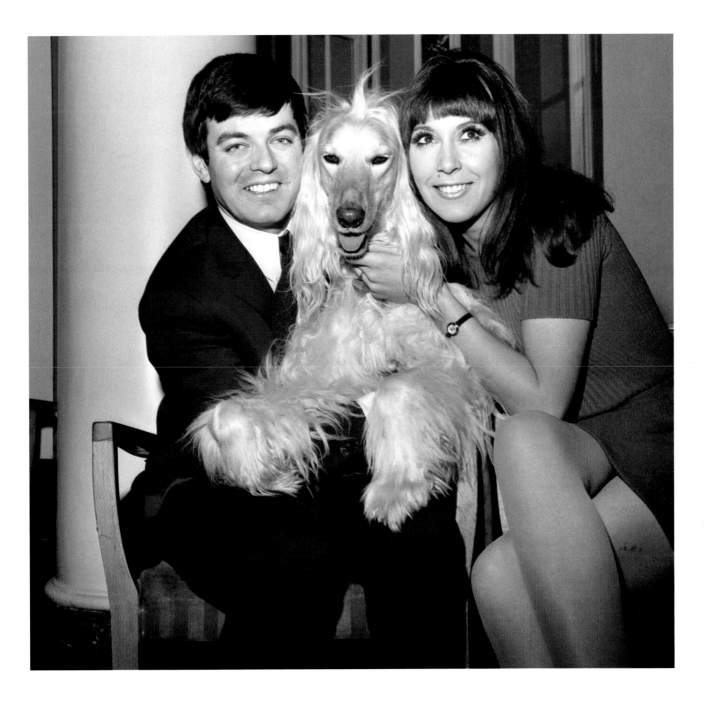

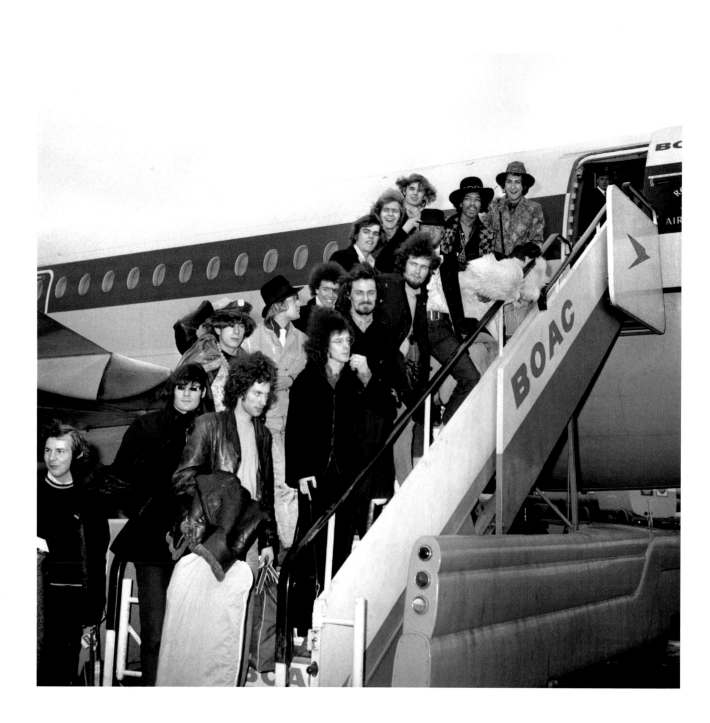

Facing page: Four British pop groups bound for the United States: The Jimi Hendrix Experience, Eric Burdon and the Animals, The Alan Price Set and Éire Apparent.
30th January, 1968

The Paper Dolls from Northampton. (L–R) Sue Marshall '*Copper*', Susie Mathis '*Tiger*', and Pauline Bennett '*Spyder*'.
14th February, 1968

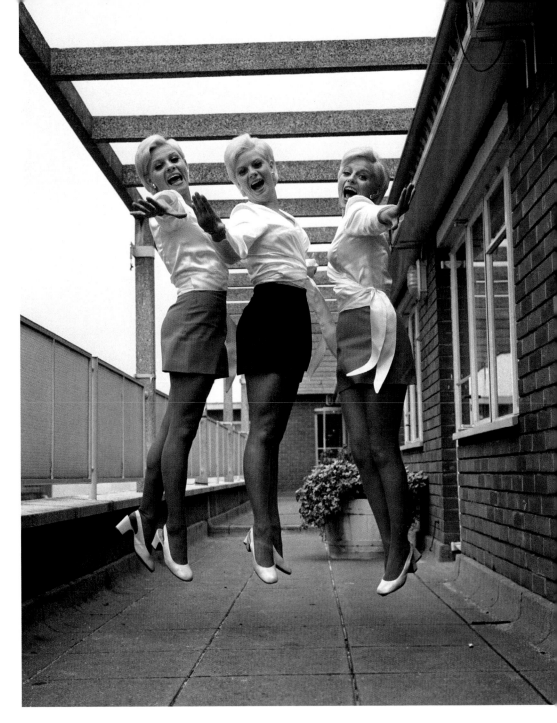

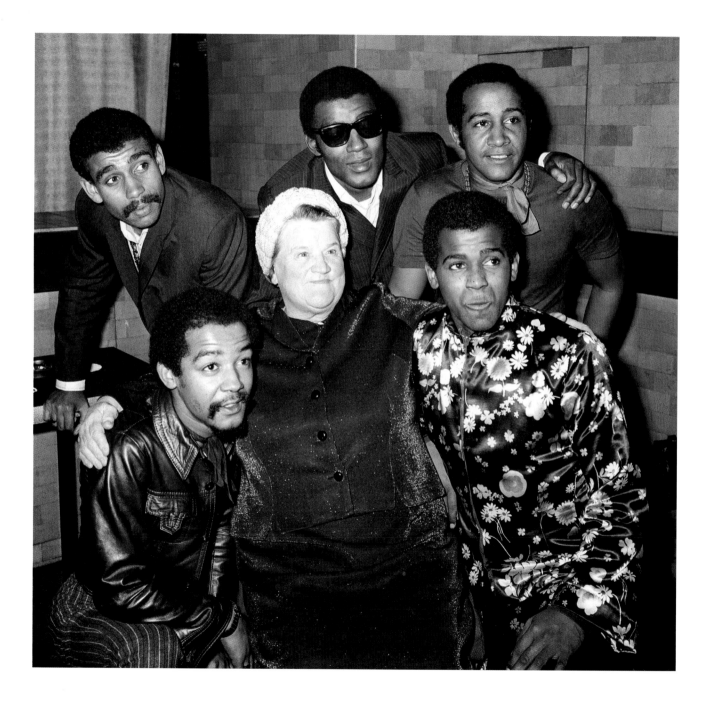

Facing page: MP for Liverpool Exchange, Bessie Braddock, with Liverpool-born group The Chants. They made their debut at the Cavern Club, backed instrumentally by The Beatles.
22nd October, 1968

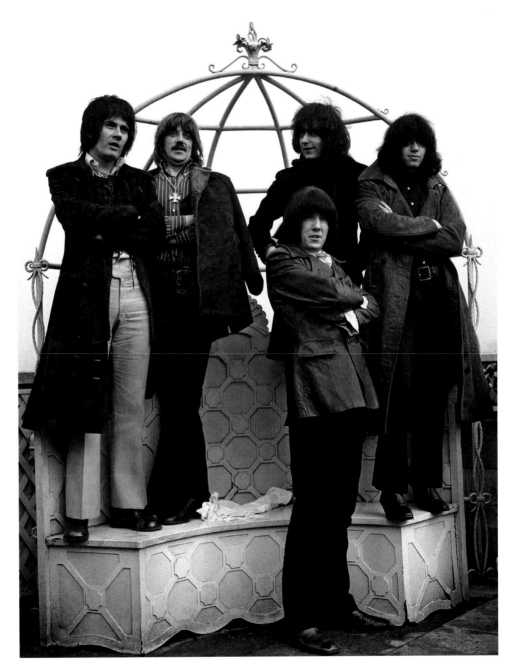

(L–R) Rod Evans, Jon Lord, Ritchie Blackmore, Nicky Simper and Ian Paice of Deep Purple, on the roof of the Dorchester.
3rd January, 1969

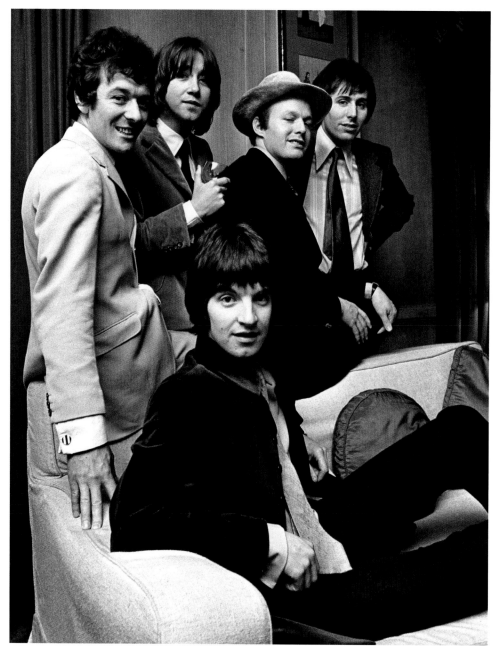

The Hollies announce the replacement for Graham Nash who left the group to concentrate on a songwriting career in America. Liverpool-born Terry Sylvester (seated, then L–R) Alan Clarke, Tony Hicks, Bobby Elliott and Bernie Calvert.
16th January, 1969

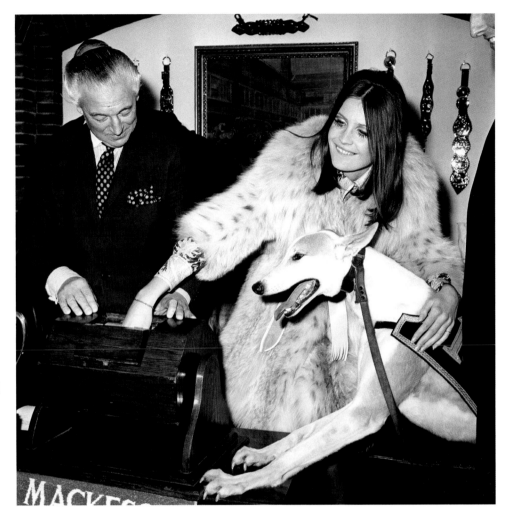

Sandie Shaw makes the draw for the first round of the *Mackeson Greyhound Championship*, with Major Percy Brown, the Greyhound Racing Association's Director of Racing, and the Duke of Edinburgh's greyhound *Camira Flash*, winner of the 1968 Greyhound Derby.
29th January, 1969

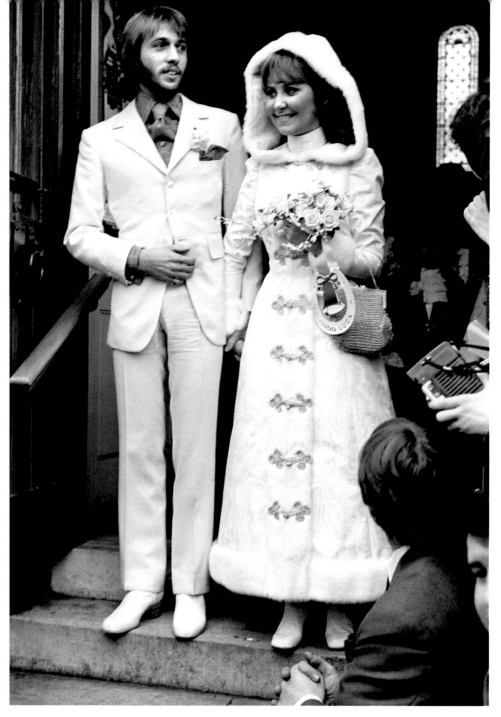

Lulu marries Maurice Gibb of
The Bee Gees at Gerrard's
Cross in Buckinghamshire.
18th February, 1969

The Rolling Stones in concert at Hyde Park. The band are putting on a brave face after the sudden and controversial death of former Stone Brian Jones.
5th July, 1969

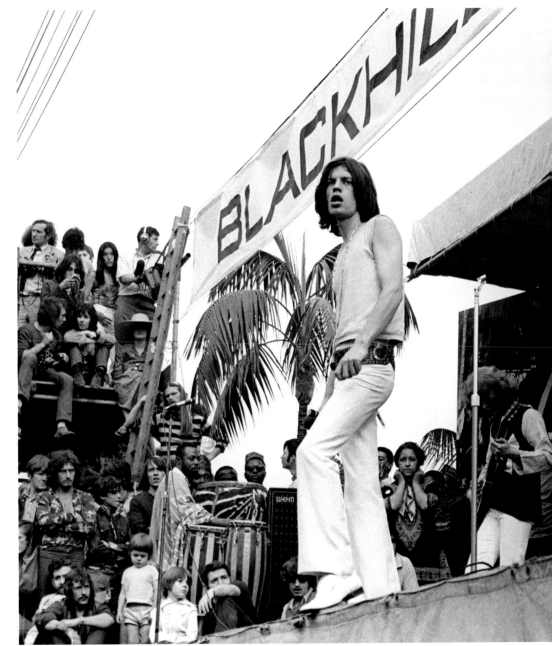

Facing page: Some 200,000 fans gathered for the Isle of Wight Festival, which was dogged by technical problems – the prevailing wind ensured the sound was better behind the stage than in front – and riotous behaviour from fans.
31st August, 1969

Ginger Baker, drummer with Cream, at Hyde Park.
5th July, 1969

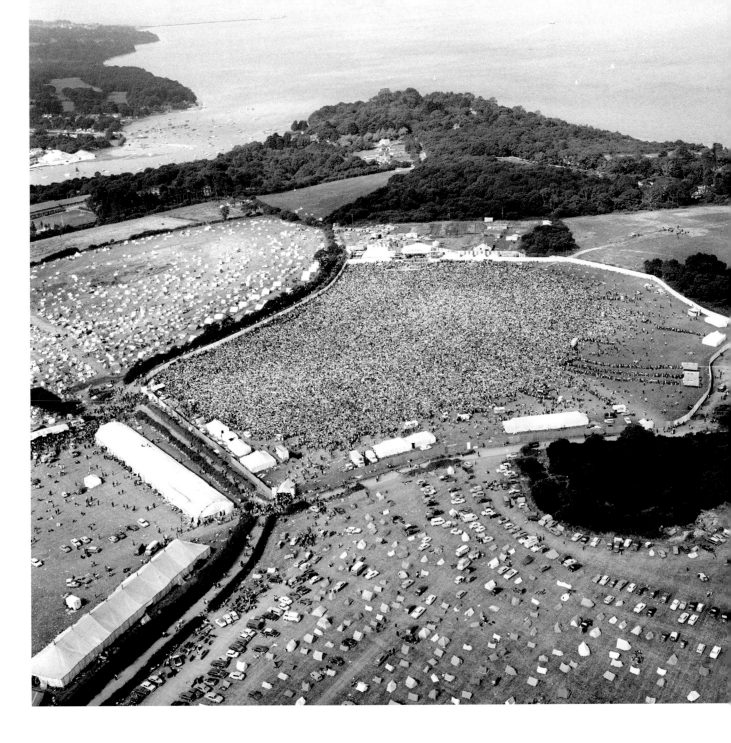

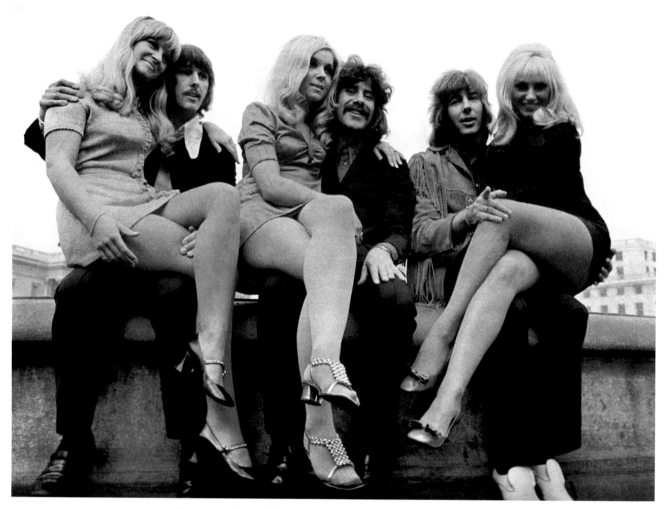

Three members of the
Tremeloes with their
partners: (L–R) Chip Hawkes
and Carol Dilworth; Alan
Blackley with Lyn Stevens
and Dave Munden with
Andree Wittenberg.
10th September, 1969

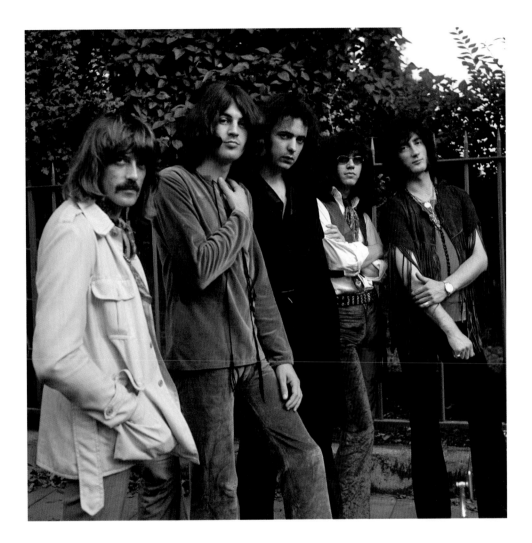

Deep Purple.
19th September, 1969

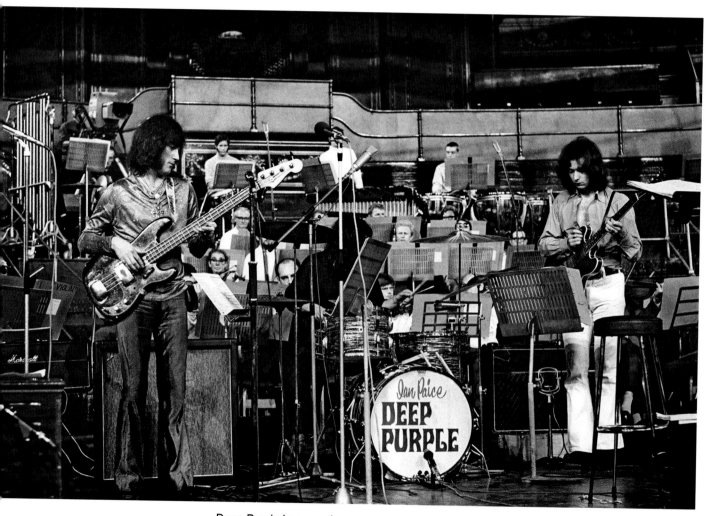

Deep Purple become the
first pop group to perform
live with the backing of
the Royal Philharmonic
Orchestra, at the Royal
Albert Hall.
24th September, 1969

Mary Hopkin, who was recommended to Paul McCartney by Twiggy after her winning appearance on *Opportunity Knocks*. She became one of the first artists signed to the Apple record label.

13th October, 1969

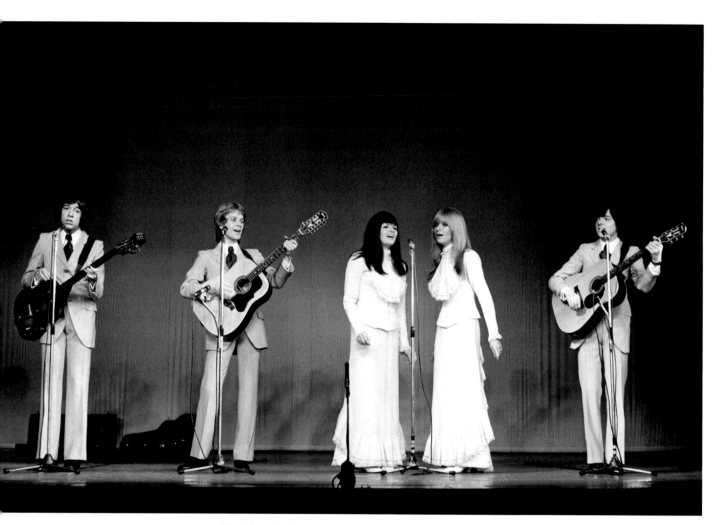

The New Seekers
perform on stage.
22nd October, 1969

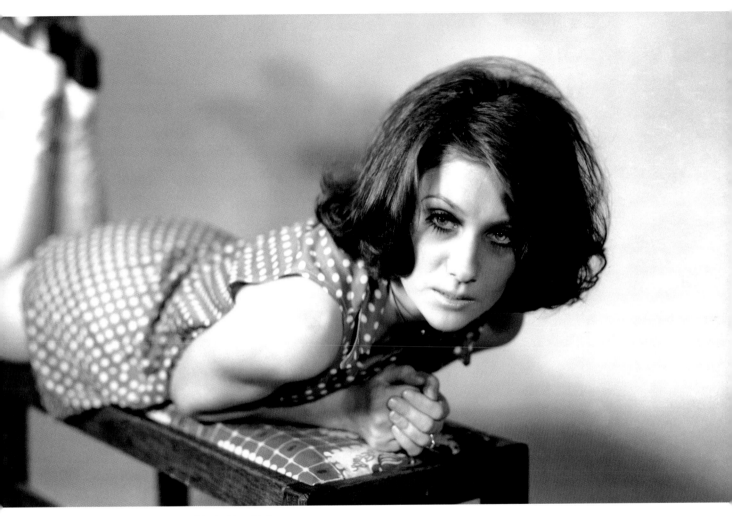

Linda Kendrick.
4th November, 1969

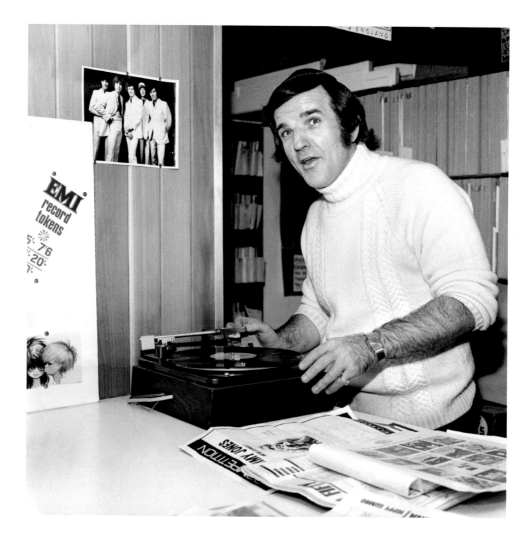

DJ Alan 'Fluff' Freeman at
his record shop in Leyton.
6th November, 1969

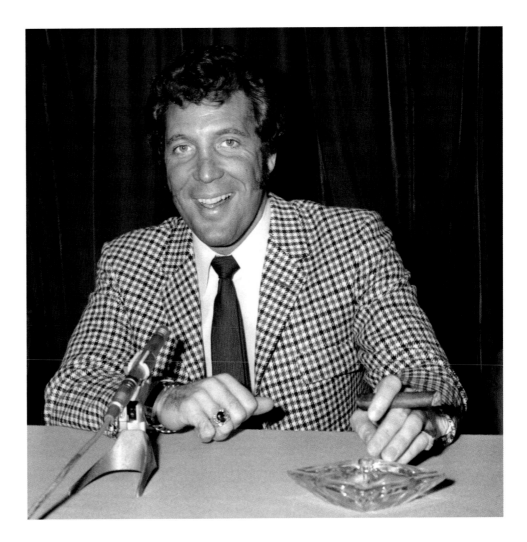

Tom Jones, at a press
conference in the ATV
Studios at Elstree.
His variety show *This is
Tom Jones* is syndicated
in the US.
18th November, 1969

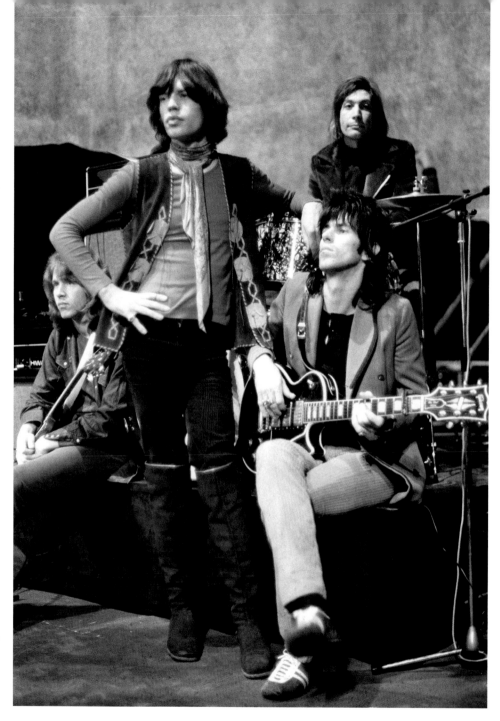

The Rolling Stones at the
Saville Theatre, London.
It's been a bad year for
the band with the death of
Brian Jones, followed by the
killing, by Hell's Angels, of
a member of the audience
during a free concert at
Altamont in California. These
events heralded the end of
the '60s and the advent of
darker times.
14th December, 1969

First female Radio 1 DJ,
Anne Nightingale.
7th January, 1970

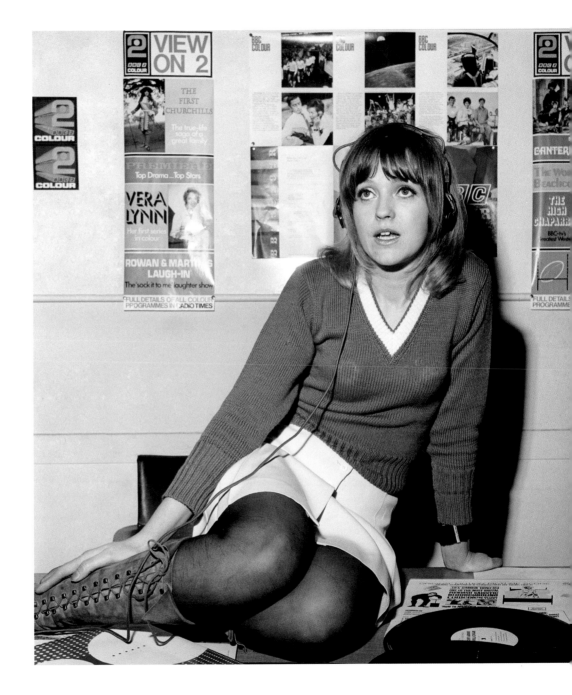

Freddie Garrity, of Freddie and the Dreamers, in Barnet General Hospital on the second day he was allowed solid foods. He was injured when thrown through the roof of his Lotus in a crash at South Mimms.

7th January, 1970

Avuncular whistling balladeer
Roger Whittaker.
13th January, 1970

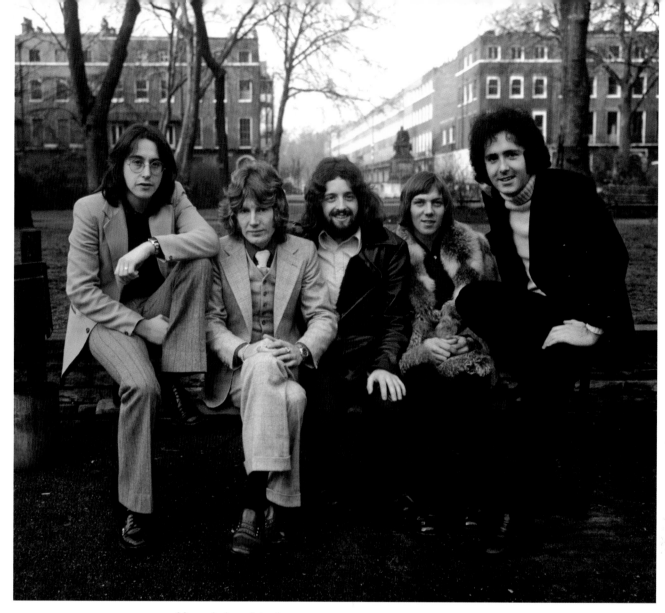

Marmalade, originally
known as Dean Ford
and The Gaylords.
27th January, 1970

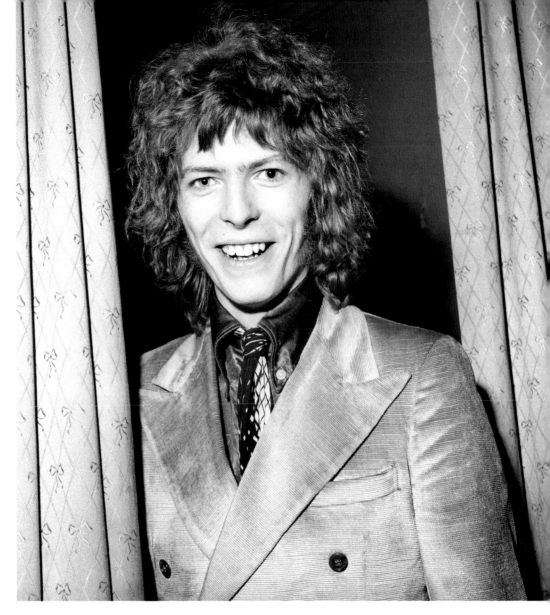

David Bowie riding high on the continued success of his 1969 hit *Space Oddity*.

13th February, 1970

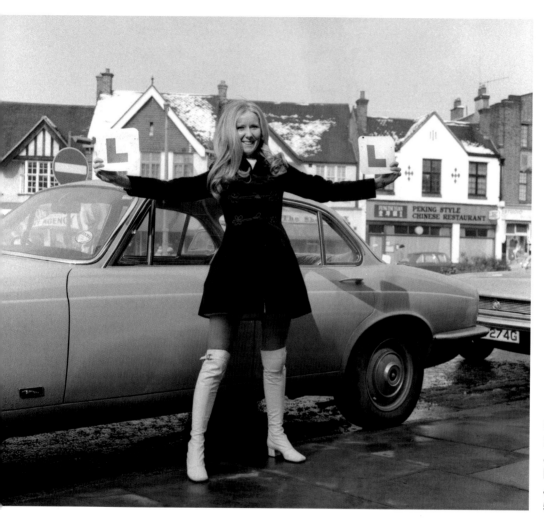

Clodagh Rodgers celebrates
her 23rd birthday with her
Jaguar *XJ6,* a gift from
her husband and manager
John Morris.
5th March, 1970

Eric Clapton and Alice Orsmby Gore, the teenage daughter of Lord Harlech. The Ormsby Gores helped Clapton overcome his heroin addiction, but Alice died of an overdose in a Bournemouth bedsit in 1995. She was 42.

8th March, 1970

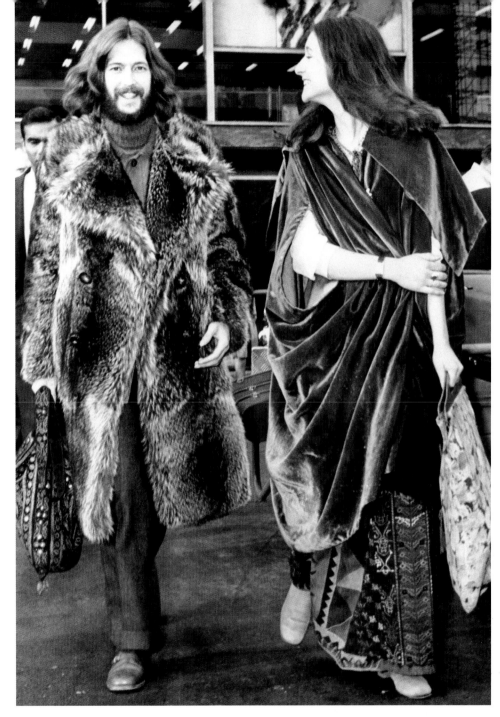

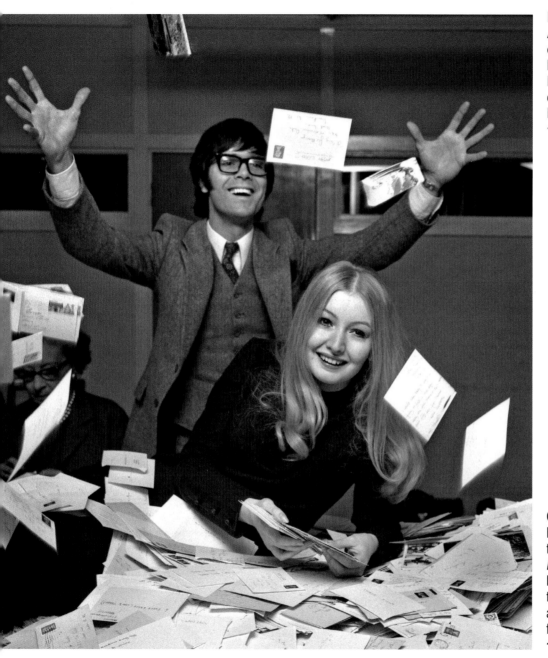

Facing page: Derek Taylor, Apple record company press officer, confirms that there has been a split between Paul McCartney and the other members of The Beatles.
10th April, 1970

Cliff Richard and Mary Hopkin with votes for the British entry in the *Eurovision Song Contest*. Mary sang six entries on the *Cliff Richard Show* and viewers voted for their favourite.
11th March, 1970

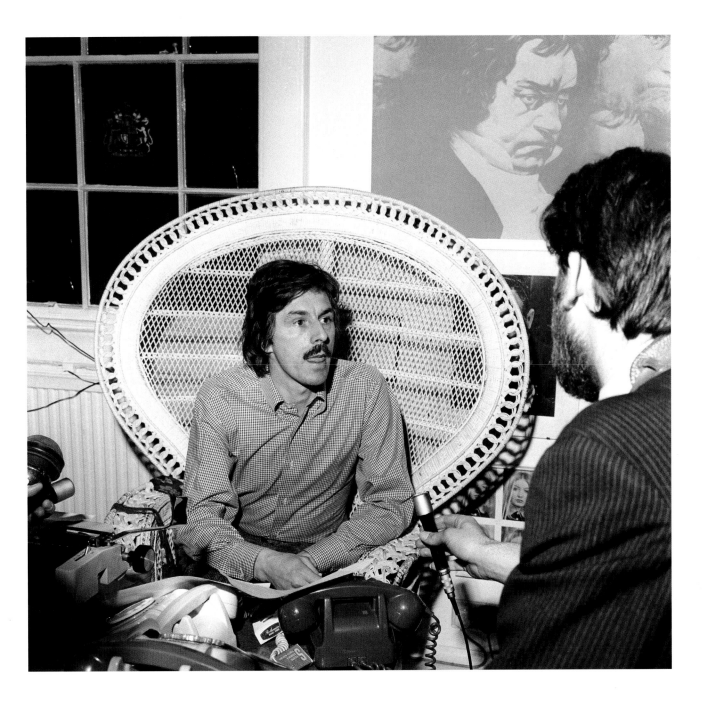

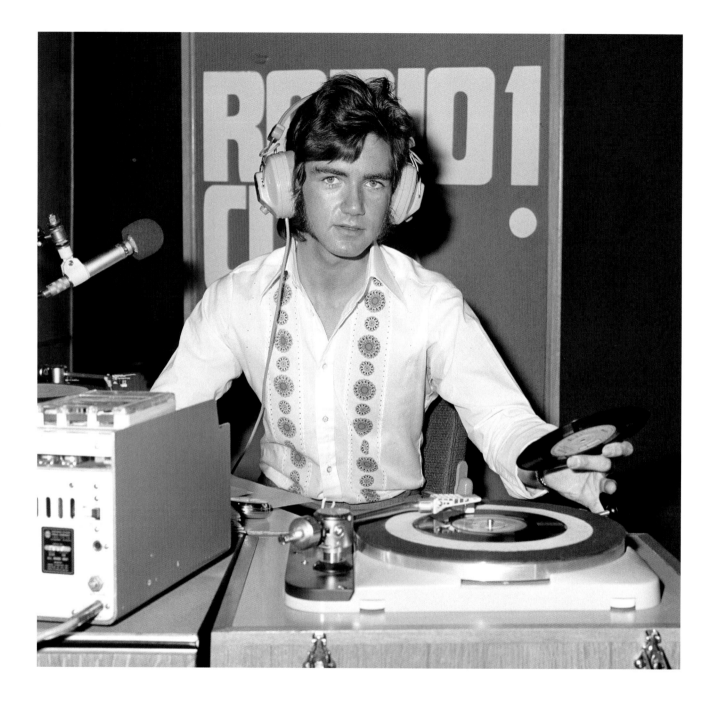

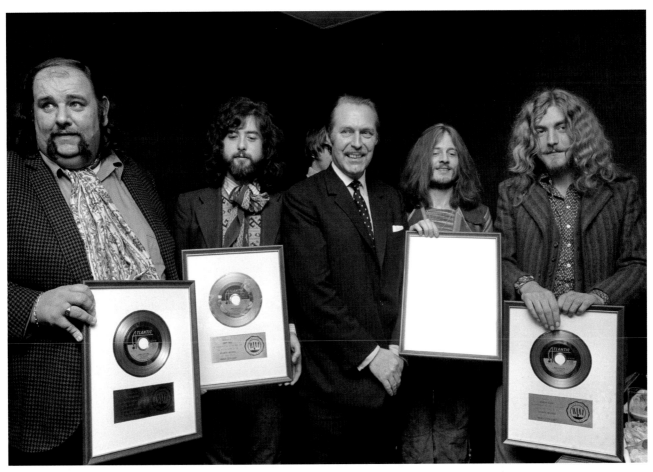

Facing page: Noel Edmonds
becomes the new Radio 1
DJ, taking over from Kenny
Everett who was fired
for joking on air that the
Transport Minister's wife
might have bribed her driving
test examiner.
22nd July, 1970

Anthony Grant MP (C),
Parliamentary Secretary to
the Board of Trade, presents
Led Zeppelin with gold discs
for one million sales.
14th October, 1970

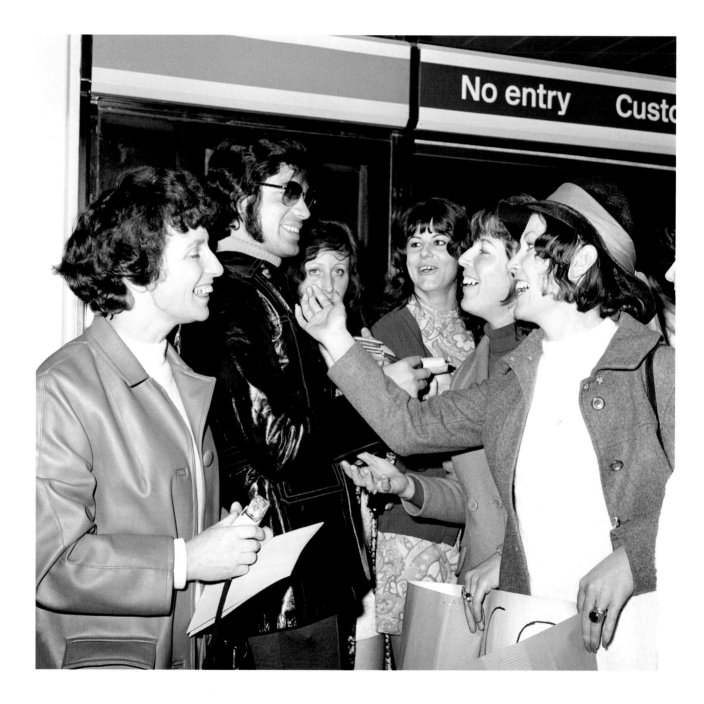

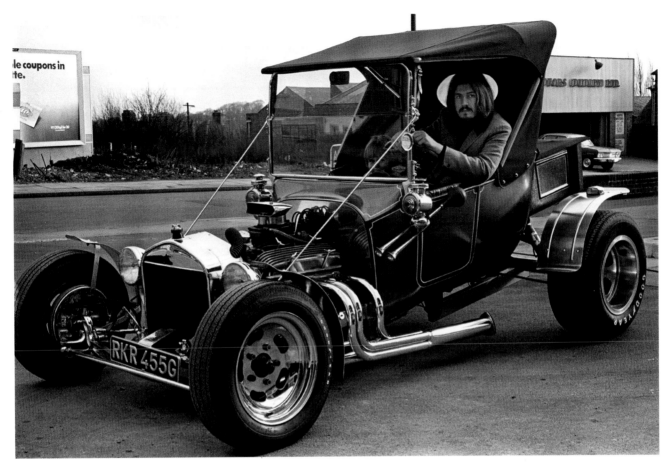

Led Zeppelin drummer
John Bonham at the wheel
of his 1923 *Model T* Ford
with a Chevrolet engine.
He imported the car from
Massachusetts.
2nd March, 1971

Facing page: Engelbert
Humperdinck returns from
his American tour. He is
to appear at the London
Palladium for two weeks
following a petition signed by
12,000 of his British fans.
12th November, 1970

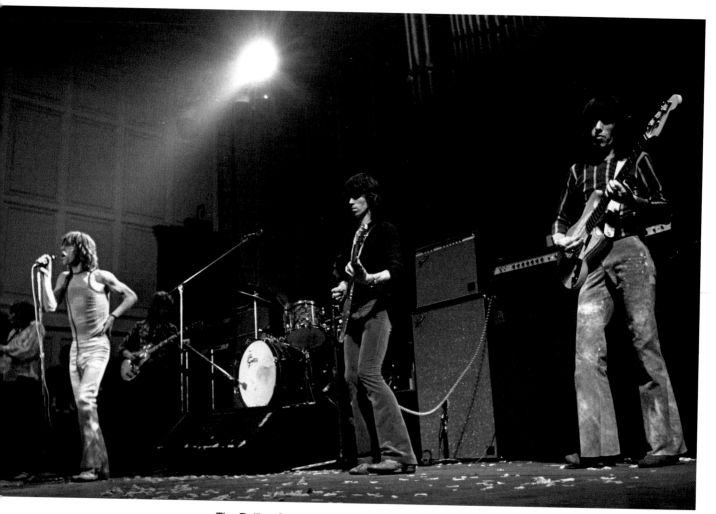

The Rolling Stones at
Newcastle City Hall on the
first night of their *Goodbye
Britain* Tour. They have just
announced that they are
becoming tax exiles in the
south of France.
4th March, 1971

Shirley Bassey at the Royal Command Performance of the film *Diamonds are Forever* at the Odeon, Leicester Square. Bassey's voice introduces *Goldfinger, Diamonds Are Forever,* and *Moonraker:* she has performed more Bond themes than any other artist.

8th March, 1971

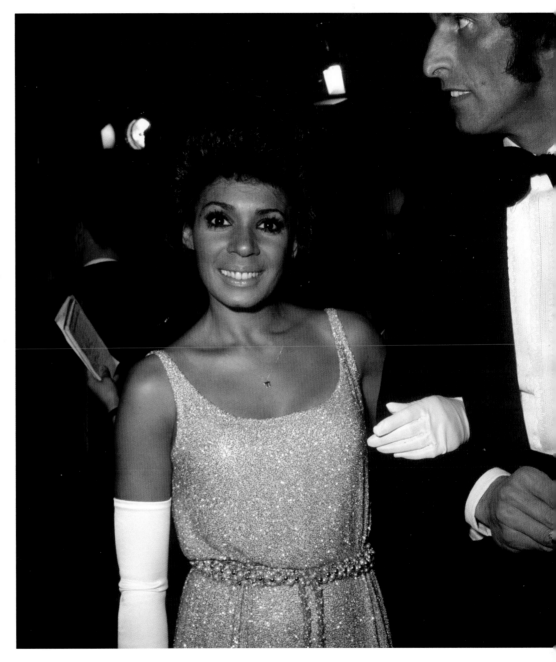

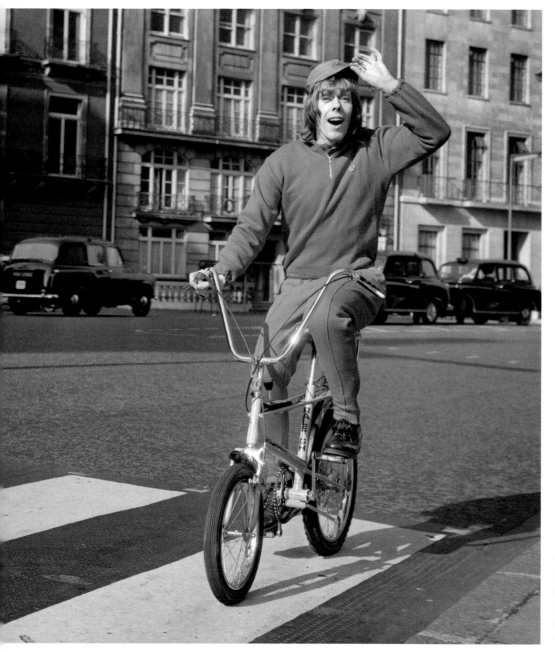

Facing page: Fans gather to wave farewell to Tom Jones, as he leaves on a five-month tour.
1st April, 1971

Manchester DJ Dave Eager takes his Chopper out on Portland Place as he takes over Tony Blackburn's breakfast show for a few weeks.
12th March, 1971

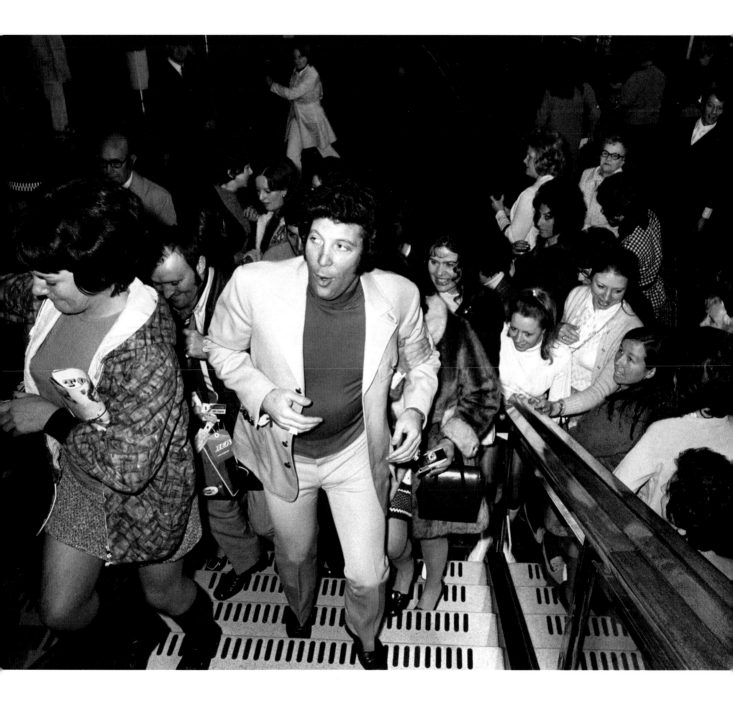

Facing page: Worthy Farm,
Pilton, site of the second
Glastonbury Festival.
23rd June, 1971

Lulu at her Highgate home.
3rd June, 1971

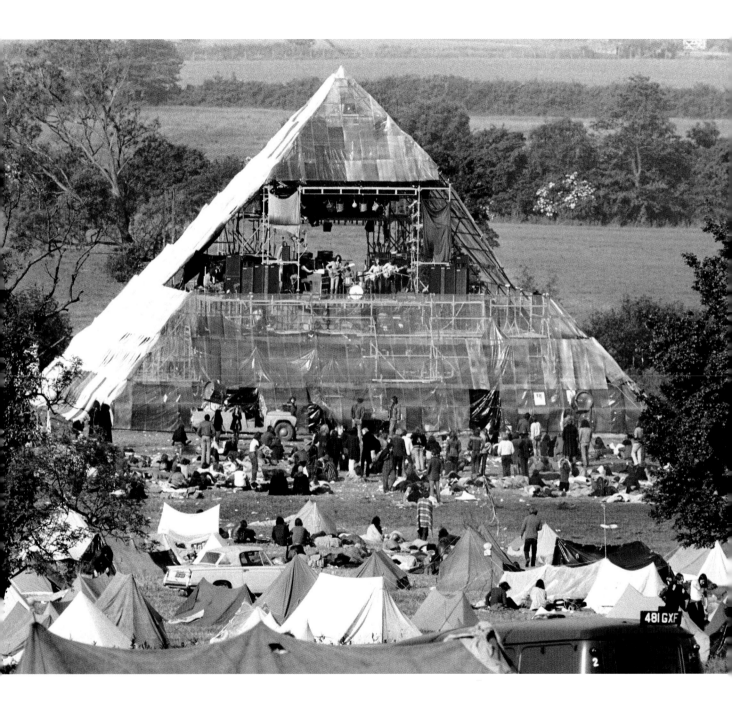

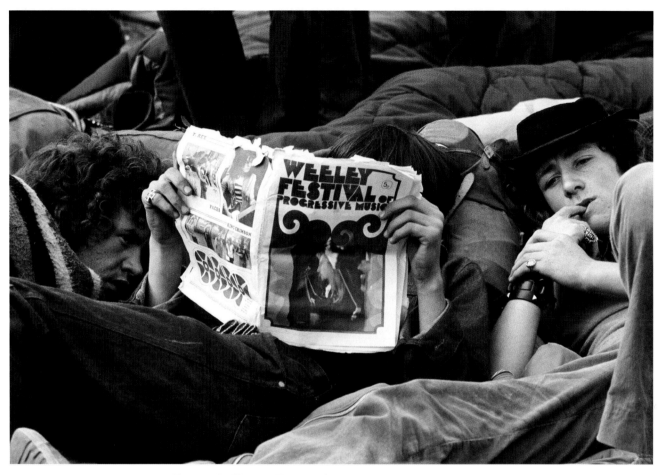

Fans at the Weeley Festival,
Clacton-on-Sea. Tickets
were £1.50 in advance and
£2.00 on the gate.
27th August, 1971

The Beverley Sisters begin a week's engagement at The Talk of the Town. (L–R) Babs, Joy and Teddie.
25th October, 1971

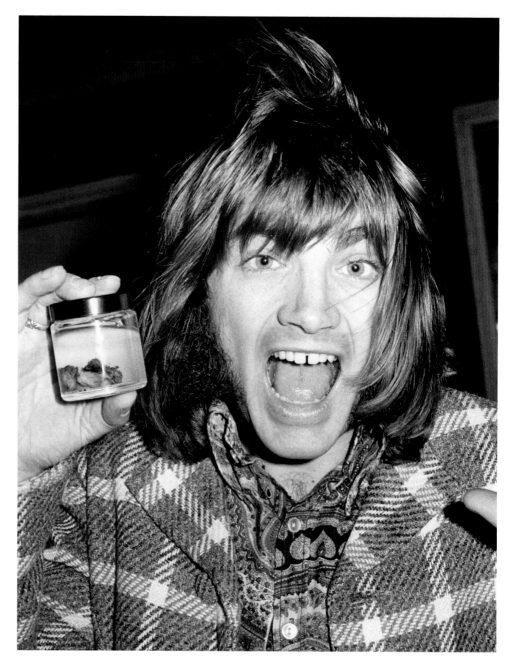

Tasteful as ever! Screaming
Lord Sutch leaves the Royal
National Throat, Nose and
Ear Hospital with his tonsils
in a jar.
20th December, 1971

Marc Bolan of T-Rex, with
his award for Top British
Group of 1971.
10th February, 1972

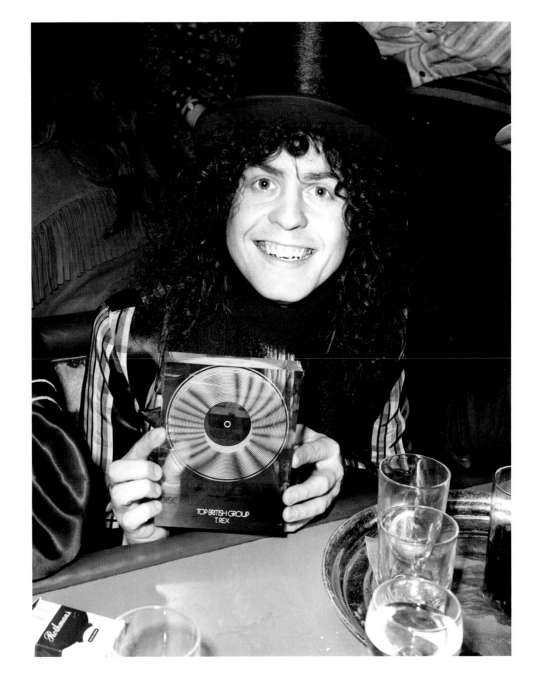

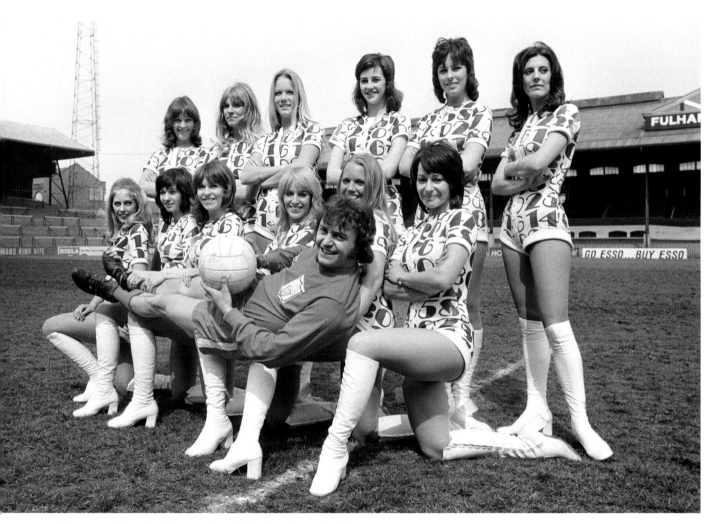

A long way from the Mersey. Gerry Marsden, formerly of Gerry and the Pacemakers, and the female members of the Young Generation at Craven Cottage, Fulham's home ground.
4th May, 1972

Facing page: Thousands of Teddy Boys and Girls at *The London Rock and Roll Show* at Wembley Stadium.
5th August, 1972

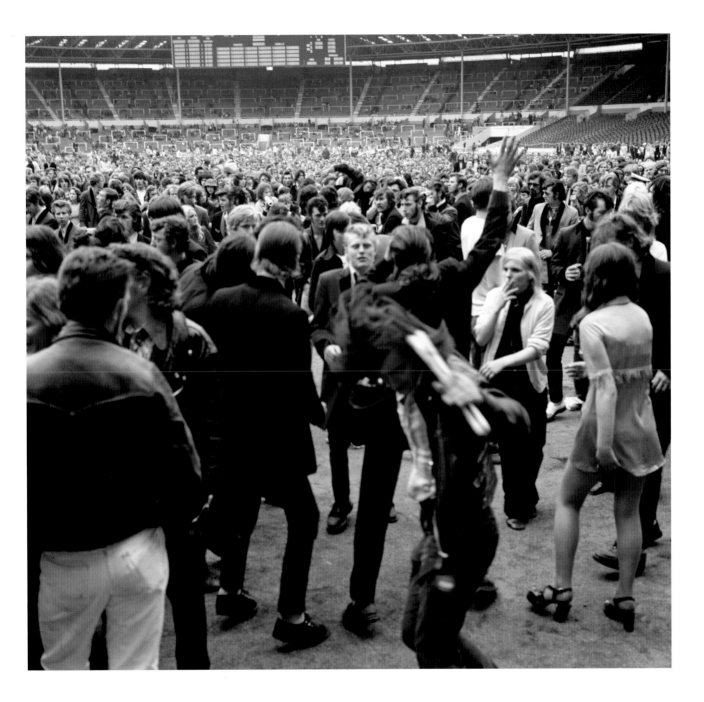

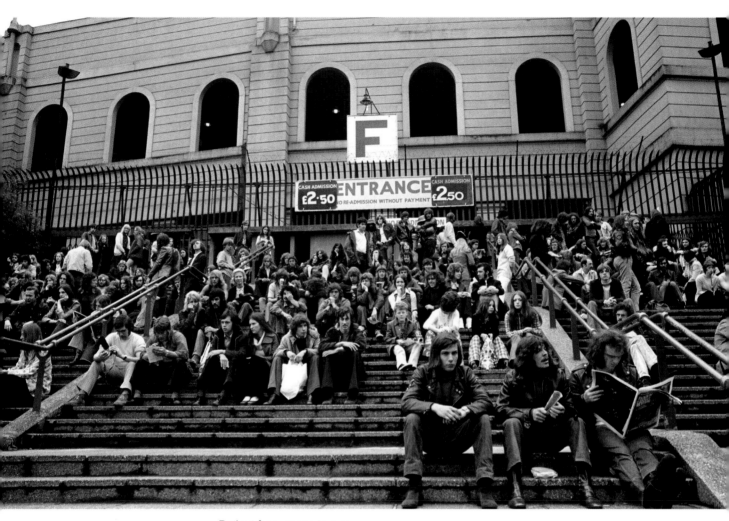

Patient fans queue to pay
their £2.50 for *The London
Rock and Roll Show* tickets.
5th August, 1972

Tony Christie, 29, gets a kiss of congratulations from Lulu as she presents him with his first gold disc for *I Did What I Did for Maria*.
10th August, 1972

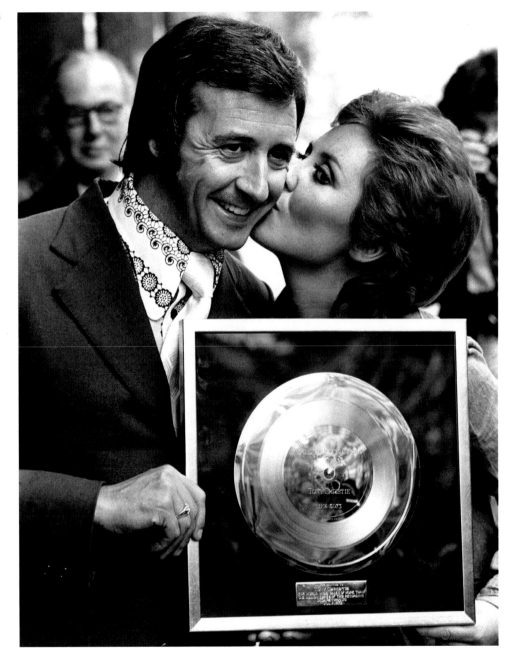

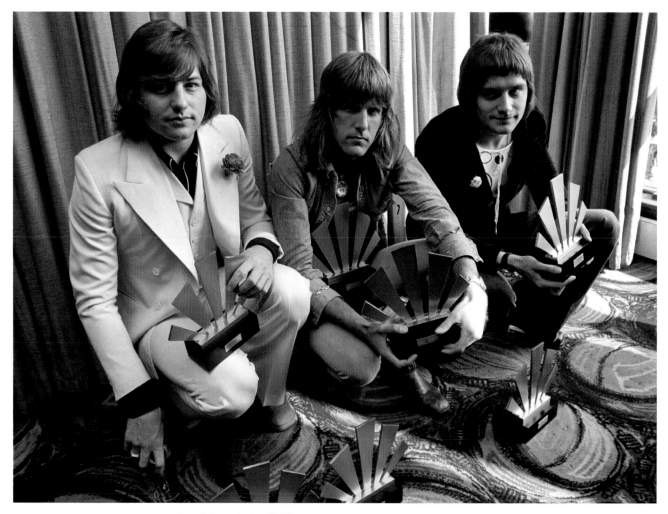

(L–R) Greg Lake, Keith
Emerson and Carl Palmer at
Kennington Oval with awards
gained in the *Melody Maker*
polls.
30th September, 1972

Joe Cocker, ordered out of Australia after being convicted of possessing drugs, leaves Heathrow Airport with his girlfriend Eileen Webster.
30th October, 1972

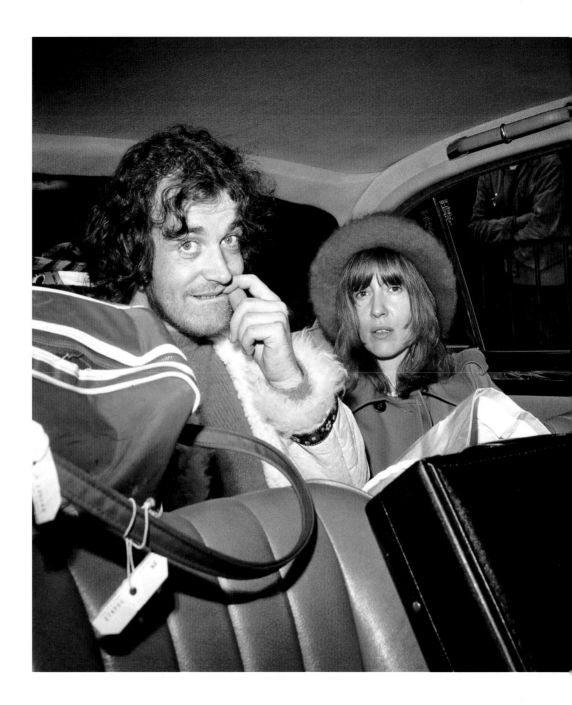

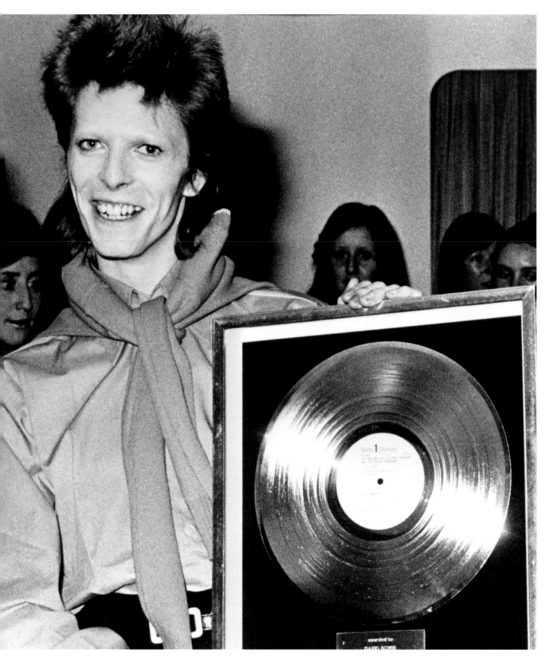

David Bowie with his gold disc for *Ziggy Stardust*.
January, 1973

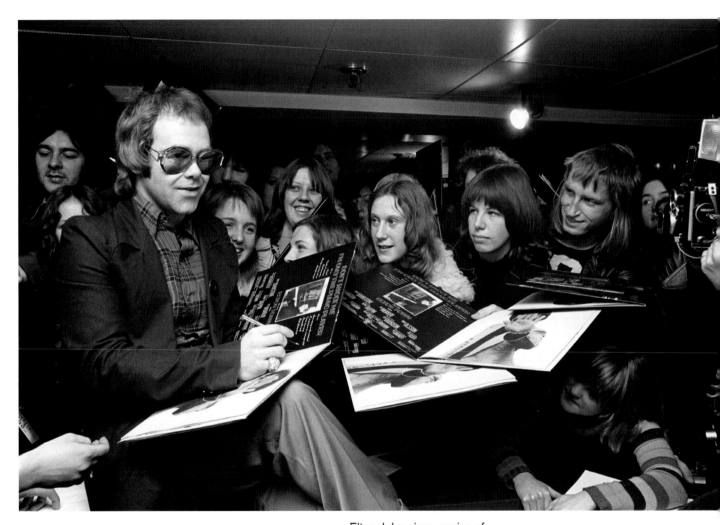

Elton John signs copies of
his new album, *Don't Shoot
Me I'm Only The Piano
Player,* at the Noel Edmonds
Record Shop, Chelsea.
20th January, 1973

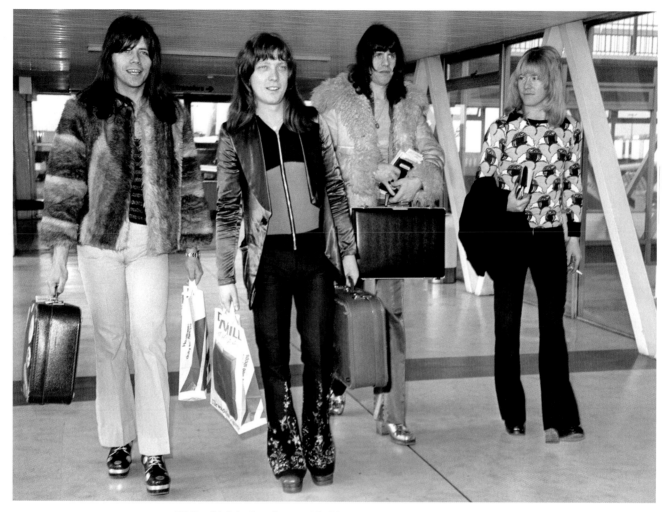

Riding high in the charts with *Blockbuster,* The Sweet
head off on a tour of the Far East.
13th February, 1973

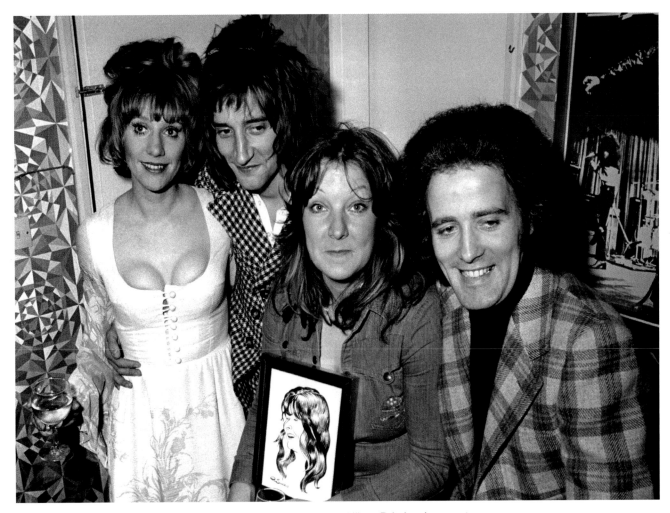

Hilary Pritchard presents
the *Disc Awards* to Rod
Stewart, Top British Singer
Maggie Bell and Top
Singer-Songwriter Gilbert
O'Sullivan.
14th February, 1973

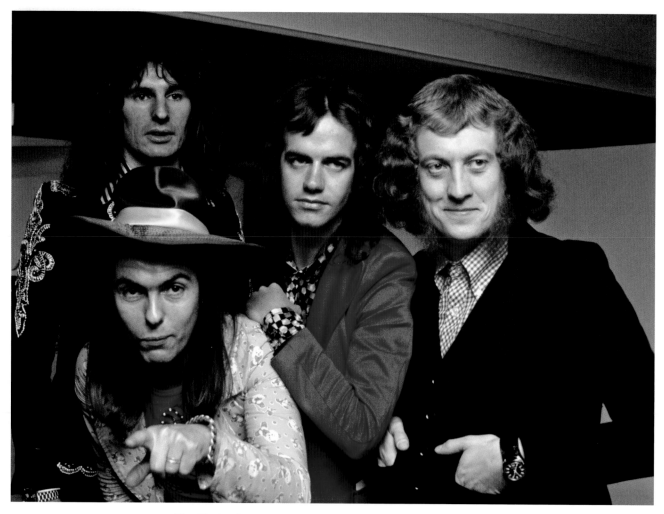

The Slade at
the Savoy Hotel.
1st March, 1973

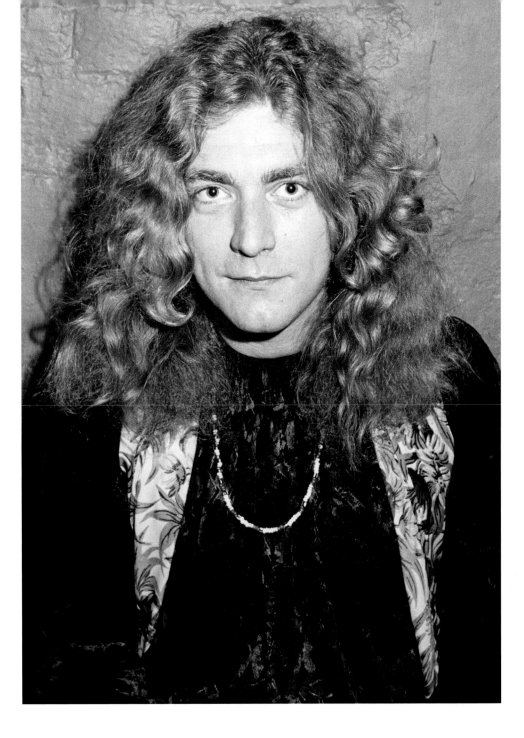

Robert Plant.
27th September, 1973

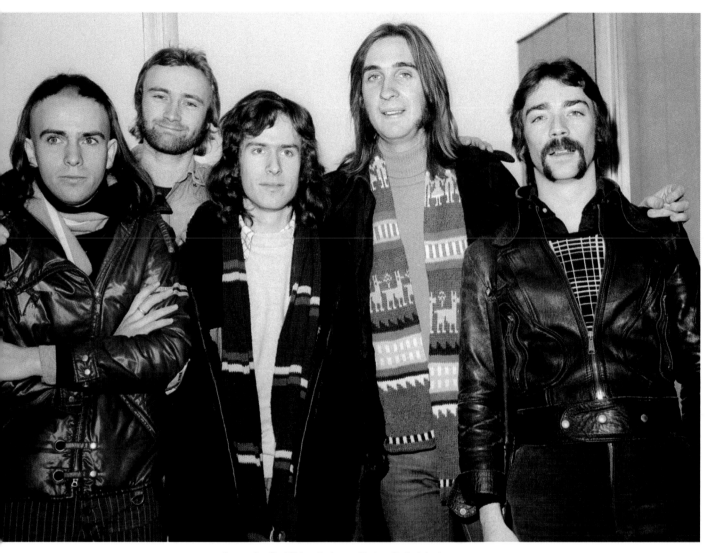

Genesis: (L–R) lead singer Peter Gabriel, drummer
Phil Collins, keyboards Tony Banks, bass Mike Rutherford,
guitar Steve Hackett.
28th February, 1974

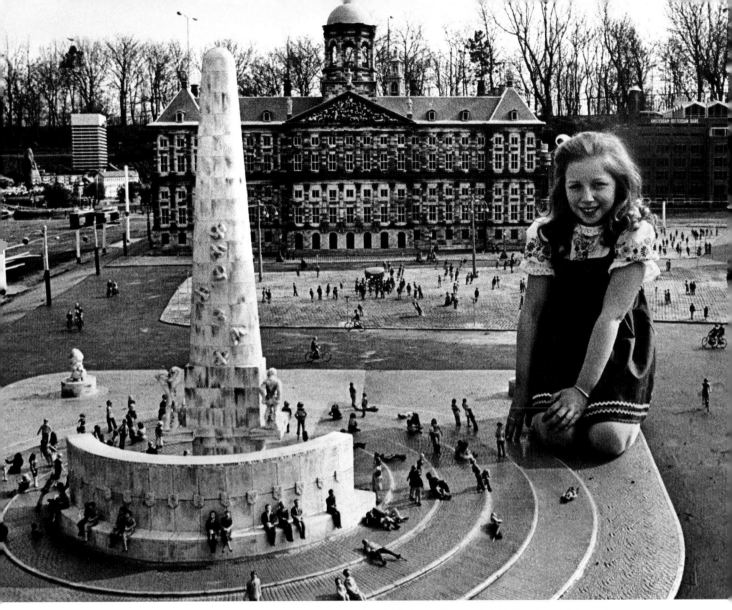

Aged 10, Lena Zavaroni at Holland's miniature city of *Madurodam*. Lena's first record, *Ma, He's Making Eyes At Me,* sold more than 300,000 copies in Britain.
25th April, 1974

Alvin Stardust leaving
for Paris.
5th June, 1974

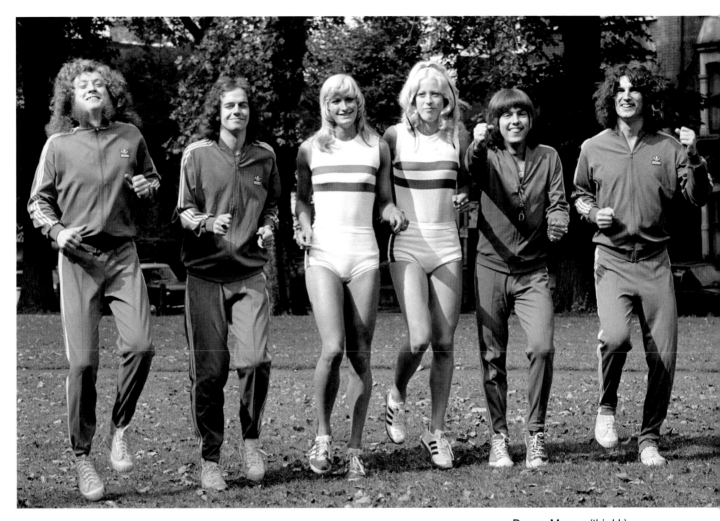

Donna Murray (third L)
holder of the UK 400m
record, and Lesley Kiernan
keeping fit with Slade (L–R)
Noddy Holder, Jim Lea,
Dave Hill and Don Powell, in
Brook Green, Hammersmith.
12th September, 1974

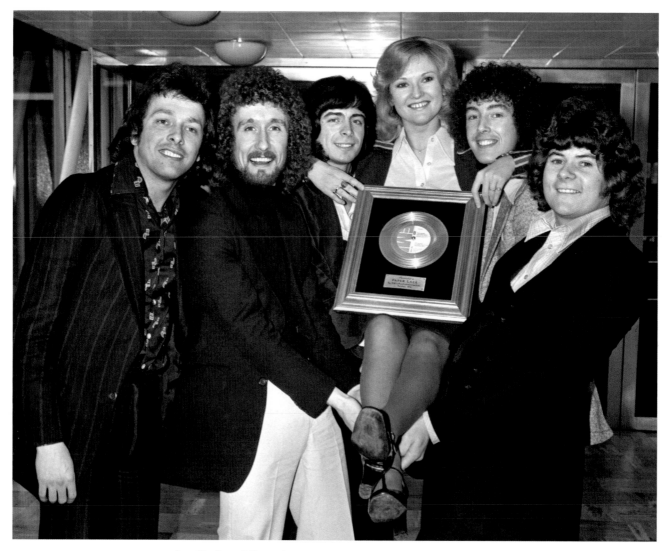

Lyn Paul, and Paper Lace:
(L–R) Mick Vaughan, Carlo
Santana, Phil Wright, Cliff
Fish and Chris Morris.
14th February, 1975

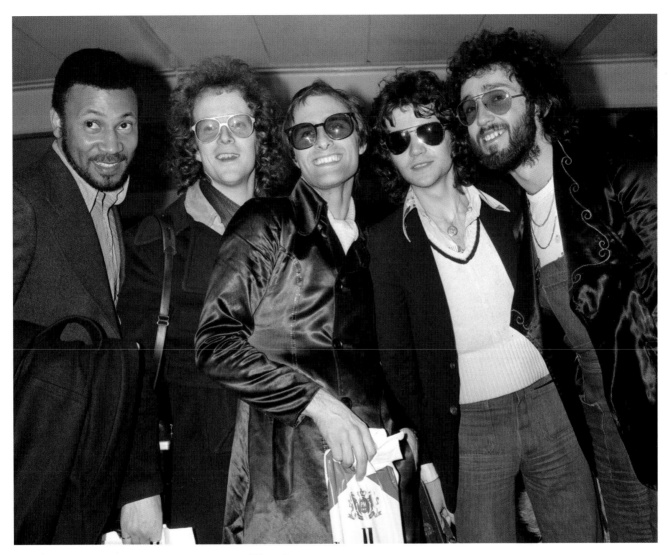

Steve Harley (C) and
Cockney Rebel topping the
charts with *Make Me Smile
(Come Up and See Me).*
26th February, 1975

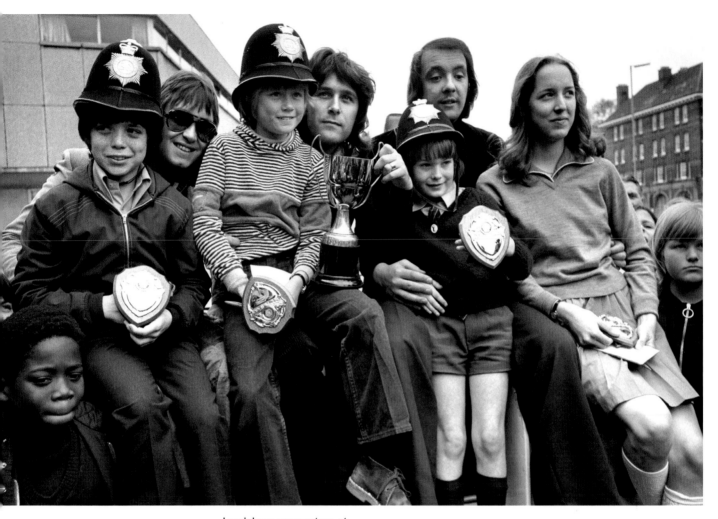

Lewisham youngsters at
Ladywell Road police station
with Mud: Les Gray (dark
glasses), Ray Stiles (C) and
Dave Mount.
2nd May, 1975

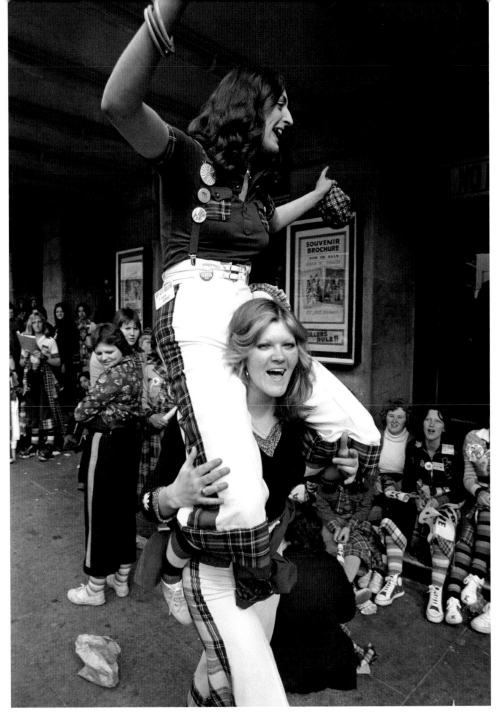

High spirits from two fans of the Bay City Rollers as they wait with others for the doors to open at the Odeon, Hammersmith, for the first of two concerts.
1st June, 1975

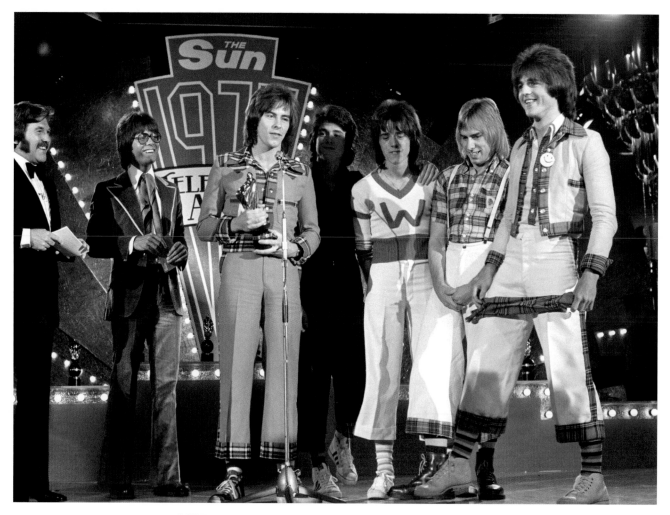

Cliff Richard presents
The Bay City Rollers with
the *Sun Television Awards*
Top Pop Act award
at the London Hilton.
14th June, 1975

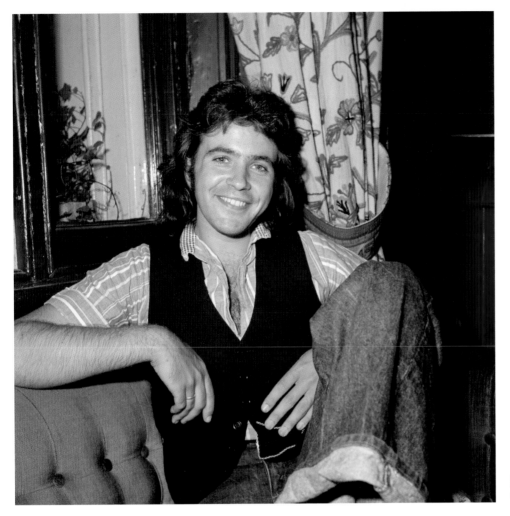

David Essex.
1st July, 1975

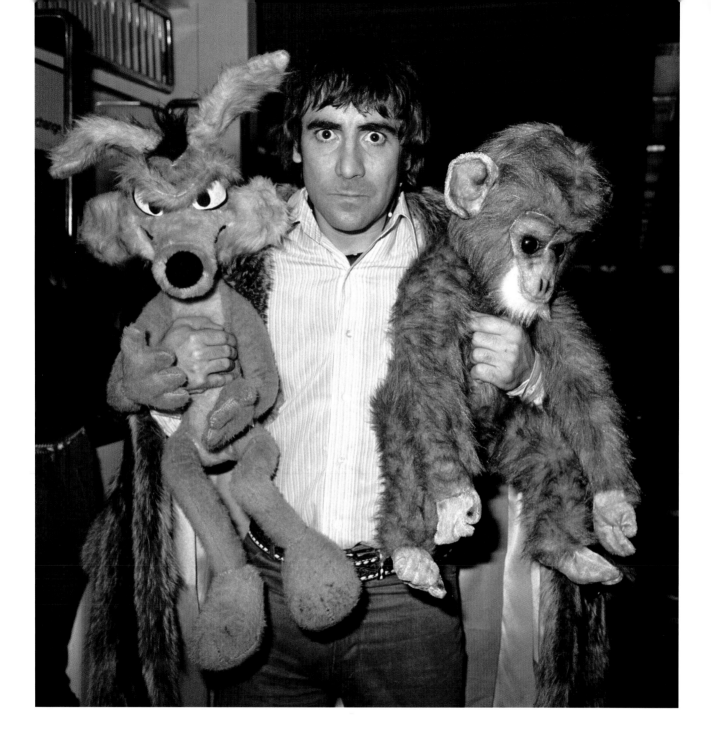

Facing page: Keith Moon of The Who, at Heathrow Airport on return from the United States where he has been recording with Bo Diddley.
19th December, 1975

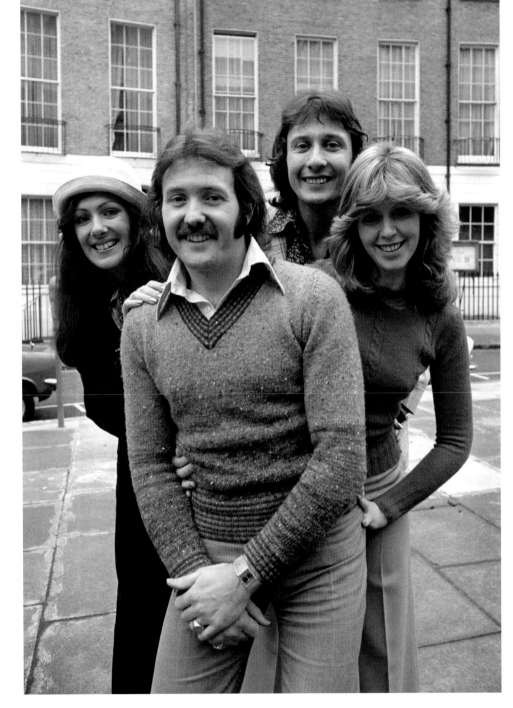

Brotherhood of Man are chosen to represent Britain in the *Eurovision Song Contest:* (L–R) Nicky Stevens, Martin Lee, Lee Sheriden and Sandra Stevens.
26th February, 1976

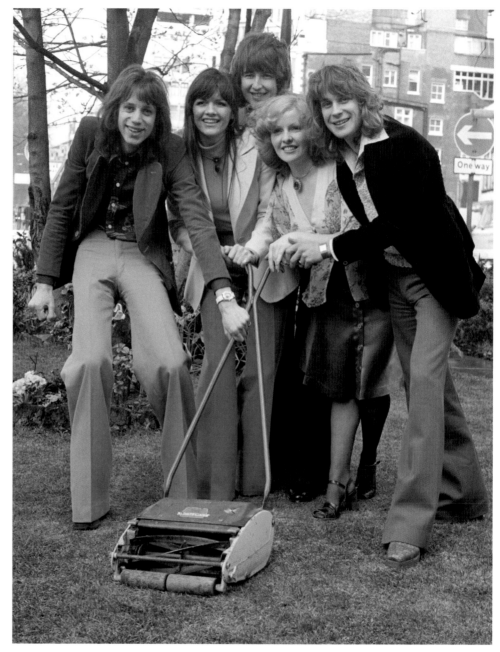

The New Seekers in London. The group reformed after extended gardening leave: (L–R) Paul Layton, Eve Graham, Danny Finn, Kathy Ann Rae and Martin Kristian.
5th April, 1976

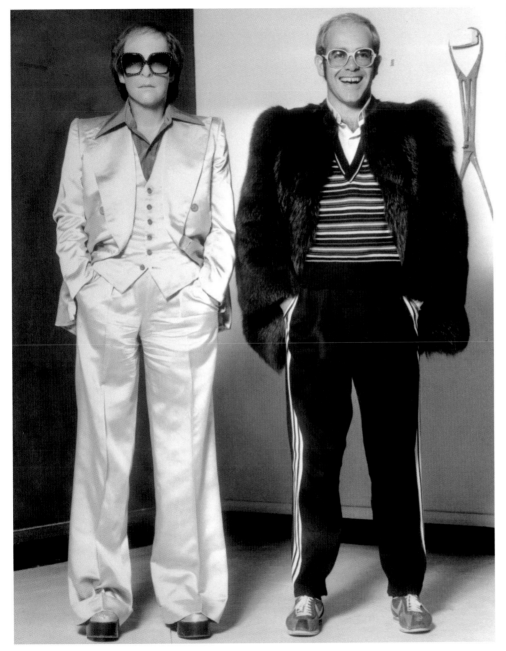

Elton John (R) with his wax portrait in Madame Tussaud's studio.
8th April, 1976

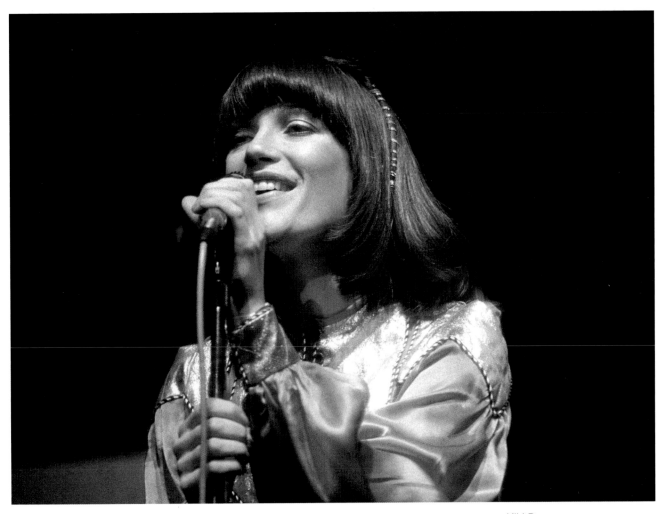

Kiki Dee.
3rd December, 1976

Policemen link arms to control some of the 500 David Bowie
fans at Victoria Station. Bowie has returned home after
two years in America, during which he starred in the film
The Man who Fell to Earth.
2nd May, 1976

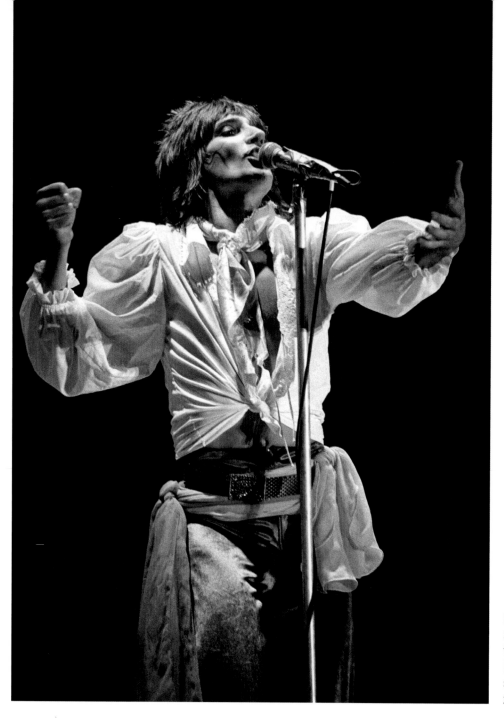

Rod Stewart performs to a packed Olympia, in the former gravedigger's first London concert since he split with The Faces.
22nd December, 1976

Johnny Rotten, AKA John Lydon, greets journalists after being fined £40 on a drugs charge at Marlborough Street Magistrates Court.
11th March, 1977

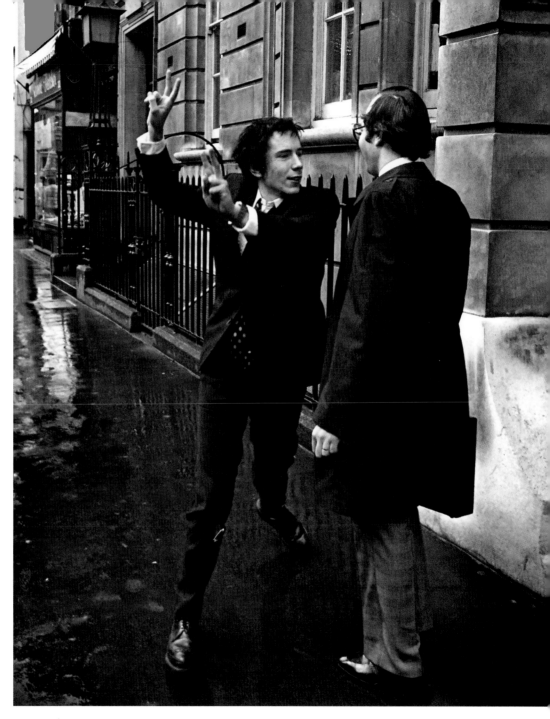

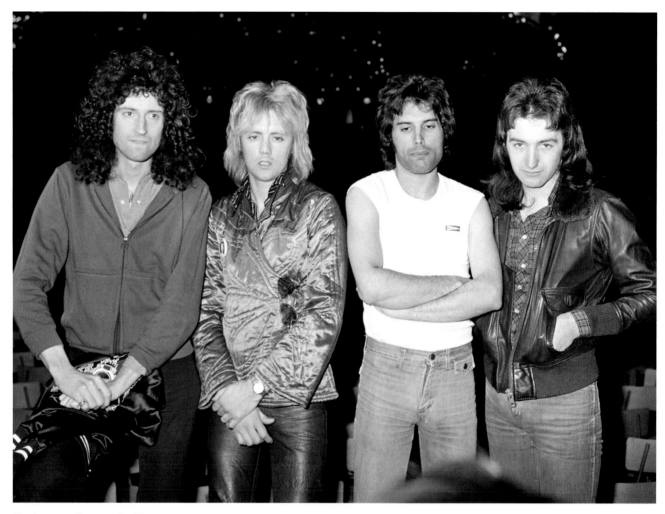

Rock group Queen, (L–R)
Brian May, Roger Taylor,
Freddie Mercury and John
Deacon, at Earls Court.
5th June, 1977

Adam Ant and punk fashion icon Jordan attend the movie premiere of *Saturday Night Fever* at the Empire, Leicester Square.

23rd March, 1978

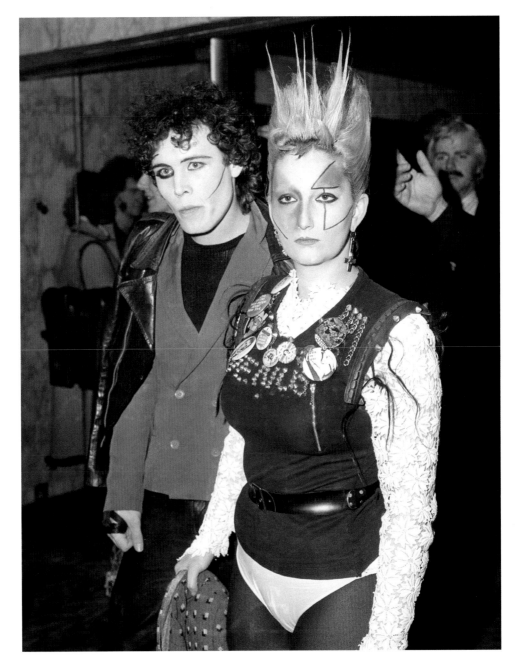

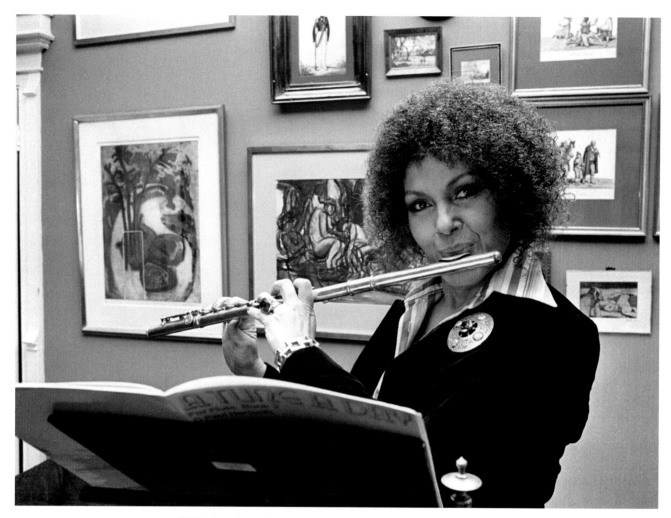

British jazz legend
Cleo Laine at her home
in Wavendon.
13th November, 1978

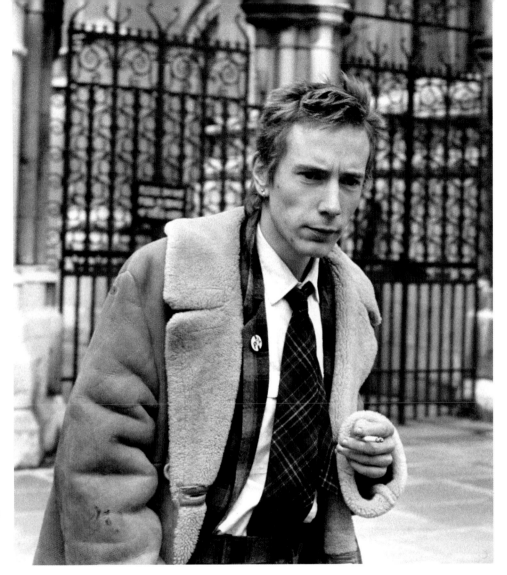

Johnny Rotten in London
for a court action against
manager Malcolm McLaren's
management company,
Glitterbest.
8th February, 1979

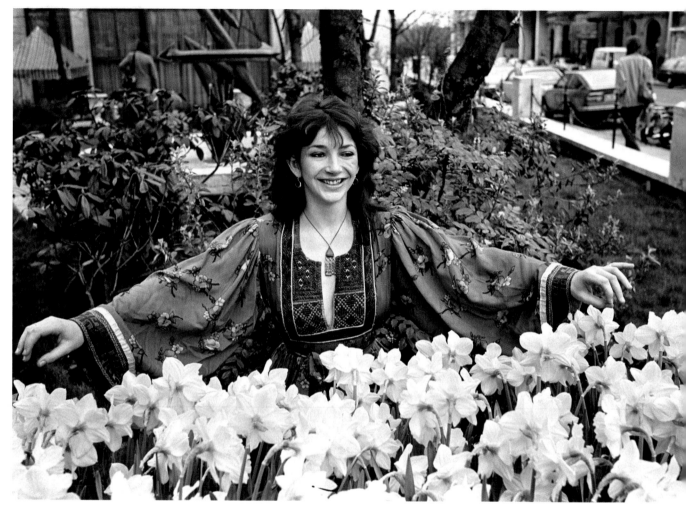

Kate Bush among the daffodils at the Inn-on-the-Park, London.
17th April, 1979

Cliff Richard, whose single *We Don't Talk Anymore* hit the Number 1 spot in the UK charts.
21st August, 1979

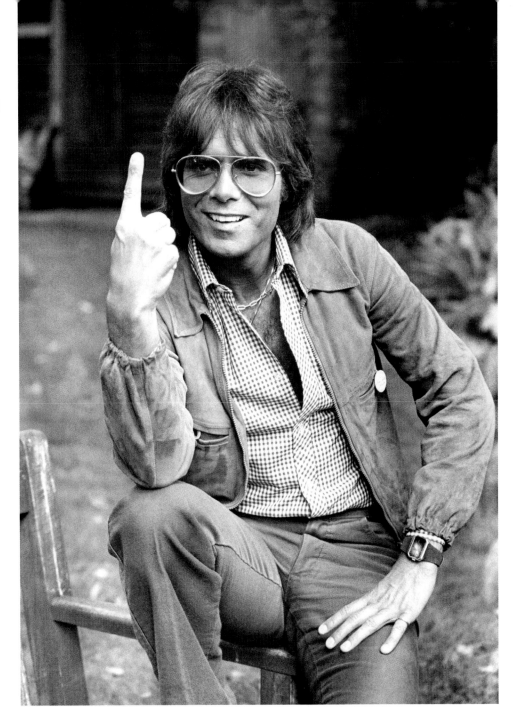

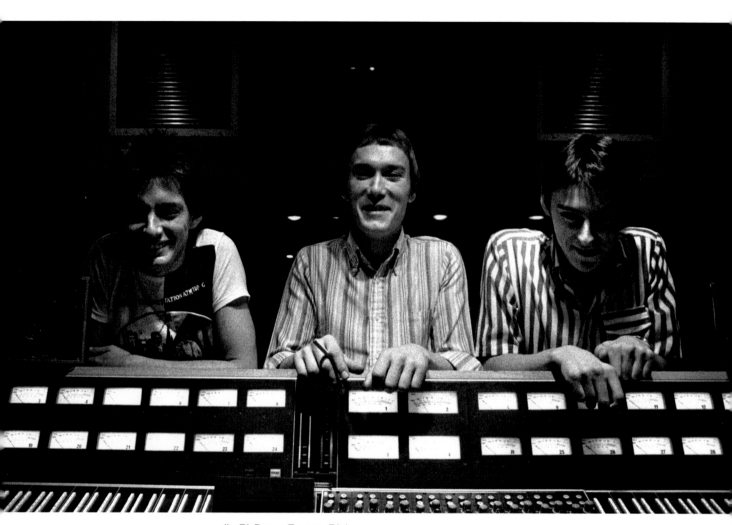

(L–R) Bruce Foxton, Rick
Butler and Paul Weller
of The Jam, backstage
at the Shepherd's Bush
Townhouse.
30th August, 1979

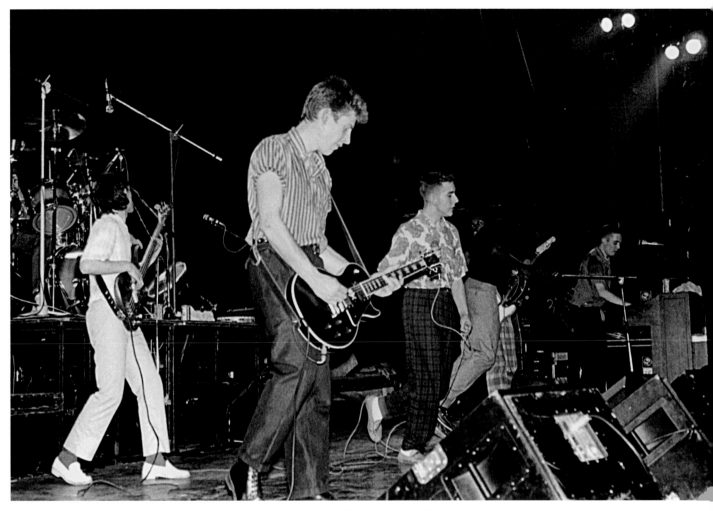

The Specials at the Lyceum.
2nd December, 1979

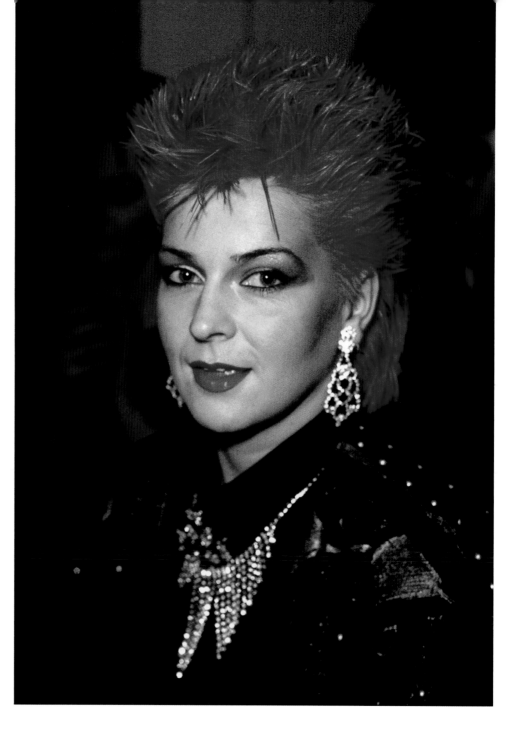

Punk and new wave diva
Toyah Willcox.
1980

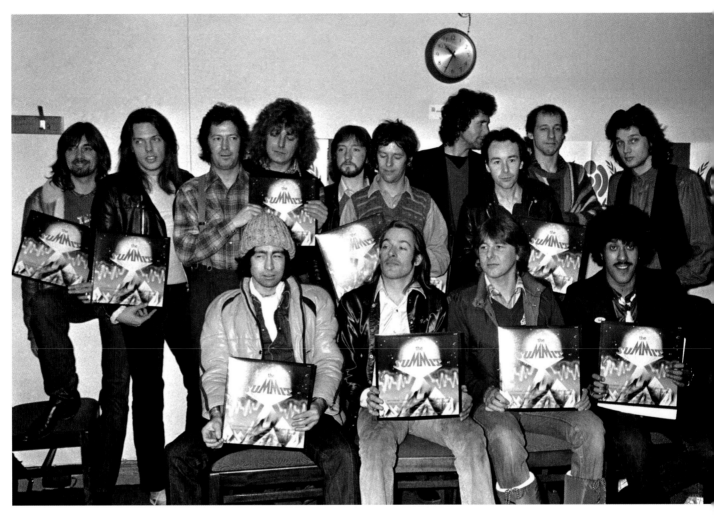

Dire Straits, Thin Lizzy, Eric
Clapton, Led Zeppelin, Bad
Company and the Electric
Light Orchestra at the
launch of *The Summit,* a
fundraising record for sick
and handicapped children.
15th January, 1980

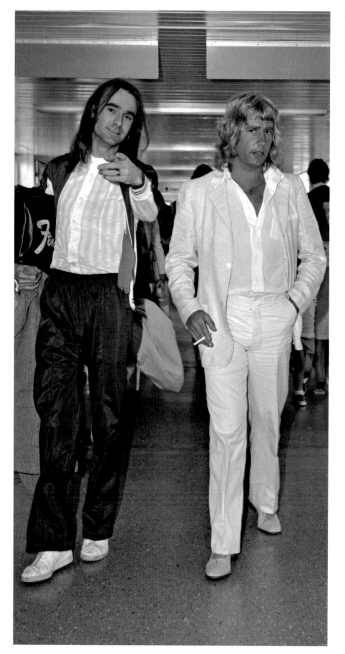

Facing page: The Nolan Sisters: (L–R) Coleen, Linda, Maureen and Bernadette.
15th October, 1980

Status Quo's Francis Rossi (L) and Rick Parfitt arrive at Heathrow.
19th May, 1980

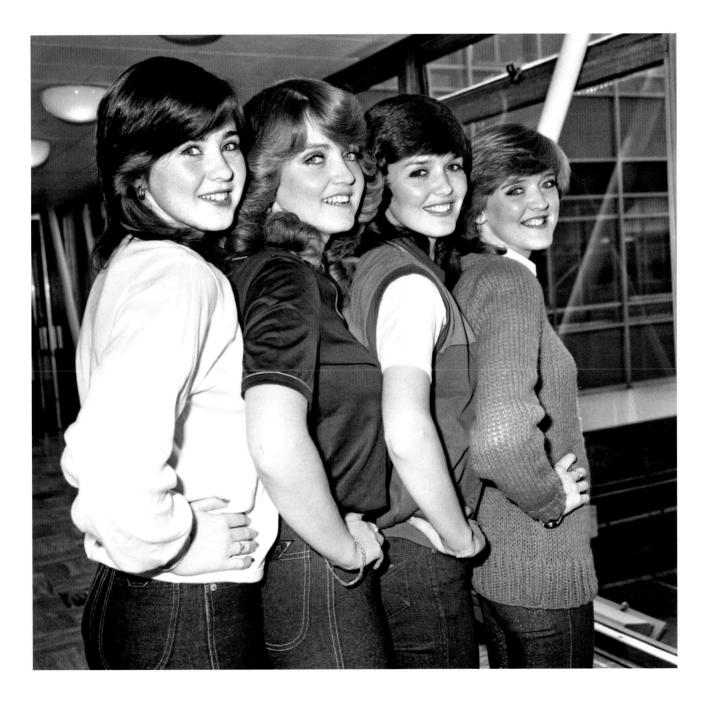

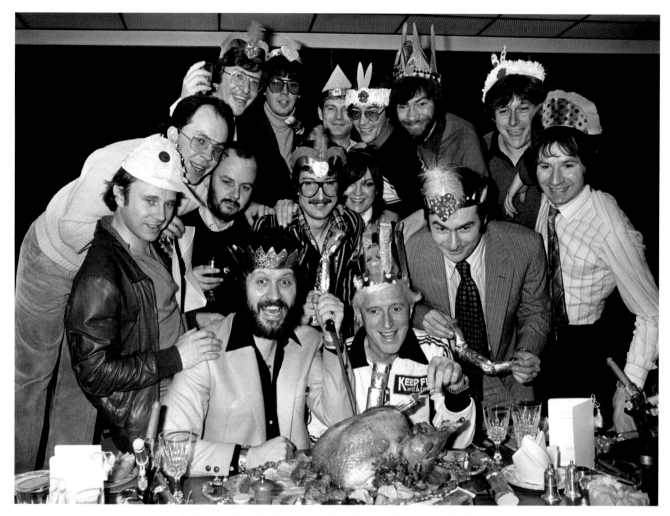

Christmas Lunch at Broadcasting House: (back row, L–R) Simon Bates, Mike Read, Peter Powell, Tommy Vance, Adrian Love and Richard Skinner; (middle row, L–R) Paul Burnett, Andy Peebles, John Peel, Steve Wright, Annie Nightingale, Paul Gambaccini and Adrian Juste; (front row L–R) Dave Lee Travis and Jimmy Savile.
4th December, 1980

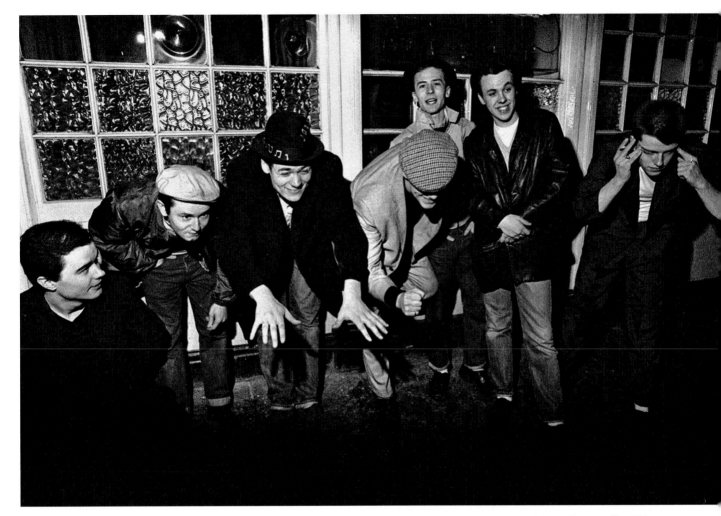

On location in London, Madness with their feature film *Take It or Leave It*, a documentary with music. The film features band members Bedders, Chas, Chrissy Boy, Lee, Mike, Suggs and Woody as themselves.
24th April, 1981

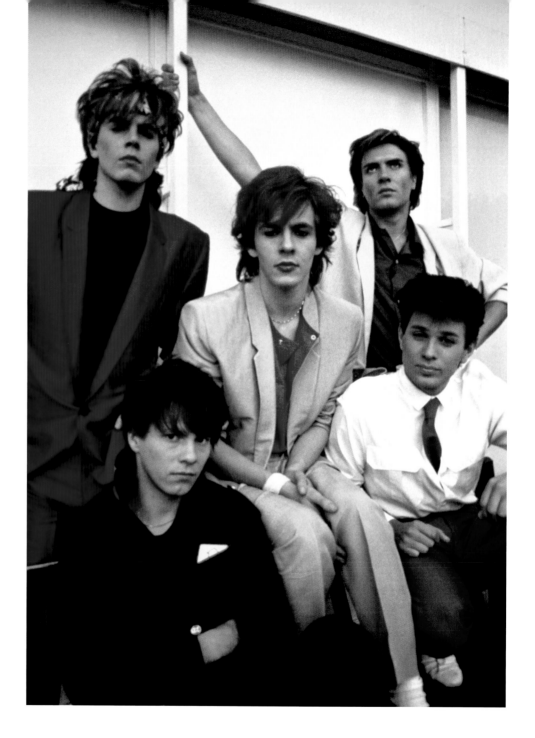

Duran Duran: John Taylor,
Nick Rhodes, Simon
Le Bon, Roger Taylor
and Andy Taylor.
1st June, 1981

Adam Ant rehearsing without
his trademark make-up at
the Theatre Royal for the
Royal Variety Performance.
22nd November, 1981

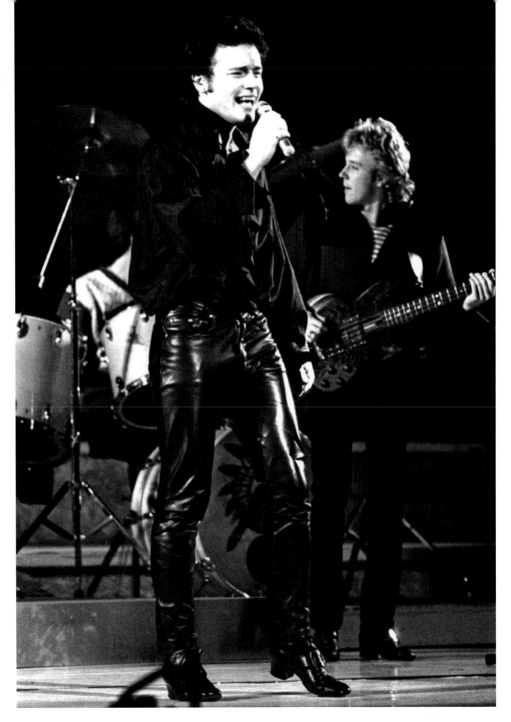

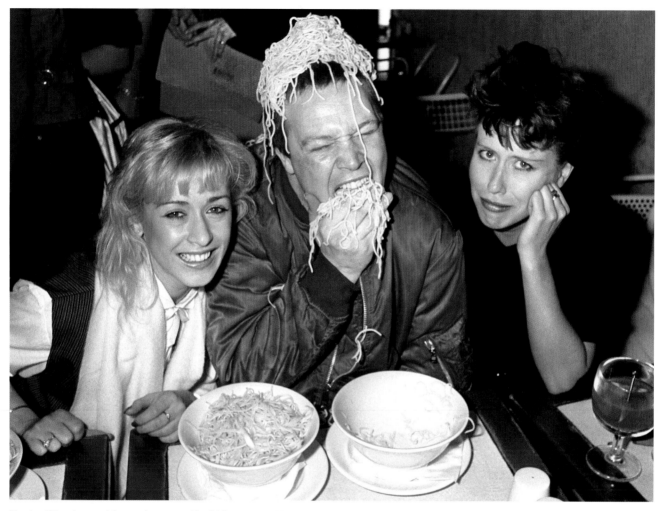

Buster Bloodvessel from ska group Bad Manners at Fatso's
Pasta Joint in Soho, where he was part of the judging team
in a spaghetti eating contest. Thereza Bazar (L) of pop duo
Dollar and Hazel O'Connor (R) are along for the breadsticks.
14th February, 1982

Mark King, bass-playing
virtuoso of Level 42.
1983

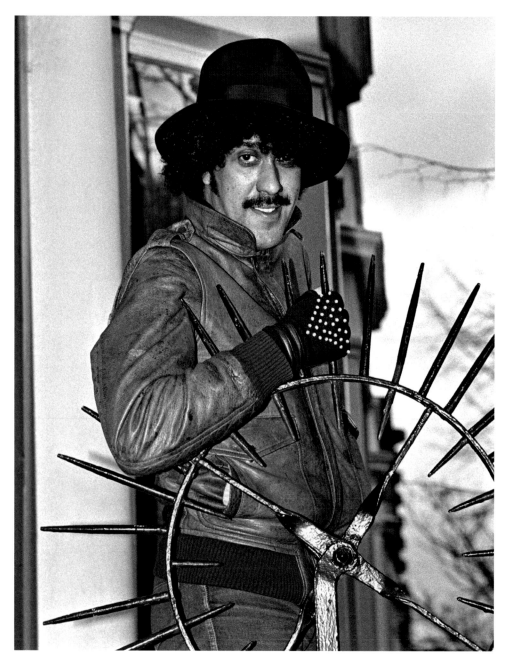

Phil Lynott, 33, in London to announce that Thin Lizzie is calling it a day after 10 years and a string of hits.
18th January, 1983

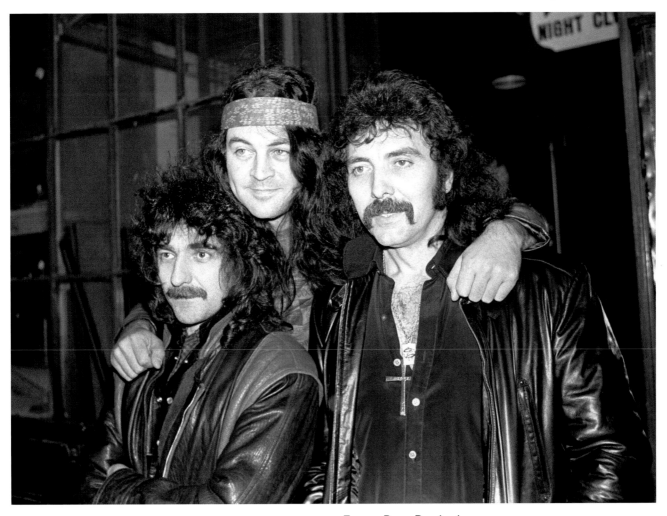

Former Deep Purple singer
Ian Gillan (C), with 'Geezer'
Butler (L) and Tony Iommi
of Black Sabbath announce
that Gillan is to join the band.
6th April, 1983

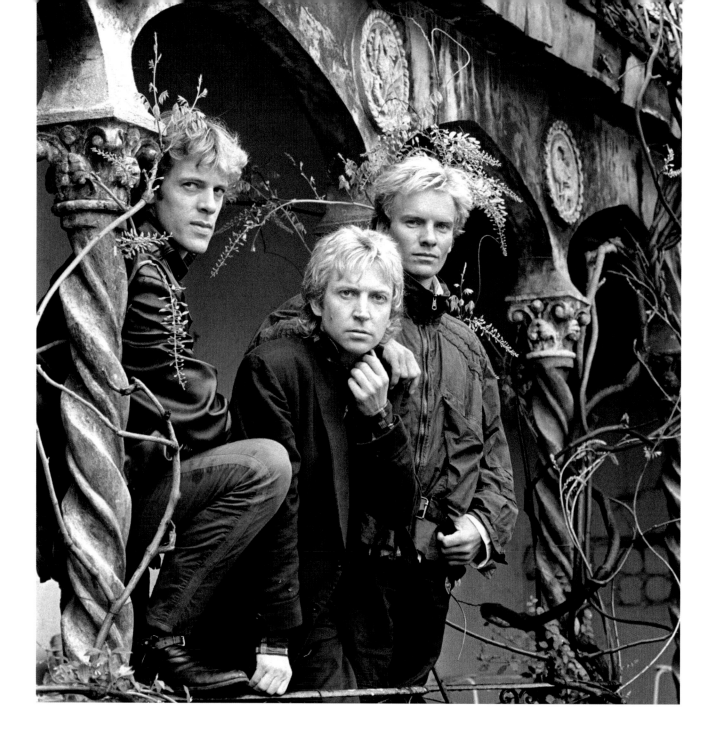

Facing page: The Police, (L–R) Stewart Copeland, Andy Summers and Sting, launch the single *Every Breath You Take*, and their first album for over a year, *Synchronicity*. It was to be the band's last album together, and their biggest-selling.
18th May, 1983

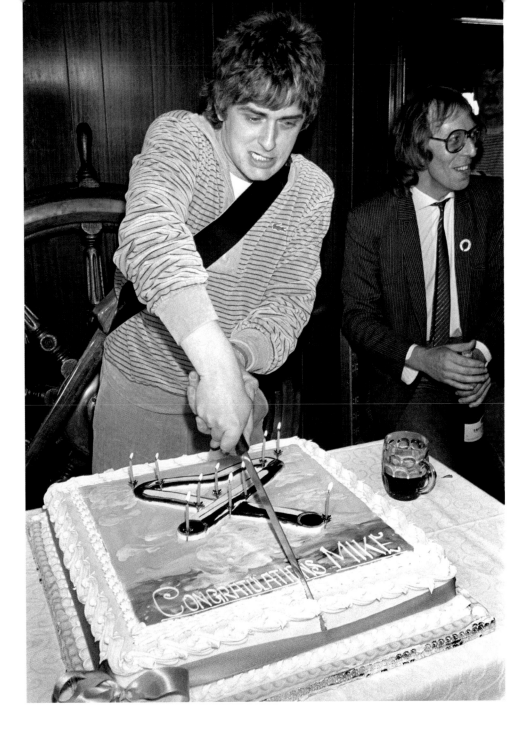

Mike Oldfield on the 10th anniversary of the release of *Tubular Bells*.
22nd May, 1983

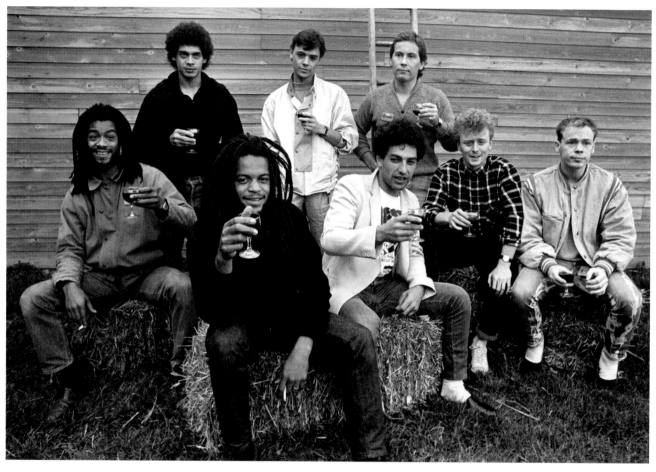

UB40 at Shepton Mallet for Channel 4's live rock show: (standing, L–R) Mickey Virtue, James Brown and Robin Campbell; (sitting L–R) Earl Falconer, Astro, Norman Hassan, Brian Travers and Ali Campbell.
23rd September, 1983

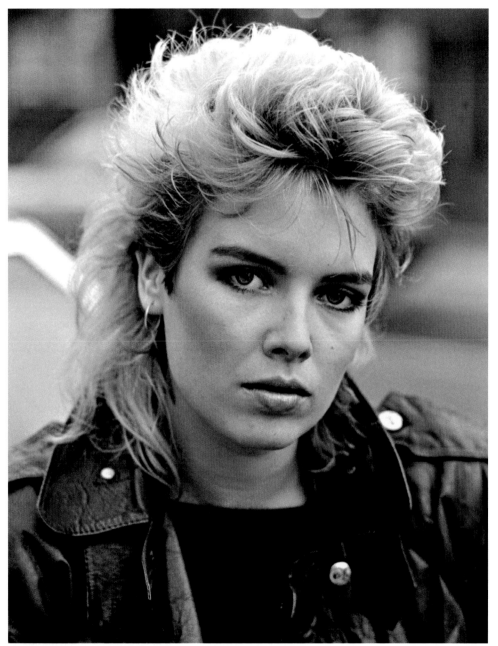

Singer Kim Wilde, whose father, the '50s and '60s rock and roll singer Marty Wilde (*see page 35*), wrote and produced much of her early material.
15th November, 1983

The Thompson Twins
return from a TV interview
in Germany, for which they
reportedly cancelled a sell-
out show in London. (L–R)
Tom Bailey, Alannah Currie
and Joe Leeway.
2nd March, 1984

Ray Burns 28, AKA Captain
Sensible of The Damned.
10th August, 1984

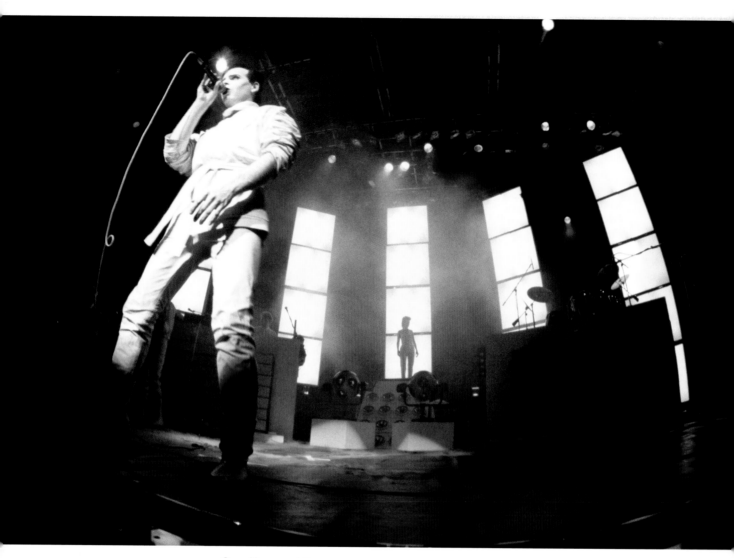

Gary Numan at the
Hammersmith Odeon
during his *Berserker* tour.
11th December, 1984

Alison 'Alf' Moyet pursues
a solo career after splitting
with Yazoo partner Vince
Clarke.
1985

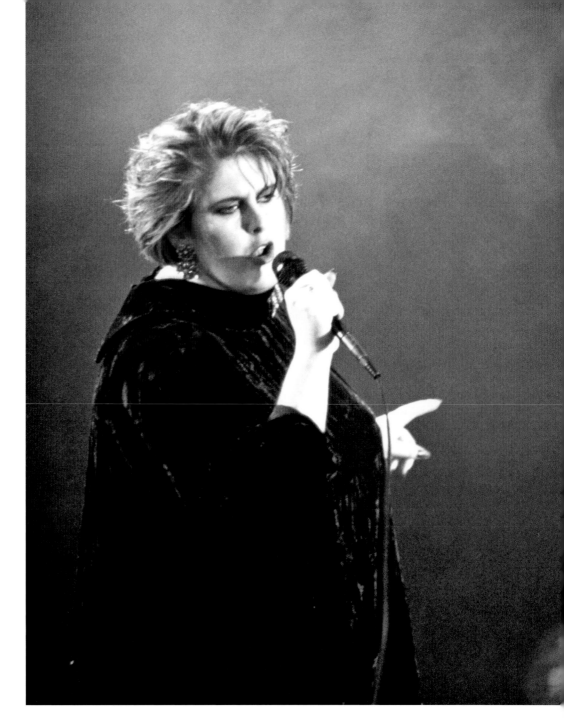

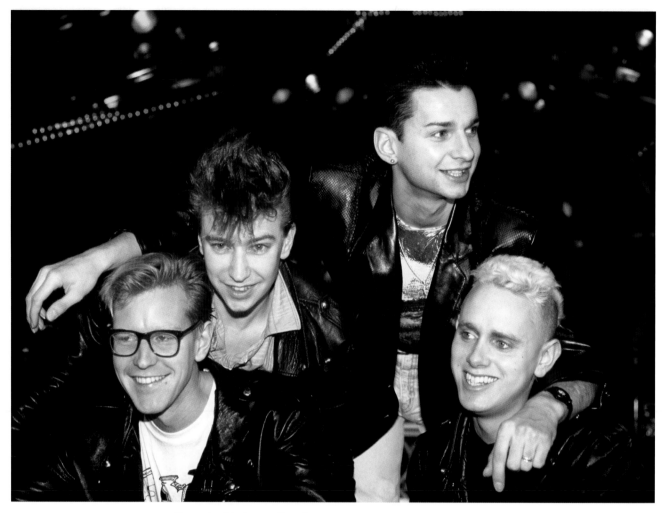

Depeche Mode, another former
Vince Clarke outfit. Clarke
went on to form Erasure.
1985

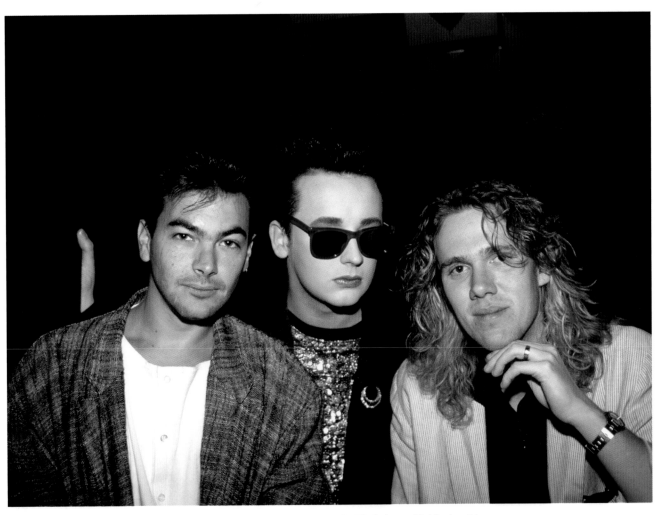

(L–R) Culture Club's Jon Moss,
Boy George and Roy Hay.
1985

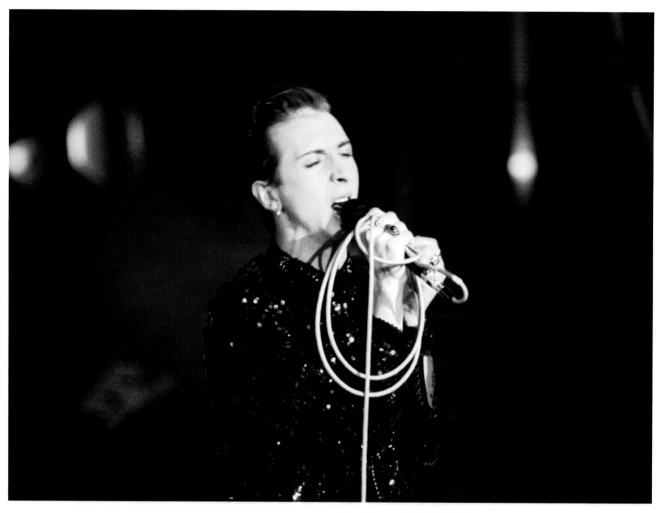

Marc Almond of Soft Cell.
1985

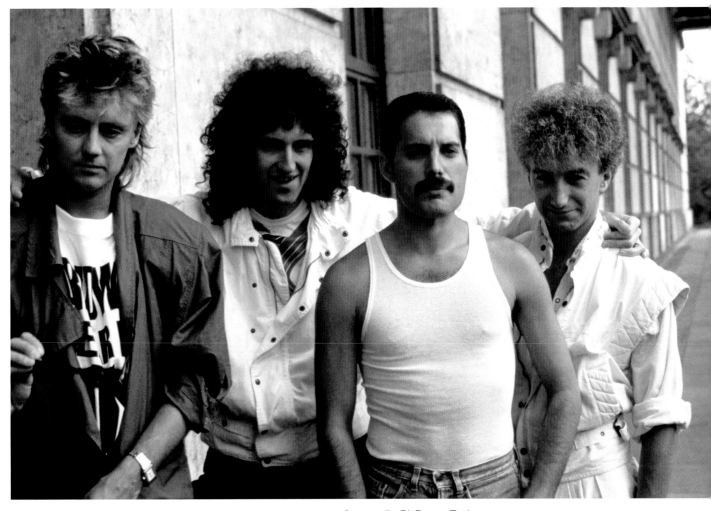

Queen: (L–R) Roger Taylor,
Brian May, Freddie Mercury
and John Deacon.
1985

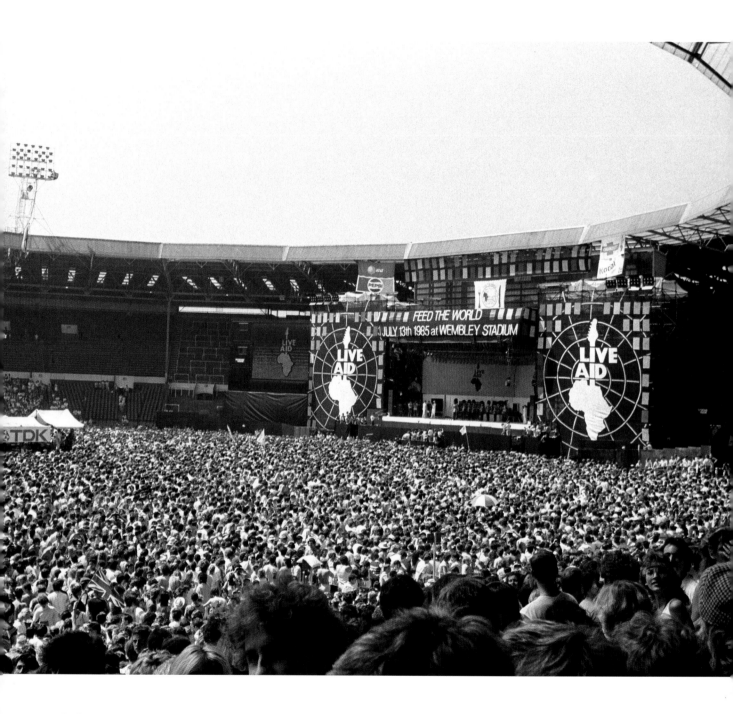

Facing page: Wembley stadium as the Guards play the National Anthem on the arrival of the Prince and Princess of Wales to open the *Live Aid* concert, promoted by members of the pop industry to raise funds for famine relief in Ethiopia.
13th July, 1985

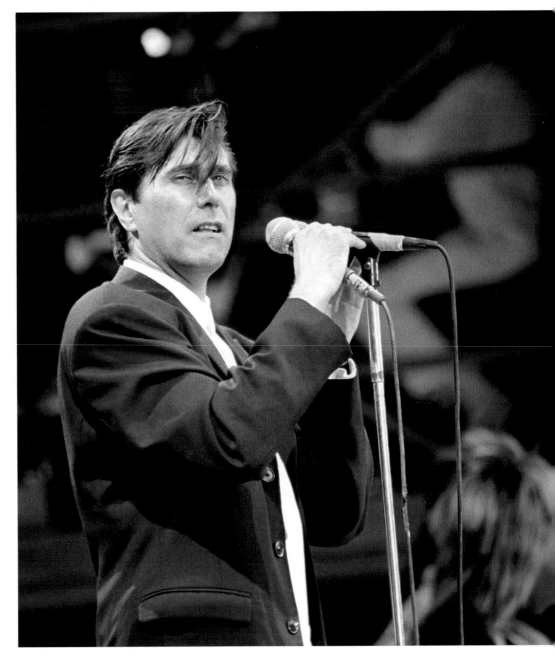

Bryan Ferry at *Live Aid*.
13th July, 1985

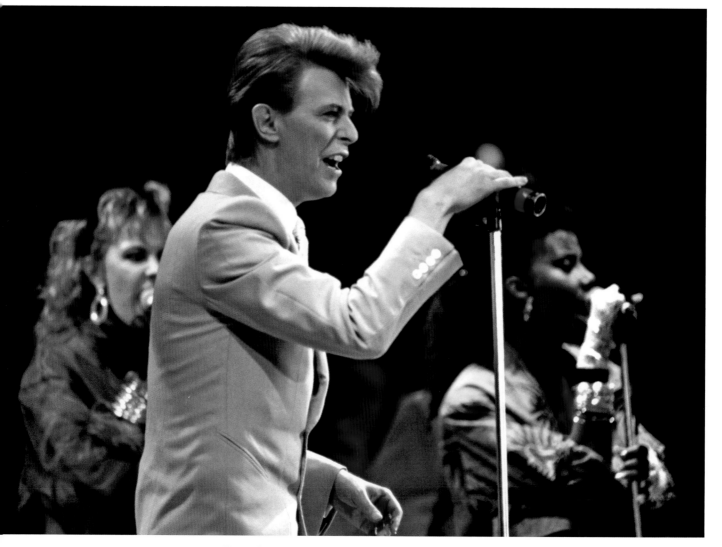

David Bowie at *Live Aid*.
13th July, 1985

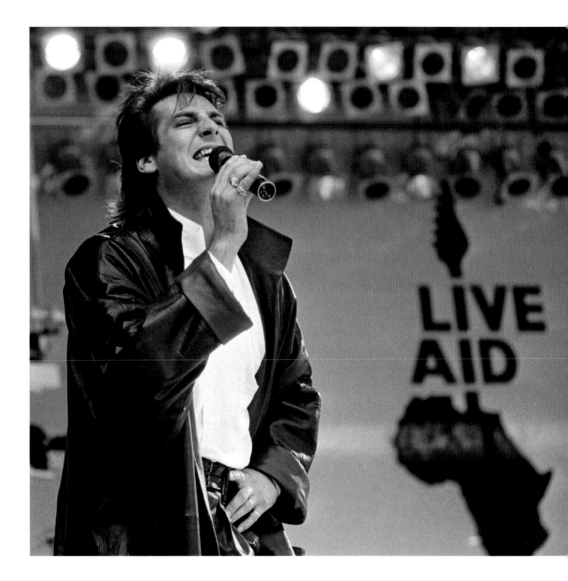

Tony Hadley of Spandau
Ballet at *Live Aid*.
13th July, 1985

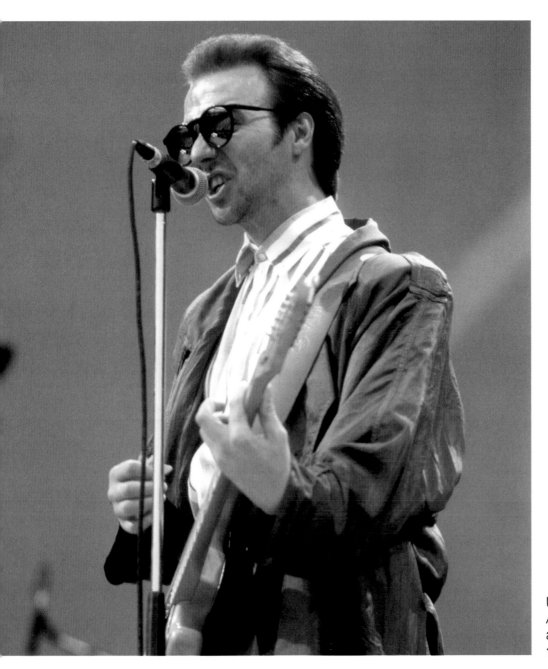

Ultravox singer and *Band Aid* leading light Midge Ure at *Live Aid*.
13th July, 1985

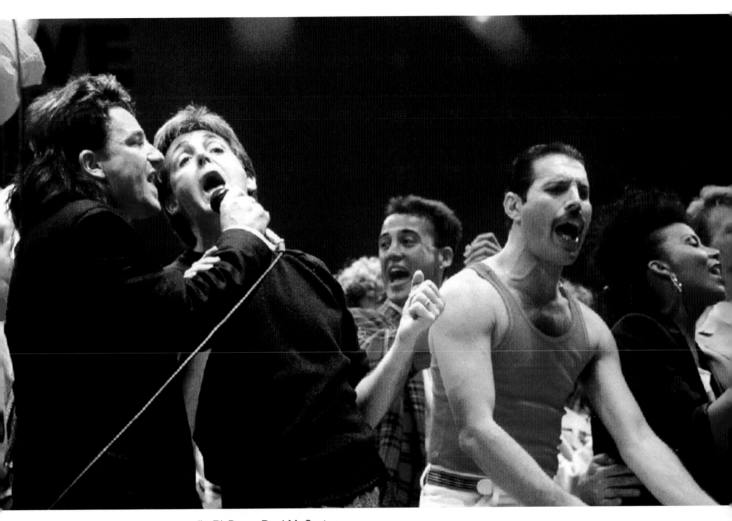

(L–R) Bono, Paul McCartney and Freddie Mercury during the finale of Live *Aid*. Andrew Ridgeley from Wham! is also visible (C).
13th July, 1985

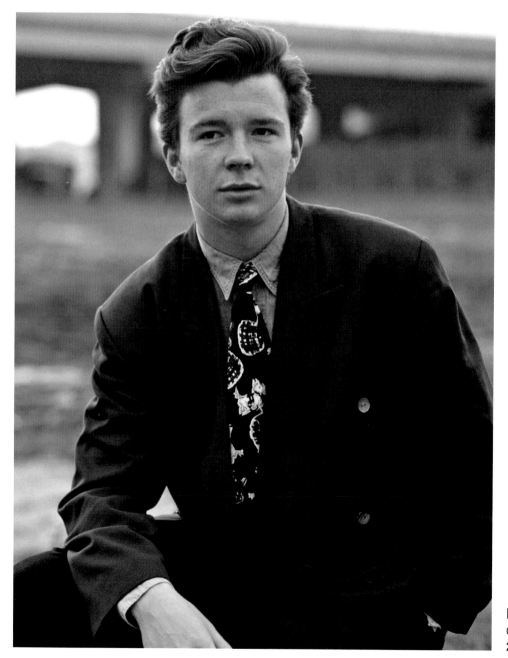

Nik Kershaw, formerly a dole
office clerk in Ipswich.
20th September, 1985

50 Years of British Pop • Twentieth Century in Pictures

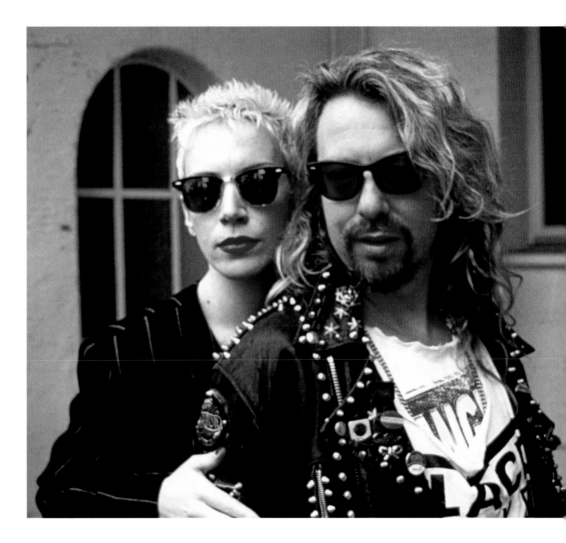

Dave Stewart and Annie
Lennox: formerly of the
Tourists, they formed the
Eurythmics in 1980.
1986

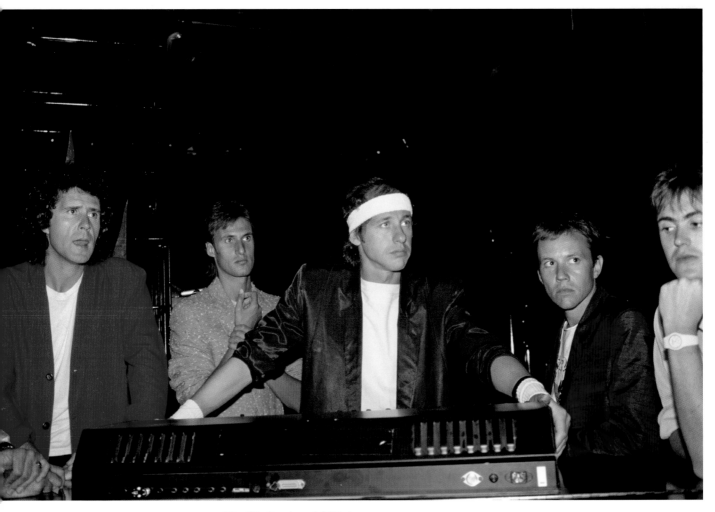

Dire Straits played 247 shows
in over 100 cities around the
world during 1985 and 1986.
1986

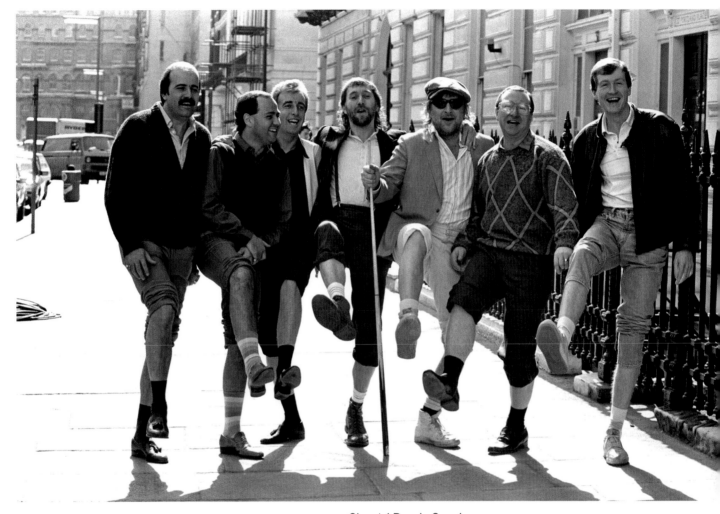

Chas 'n' Dave's *Snooker Loopy* features snooker stars (L–R) Willie Thorne, Tony Meo, Terry Griffiths, Dennis Taylor and Steve Davis.
26th March, 1986

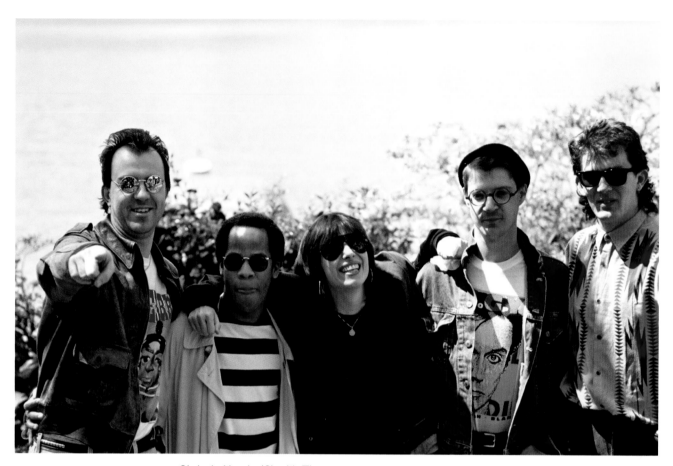

Chrissie Hynde (C) with The
Pretenders. Hynde served
her time in London's musical
hinterland, working for
Vivienne Westwood, hanging
out with Sid Vicious and
forming bands with several
future music industry figures
before hitting on this winning
formula.
1st June, 1986

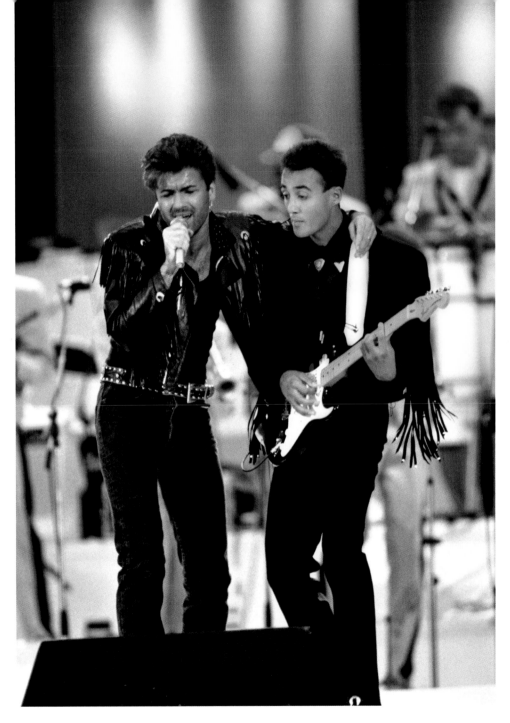

Wham!: George Michael and Andrew Ridgeley play their farewell concert. Ridgeley retired into rural obscurity in Cornwall.

28th June, 1986

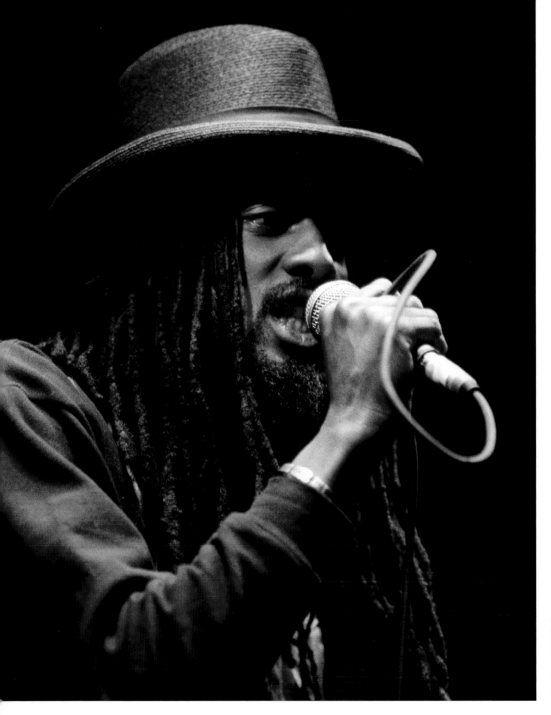

Aswad. In the following year,
the long-running reggae
band were to enjoy
a Number 1 hit with *Don't
Turn Around.*
1987

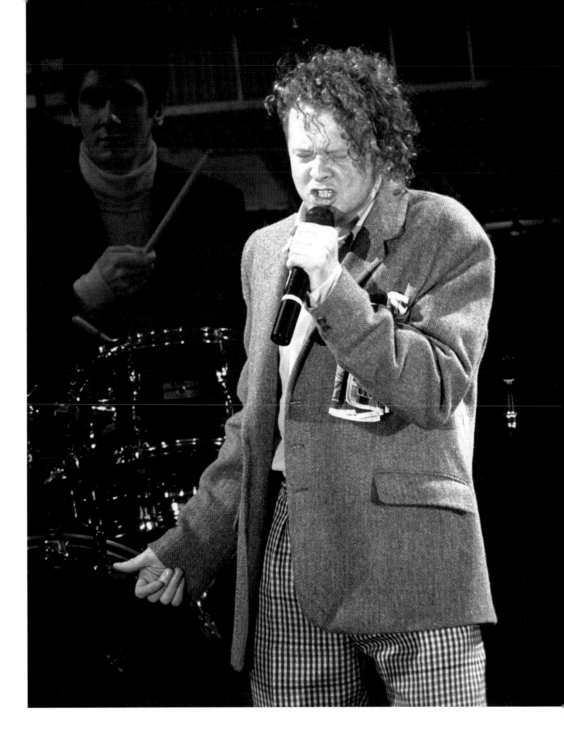

Mick Hucknall, singer
with Simply Red.
23rd February, 1987

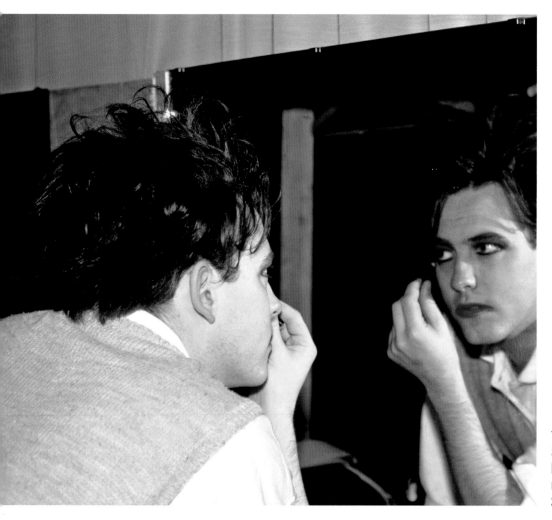

The Cure front man Robert
Smith employs his signature
light touch in applying
make-up.
29th April, 1987

British musical act Mel and Kim Appleby sign copies of their new album. Mel died of complications following chemotherapy in 1990. Kim went on to make further records and to perform in TV, cinema and theatre.
2nd July, 1987

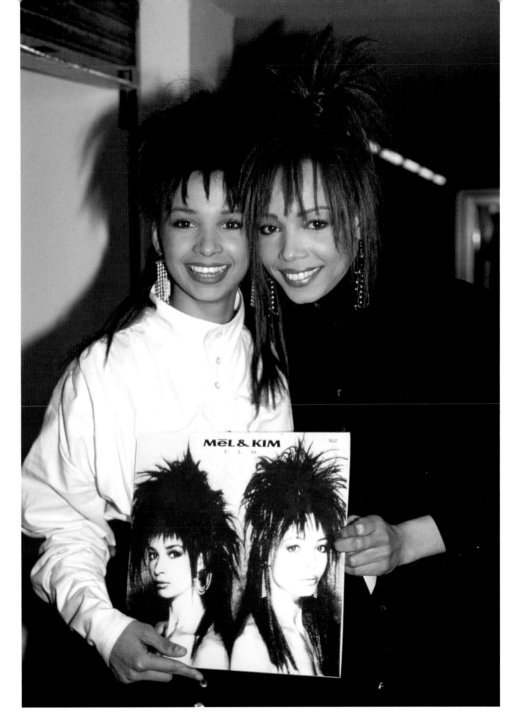

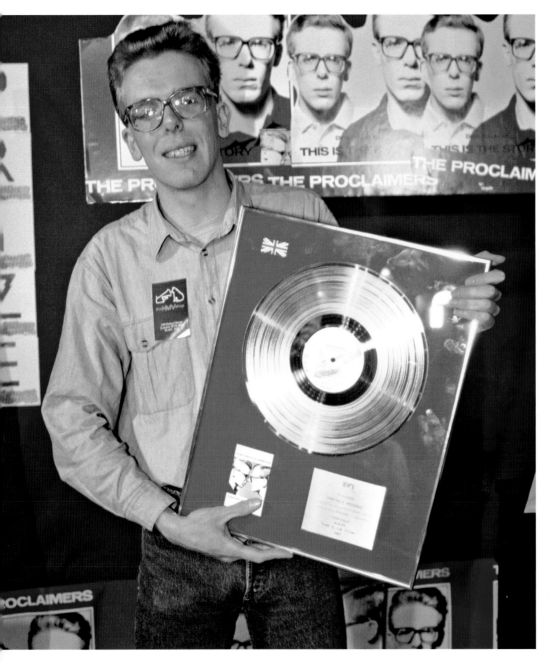

Craig Reid, one half of the Scottish duo The Proclaimers, with their gold disc. The brothers' debut album *This Is the Story* sold over 100,000 copies in 1987.

1st September, 1987

Adamski borrows the set from *Angel Heart* for his stage background.
1988

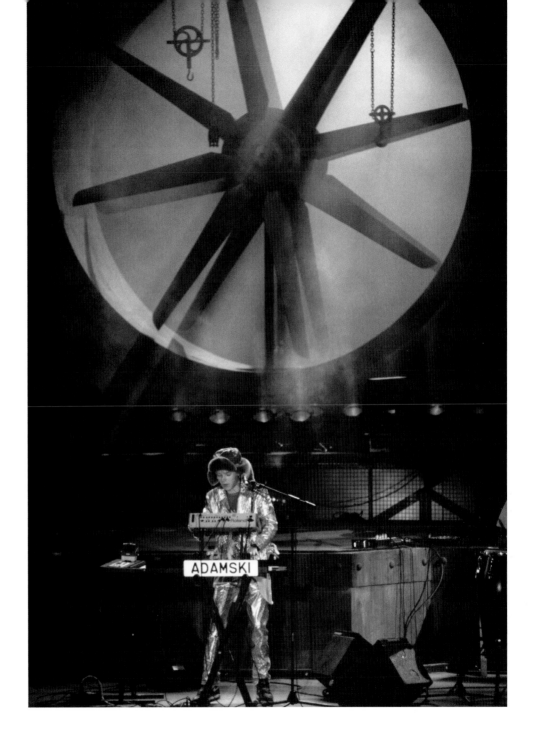

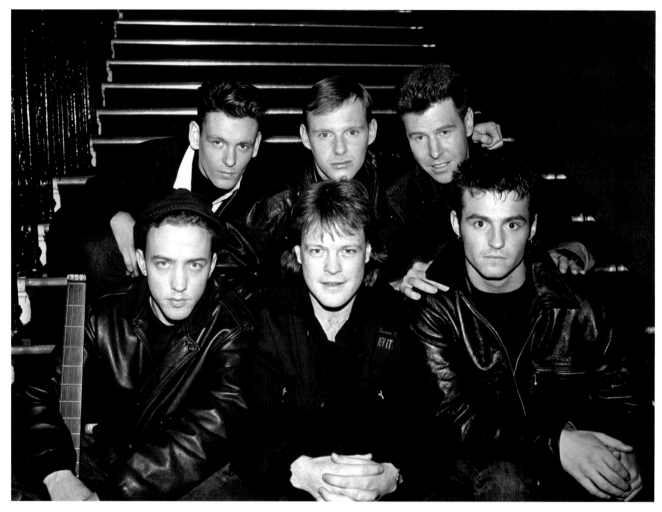

Wet Wet Wet, *Radio One
Best Newcomer Award*
winners, at the Royal Albert
Hall with DJ Bruno Brookes
(front, C).
8th February, 1988

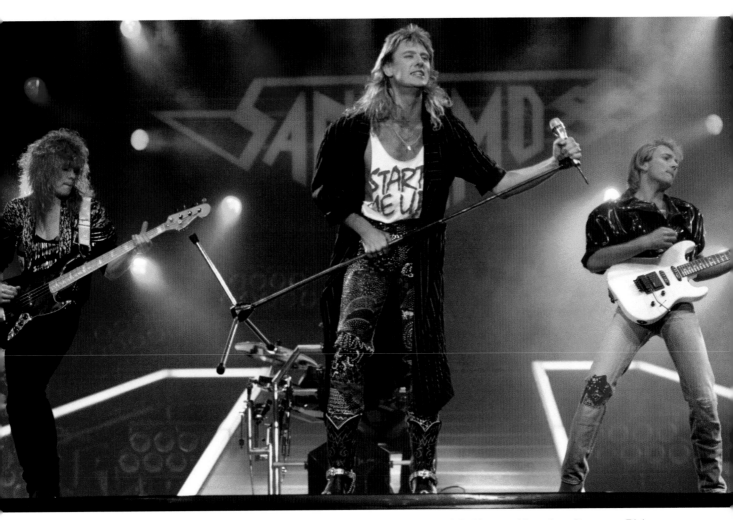

Heavy metal band Def Leppard in action. Drummer Rick Allen famously lost his left arm in a road accident in 1984. He taught himself to play without the arm and the band continued its rise to prominence.

27th February, 1988

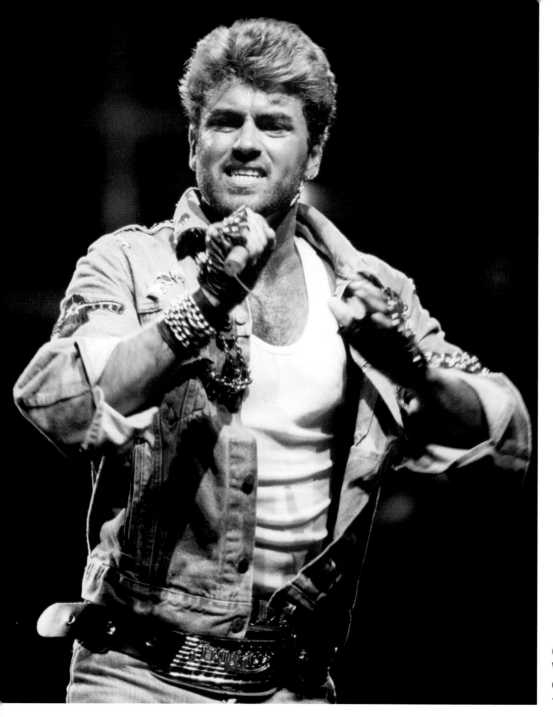

George Michael's post-Wham! career is a matter of considerable public record.
1st April, 1988

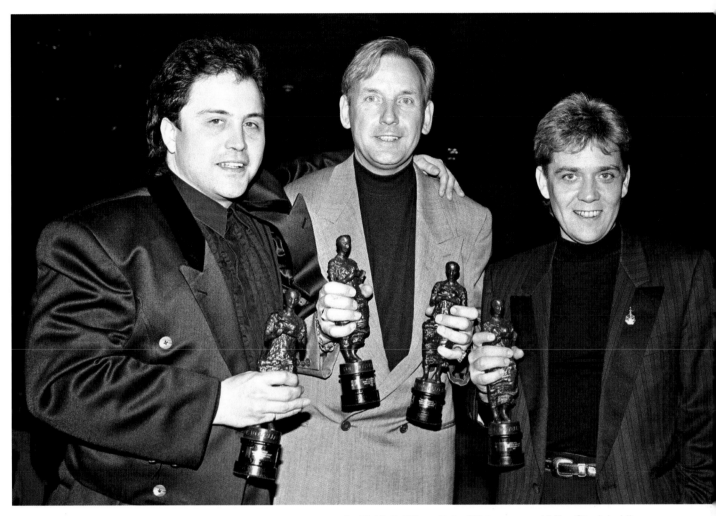

(L–R) Matt Aitken, Peter Waterman and Mike Stock holding their Ivor Novello Award. SAW, as they became known, were the most successful pop music production team of the '80s and early '90s, charting over 100 Top 40 hits and earning more than £60m.

7th April, 1988

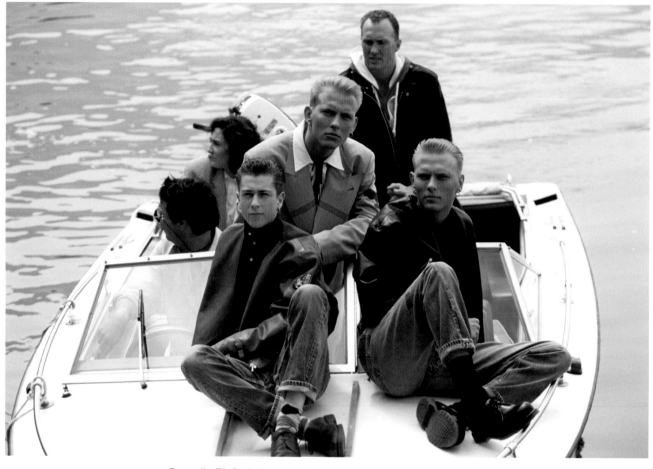

Bros, (L–R) Craig Logan and
twins Matt and Luke Goss.
Logan went on to make
albums with Mel and Kim
survivor Kim Appleby.
16th May, 1988

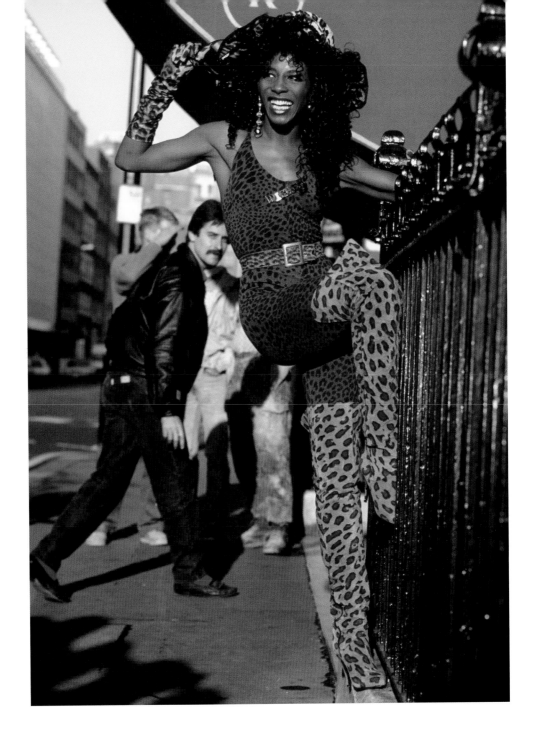

Sinitta promotes
her album *Wicked*.
1st June, 1988

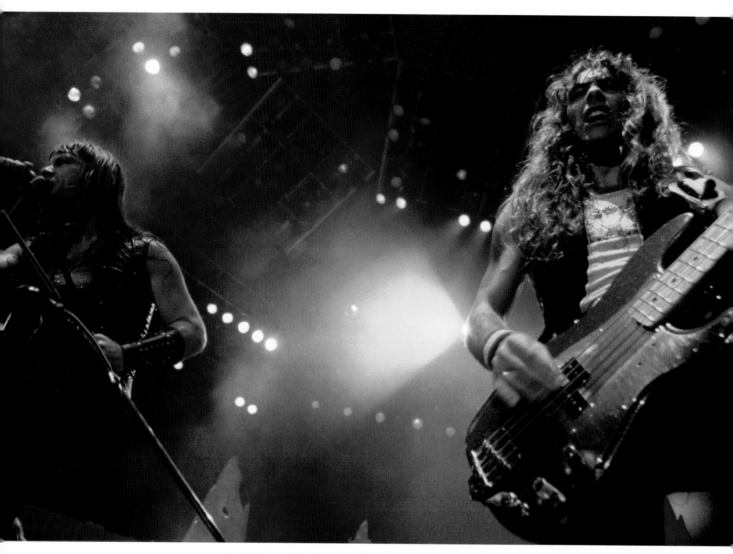

(L–R) Bruce Dickinson and
founder Steve Harris of Iron
Maiden in action on stage.
20th August, 1988

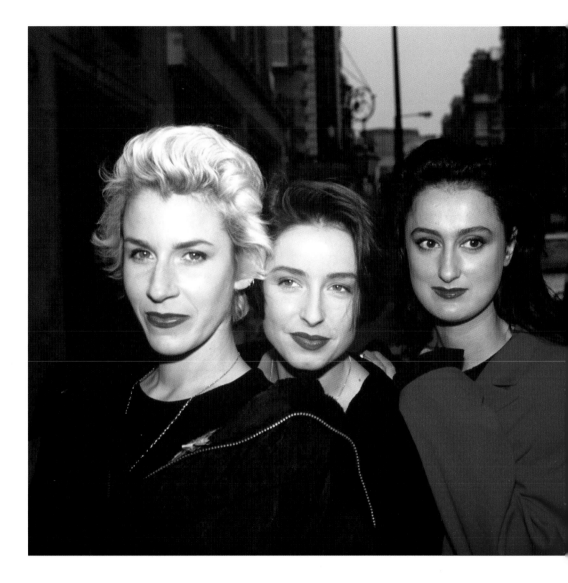

Bananarama appear
at HMV to promote
the release of their
Greatest Hits Collection.
1st October, 1988

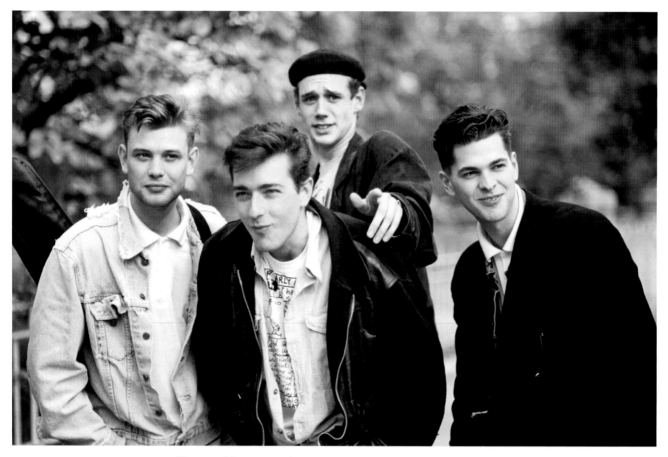

Flavour of the moment,
Curiosity Killed the Cat.
(L–R) Nick Thorpe, Julian
Godfrey Brookhouse, Ben
Volpeliere-Pierrot and Migi
Drummond.
1989

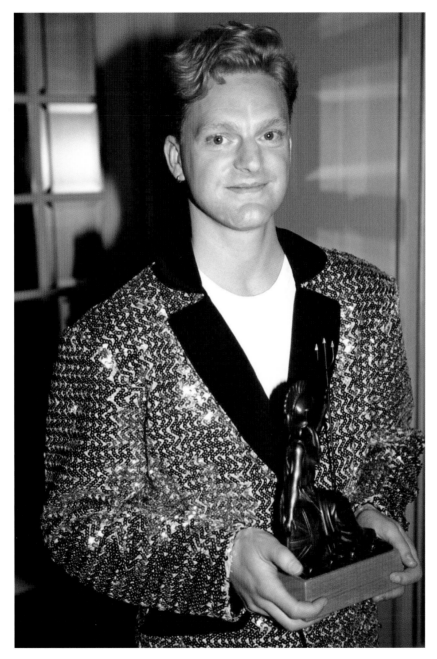

Andy Bell of Erasure, Vince
Clarke's third successful
collaboration.
1st February, 1989

Ian Dury studied art under *Sergeant Pepper* cover artist Peter Blake before forming Kilburn and the Highroads and then the legendary Blockheads. One of many musicians to benefit greatly from having a single banned by the BBC.
1990

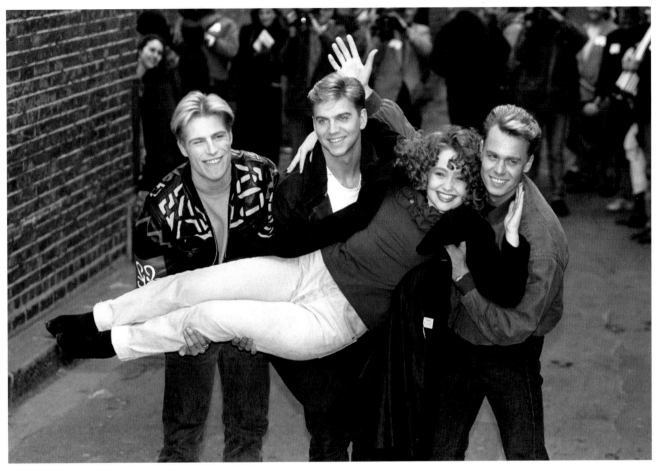

Stock, Aitken and Waterman
stable-mates Sonia and Big Fun.
2nd January, 1990

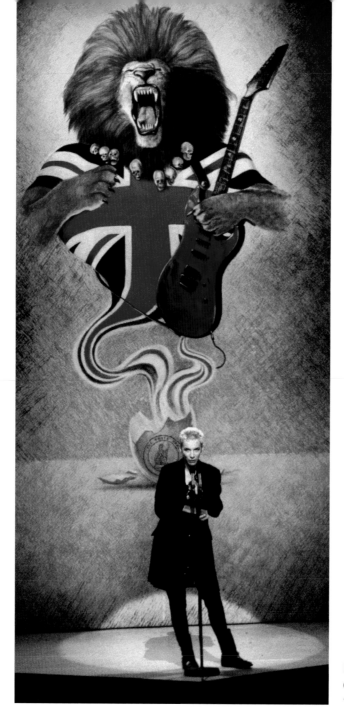

Veteran pop goddess Annie
Lennox collects a Brit Award
for Best British Female Solo
Artist.
20th February, 1990

Facing page: London R&B
entrepreneurs Soul II Soul.
19th November, 1990

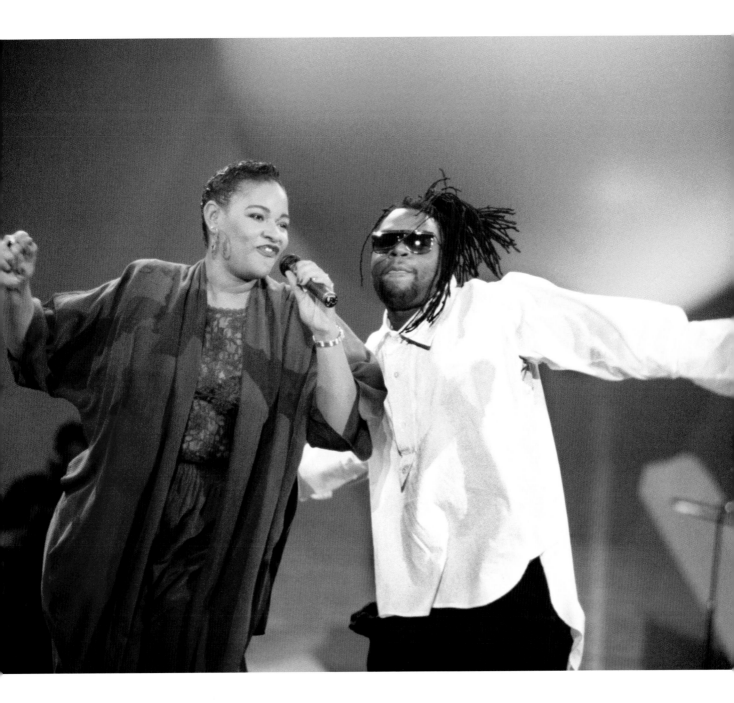

Pet Shop Boys' Neil Tennant
in sombre mood.
1st May, 1991

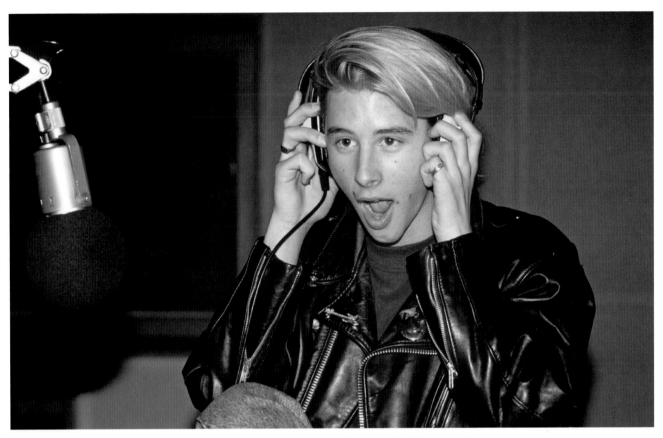

Chesney Hawkes, son of
Len 'Chip' Hawkes of the
Tremeloes (*see page 110*).
Chesney starred in the
film *Buddy's Song*, topping
the charts with *The One
and Only* from the film's
soundtrack. It was to be his
one and only hit.
8th July, 1991

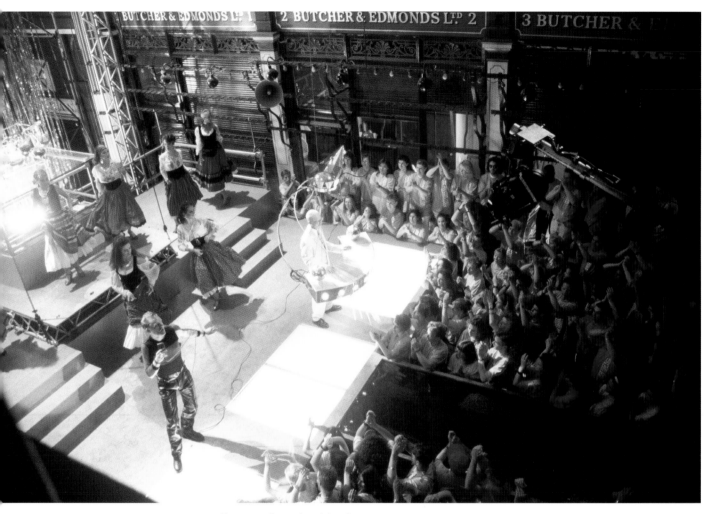

Erasure shoot the video for
their single *Love to Hate You.*
17th August, 1991

Former Smiths front man Morrissey. His departure from the band led to a protracted court battle over royalties.
1st December, 1993

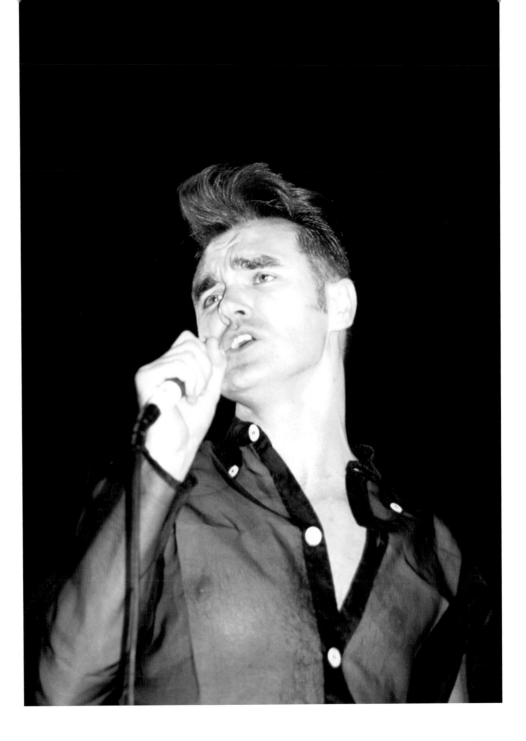

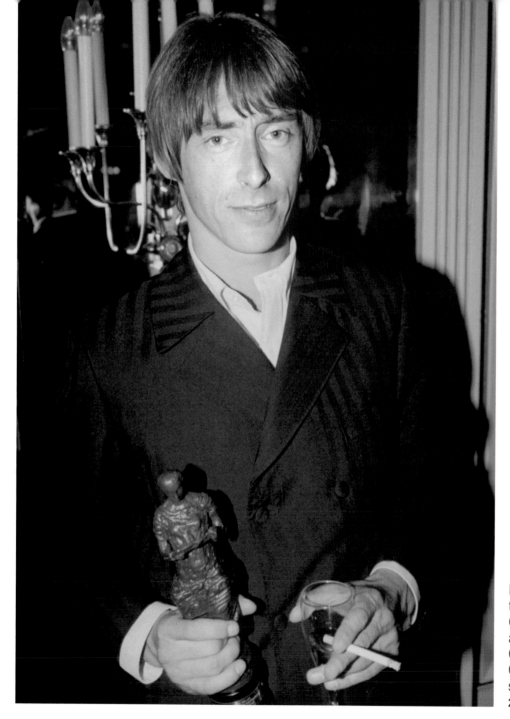

Paul Weller (formerly of the Jam and the Style Council) with his Ivor Novello award for Outstanding Contemporary Song Collection, for his second solo album *Wildwood*.
26th May, 1994

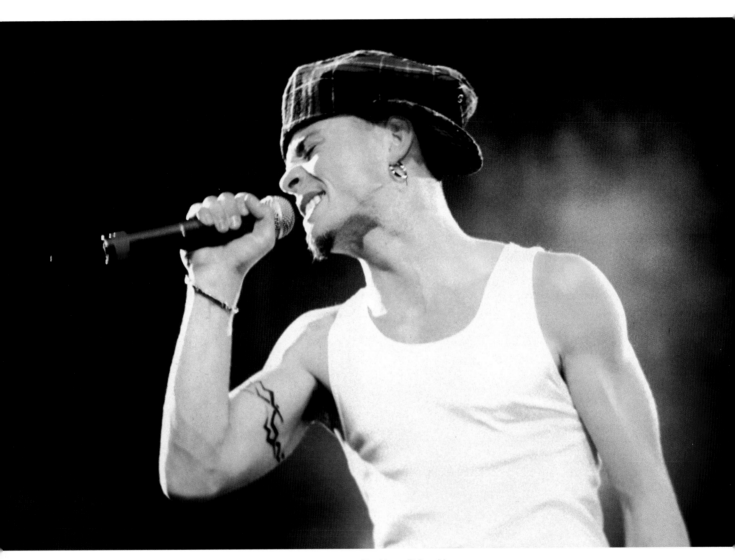

Bad boy Brian Harvey
on stage with East 17.
1st September, 1994

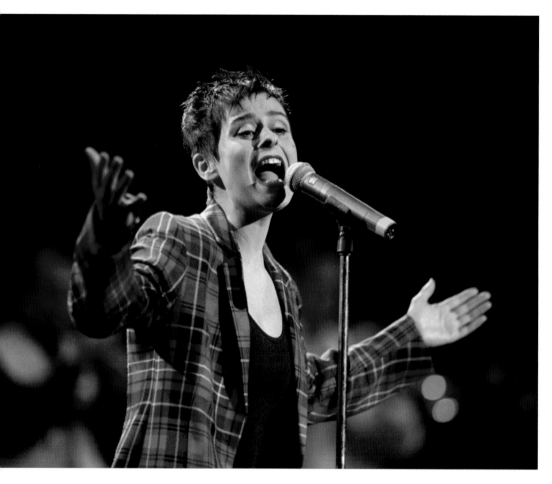

Former child TV star turned
Rochdale soul superstar,
Lisa Stansfield.
16th September, 1994

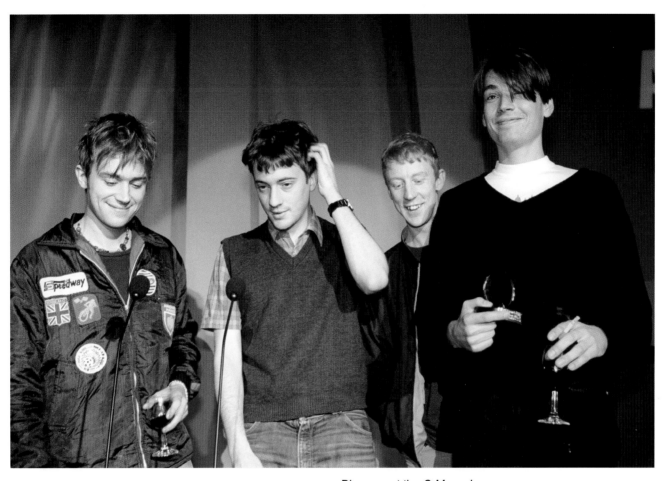

Blur accept the *Q Magazine* award for Best Album of 1994 for *Parklife*: (L–R) lead singer Damon Albarn; guitarist Graham Coxon; drummer Dave Rowntree and bass player Alex James.
9th November, 1994

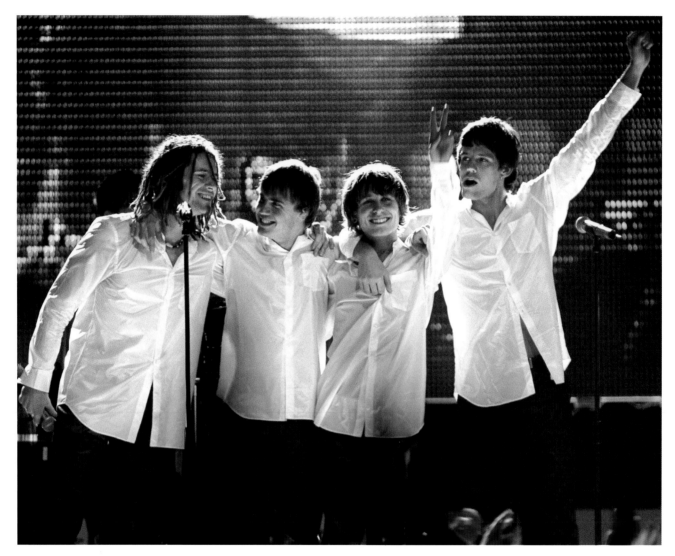

Pop group Take That after performing their final single, a
remake of the Bee Gees classic *How Deep Is Your Love?*, at
the *Brit Awards*. The single entered the UK charts at Number 1.
19th February, 1996

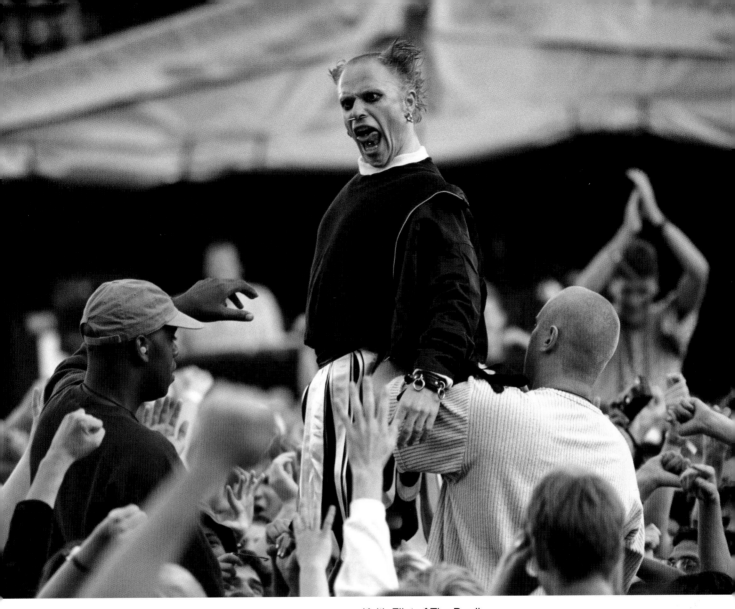

Keith Flint of The Prodigy
at Knebworth.
10th August, 1996

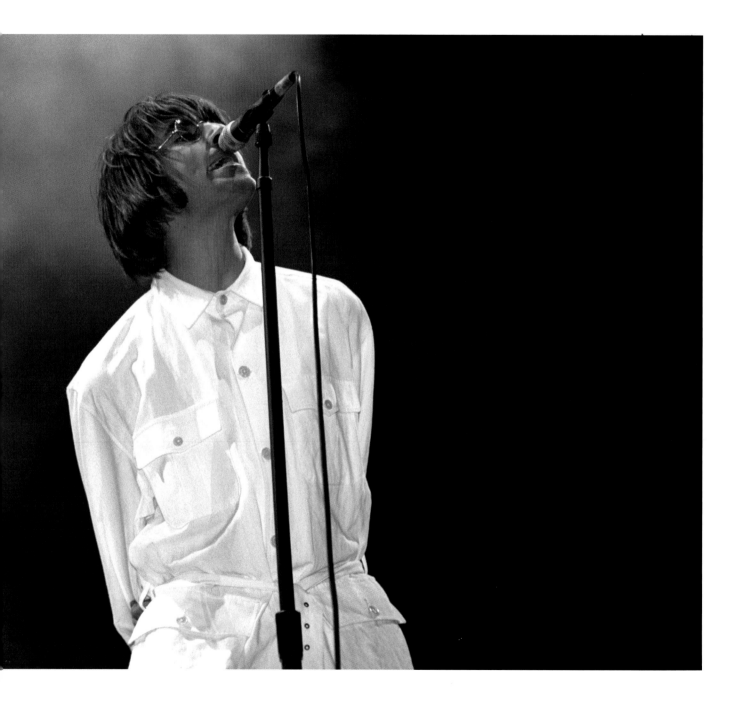

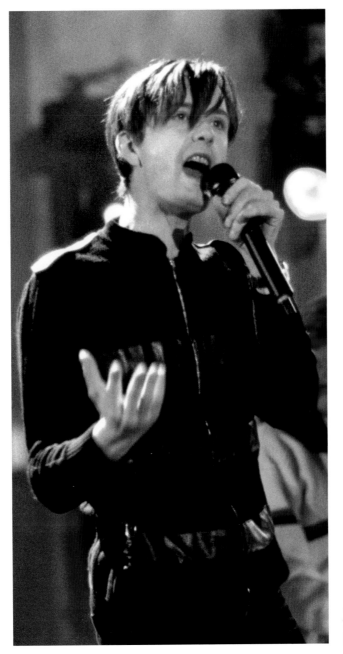

Facing page: Liam Gallagher
of Oasis at Knebworth.
10th August, 1996

Jarvis Cocker, singer
with Pulp.
20th August, 1996

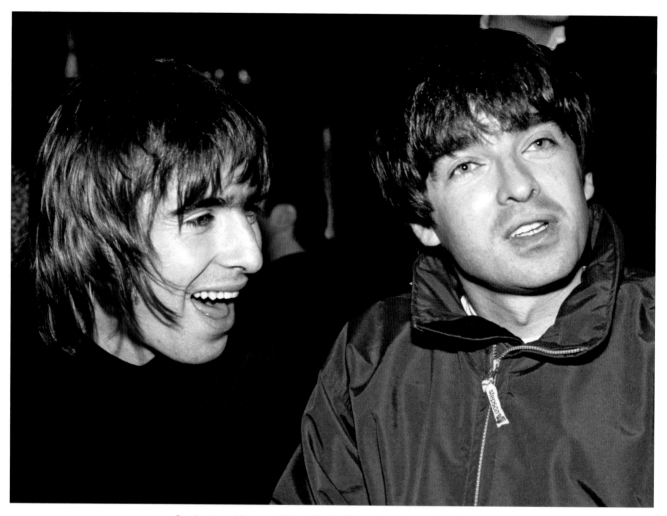

Oasis stars Liam and Noel Gallagher at the *Q Magazine* music awards in London. Liam received the Best Act in the World trophy on behalf of the band at the tenth anniversary of the awards.
8th November, 1996

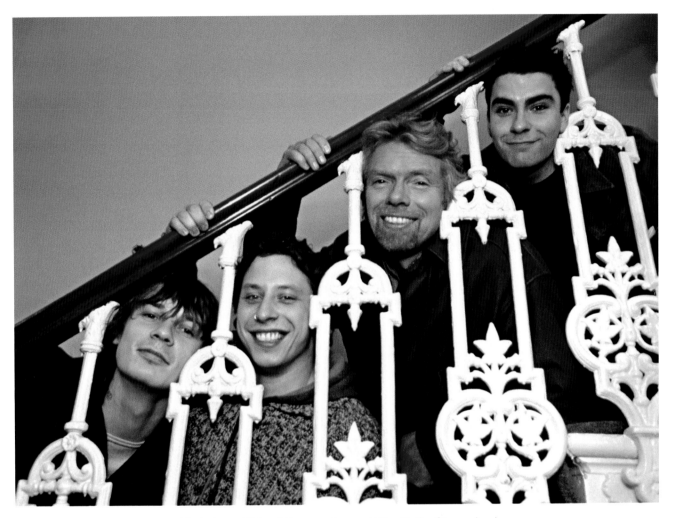

Virgin boss Richard Branson (second R) with the Stereophonics at the launch of his new company V2 records. The South Wales band, (L–R) Richard Jones, Stuart Cable and Kelly Jones, are one of the first three signings for the new label.

27th November, 1996

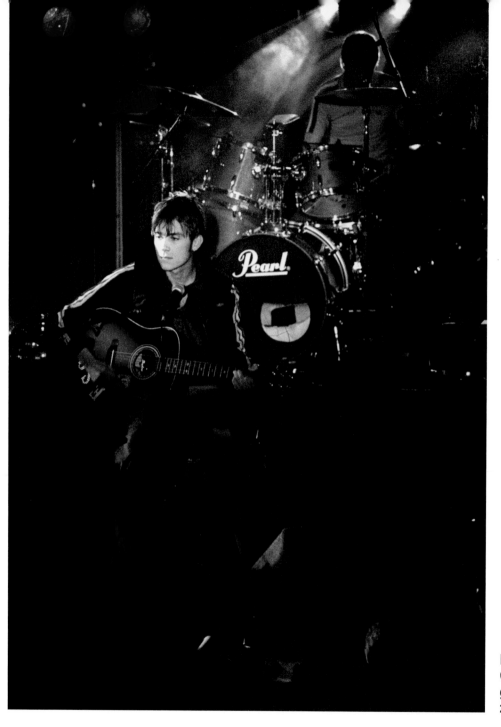

Damon Albarn at the Mayfair
Club in Newcastle, Blur's first
gig in more than a year.
22nd January, 1997

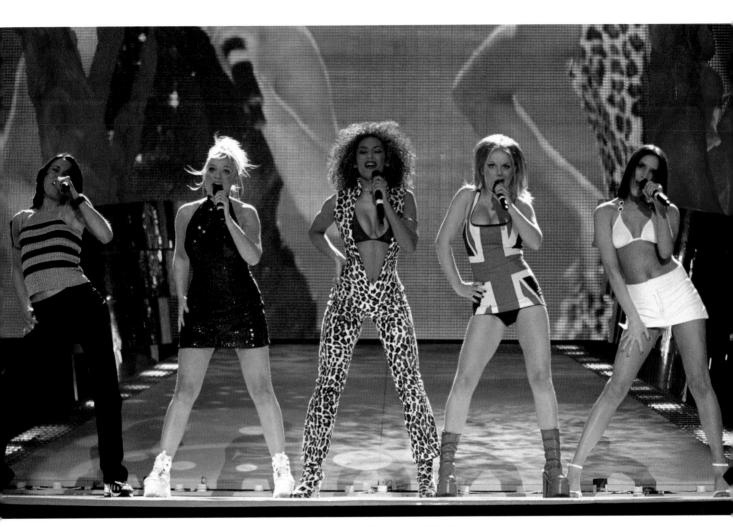

The Spice Girls, the most successful British band since the Beatles. They were given aliases by *Top of the Pops* magazine: (L–R) Sporty, Baby, Scary, Ginger and Posh.
24th February, 1997

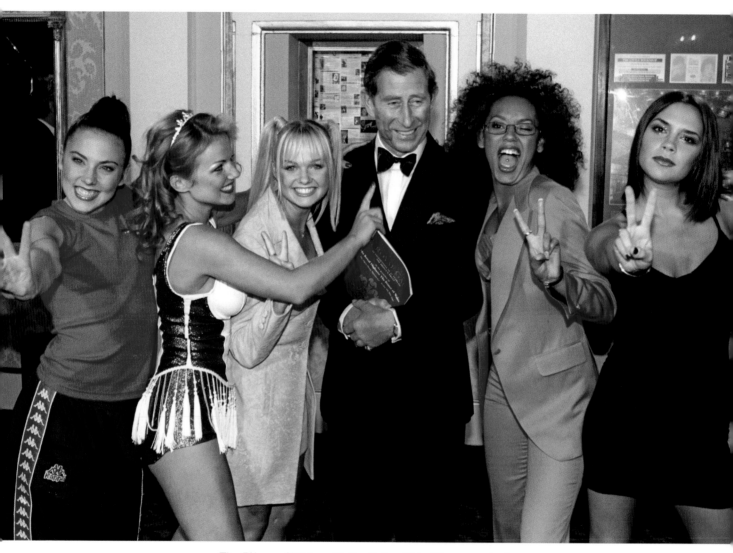

The Prince of Wales with the Spice Girls. The group had an
electrifying effect on statesmen and world leaders: Nelson
Mandela described meeting them as *"an honour"*.
9th May, 1997

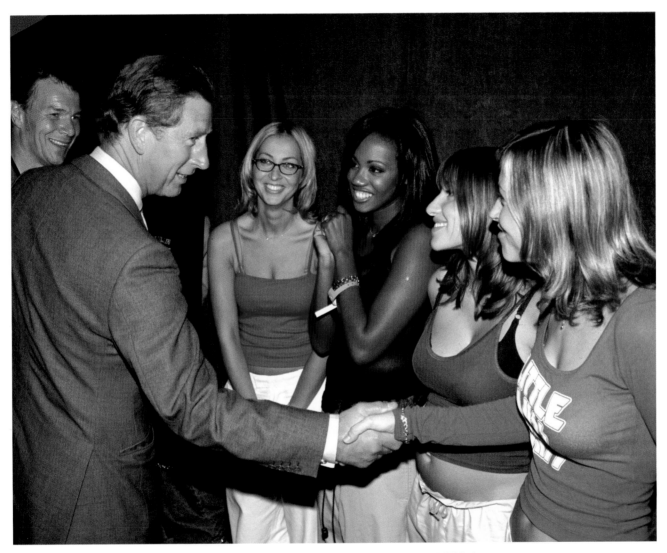

The Prince of Wales with members of the girl band All Saints:
(L–R) Natalie Appleton, Shaznay Lewis, Melanie Blatt and Nicole
Appleton. The Spice Girls' success led to a deluge of imitations,
of which All Saints were for a while the most prominent.
5th July, 1998

Singer Mica Paris launches her new album *Black Angel* with a celebrity party at the k Bar in Chelsea.
13th August, 1998

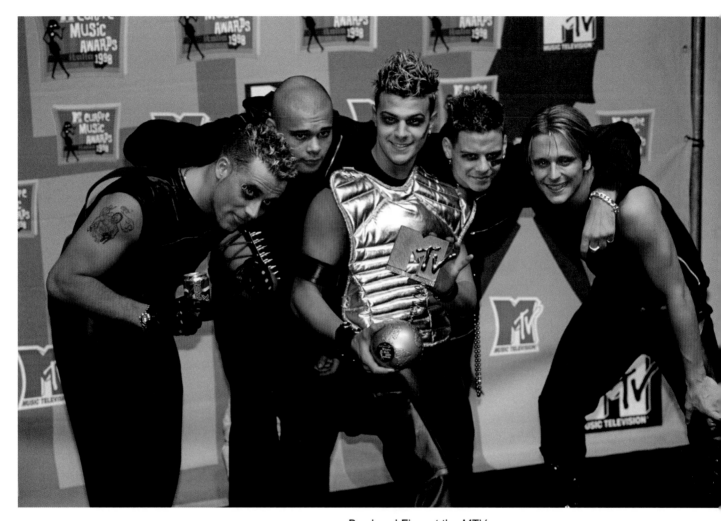

Boy band Five, at the *MTV*
Awards at the Filaforum
near Milan. (L– R) J (Jason)
Brown, Sean Conlon, Abs
(Richard) Brown, Scott
Robinson and Richie Neville.
12th November, 1998

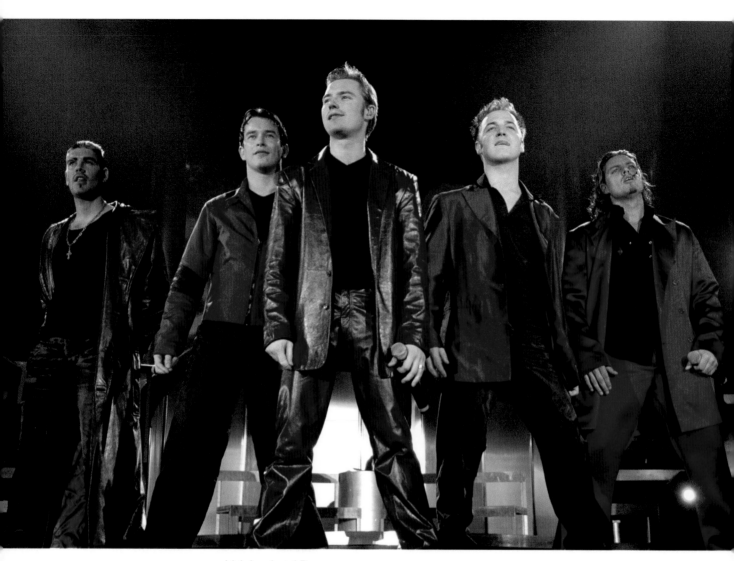

Irish boy band Boyzone
present a study in brown at
Wembley Arena.
17th May, 1999

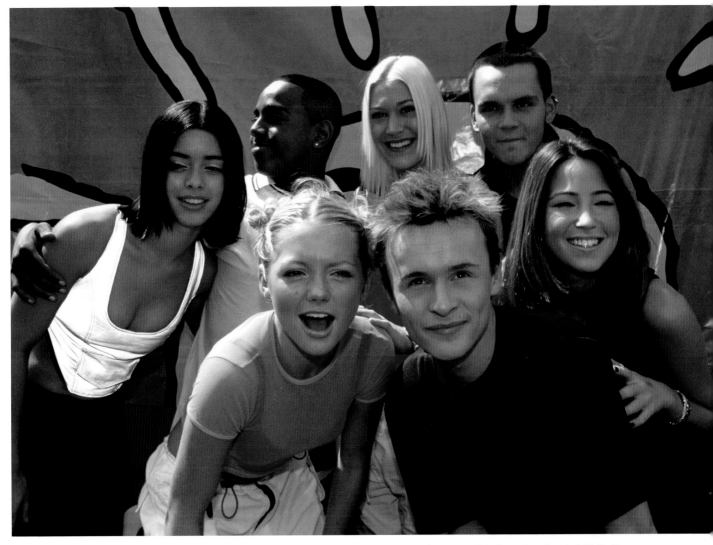

BBC Children's TV spin-off S Club 7 at Capital FM's *Power in the Park* in London. (L–R) Tina Barrett, Bradley McIntosh, Hannah Spearritt, Jo O'Meara, Jon Lee, Paul Cattermole and Rachel Stevens.
14th June, 1999

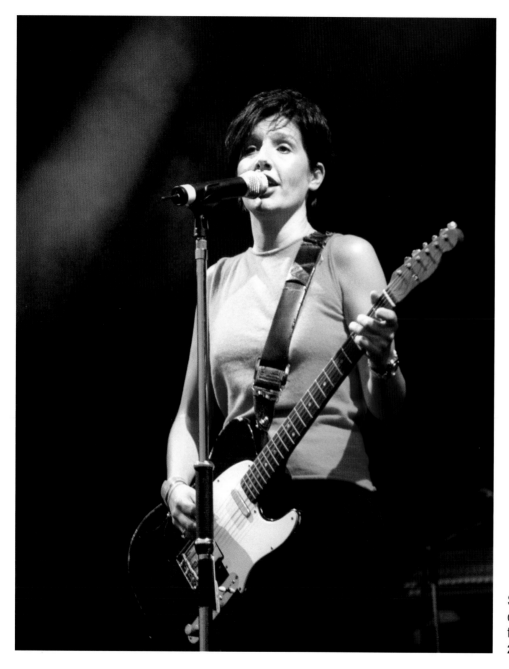

Facing page: James Dean Bradfield, lead singer of the band Manic Street Preachers.
26th June, 1999

Sharleen Spiteri of Texas, on the Pyramid stage at the Glastonbury Festival.
26th June, 1999

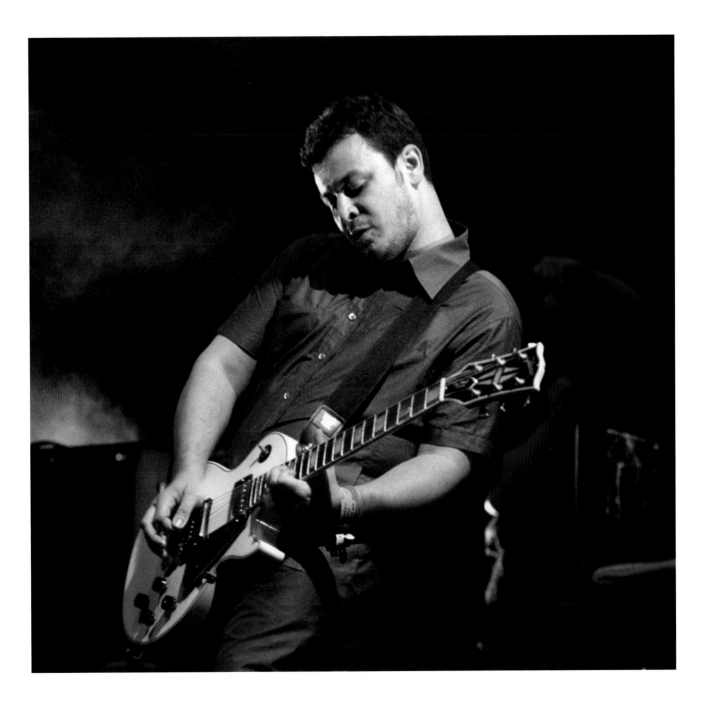

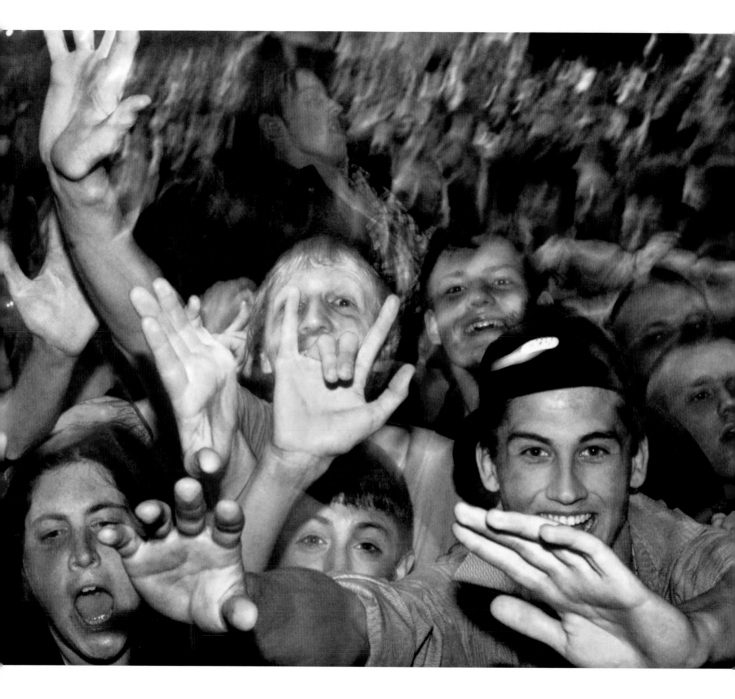

Facing page: Manic
Street Preachers' fans
at Glastonbury.
27th June, 1999

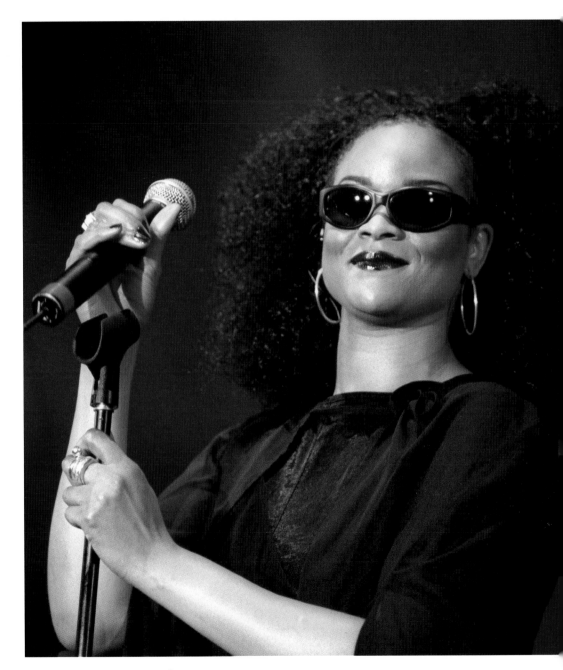

Gabrielle on stage at the
Wicked Women concert in
aid of Breakthrough Breast
Cancer in Hyde Park.
24th July, 1999

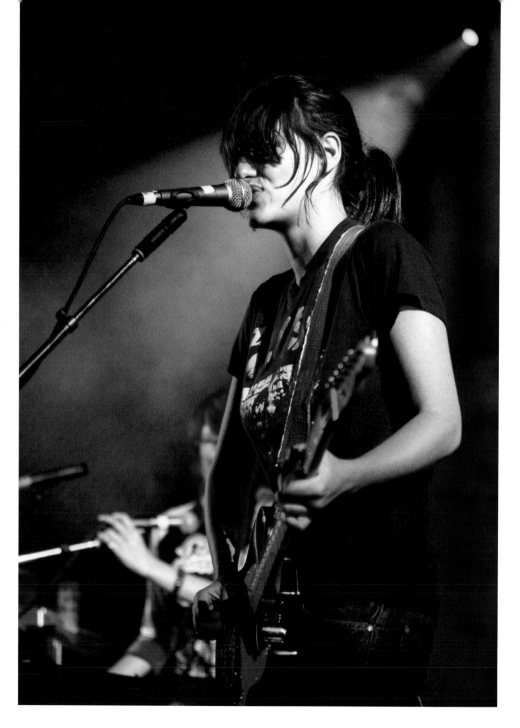

Justine Frischmann, lead singer with Elastica and sometime partner of Damon Albarn, at the Reading Festival.
27th August, 1999

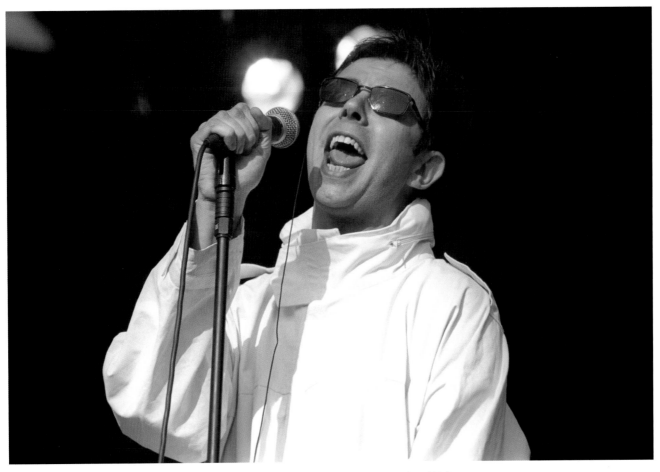

Ian McCulloch, of Echo
and the Bunnymen,
at the Reading Festival.
27th August, 1999

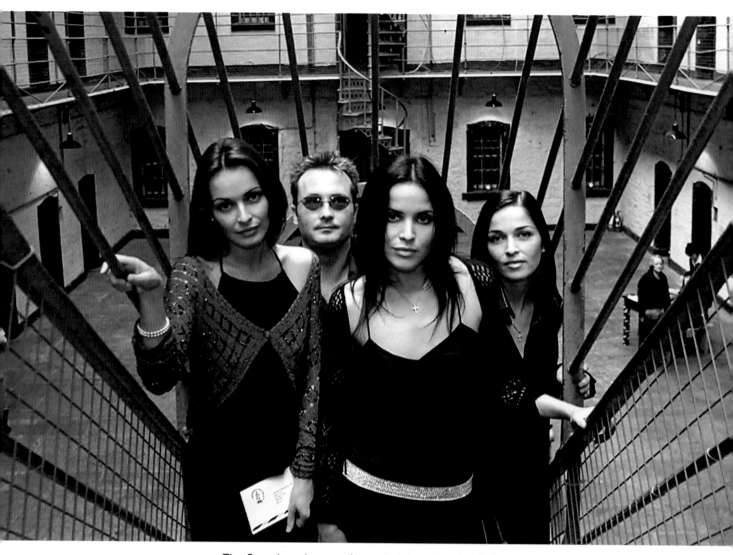

The Corrs launch a new Amnesty International global campaign against torture at Dublin's Kilmainham Jail: (L–R) Sharon, Jim, Andrea and Caroline.
18th October, 2000

Former Boyzone member Ronan Keating at the Royal Albert Hall on his solo tour.
30th October, 2000

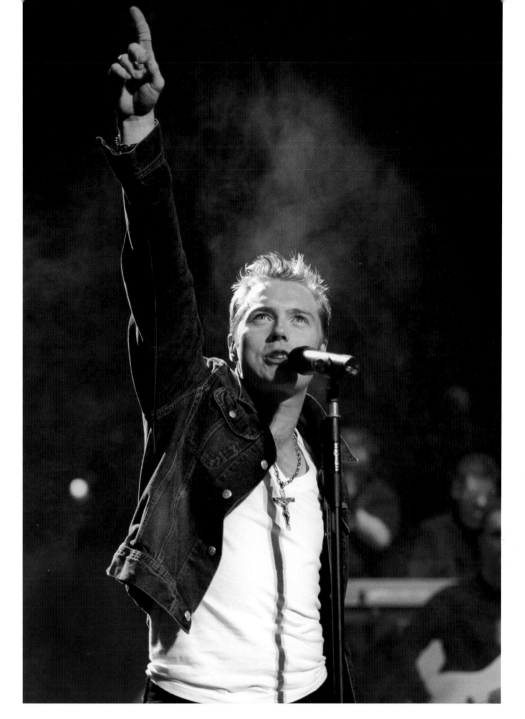

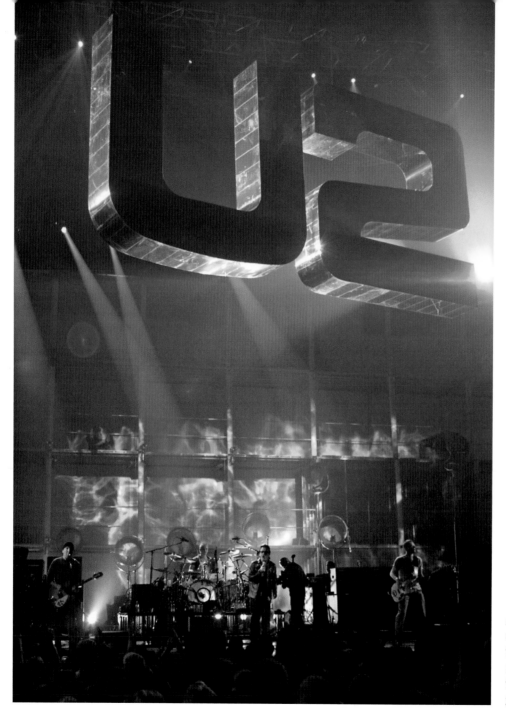

After more than two decades of pre-eminence U2 still feel the need to remind the *Brit Awards* audience who they are.
20th February, 2001

50 Years of British Pop • Twentieth Century in Pictures

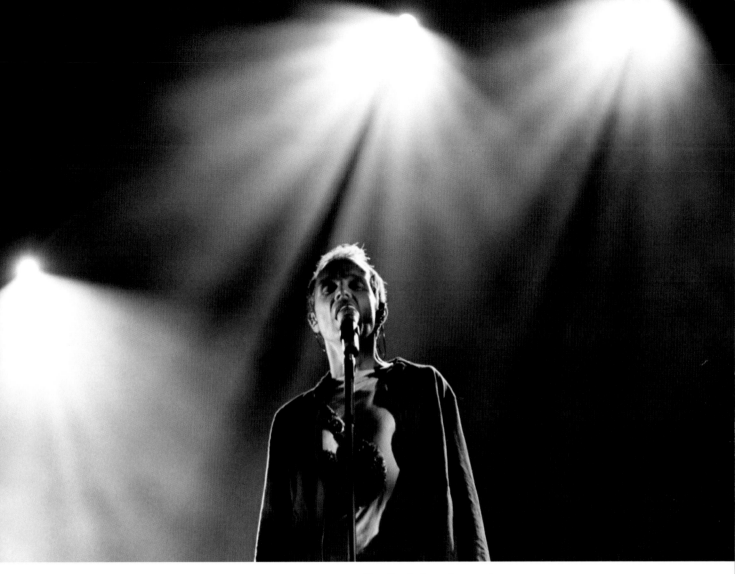

Tim Booth from James at
the Guildford Live Festival.
4th August, 2001

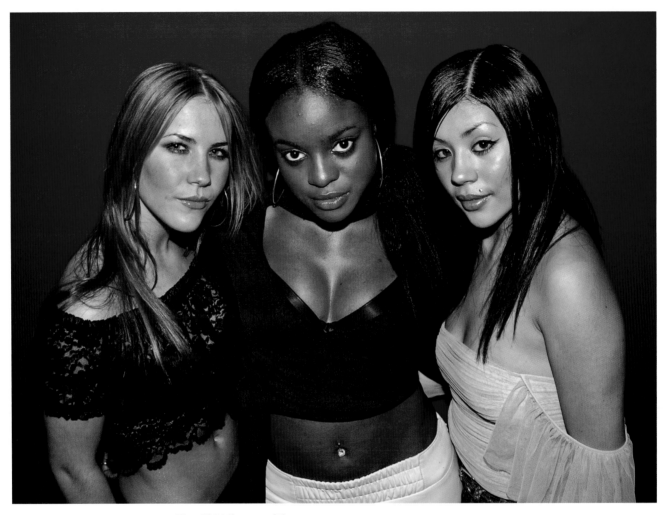

The 2001 line up of the
Sugababes (L–R) Heidi
Range, Keisha Buchanan
and Mutya Buena at the *UK
Online* music awards.
28th September, 2001

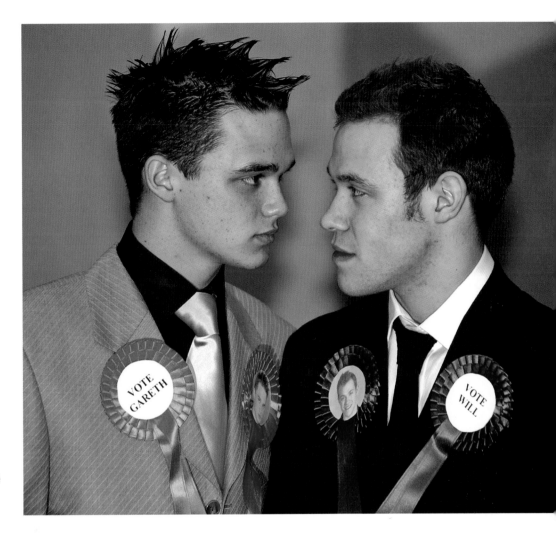

A nation holds its breath as the final *Pop Idol* contestants, Gareth Gates (L) and Will Young, face the final viewers' vote.

3rd February, 2002

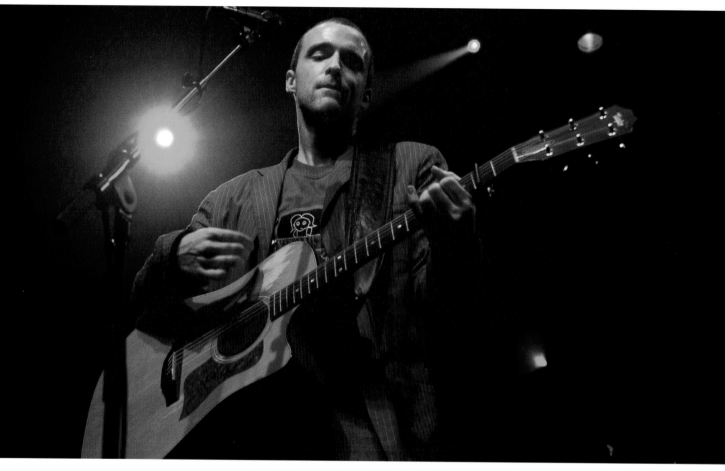

Lead singer Fran Healy of
the Glasgow band Travis,
at The London Astoria.
4th February, 2002

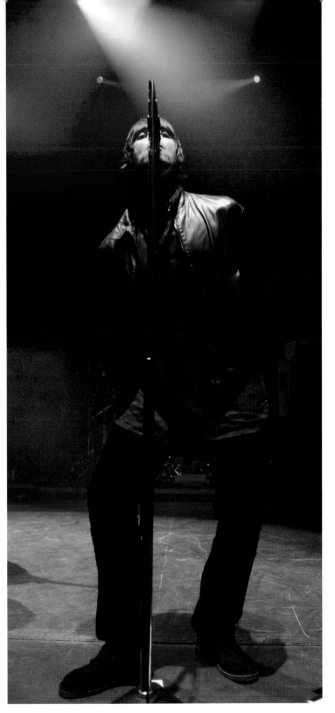

Oasis at the Royal Albert Hall, during a fundraising concert for the Teenage Cancer Trust.
6th February, 2002

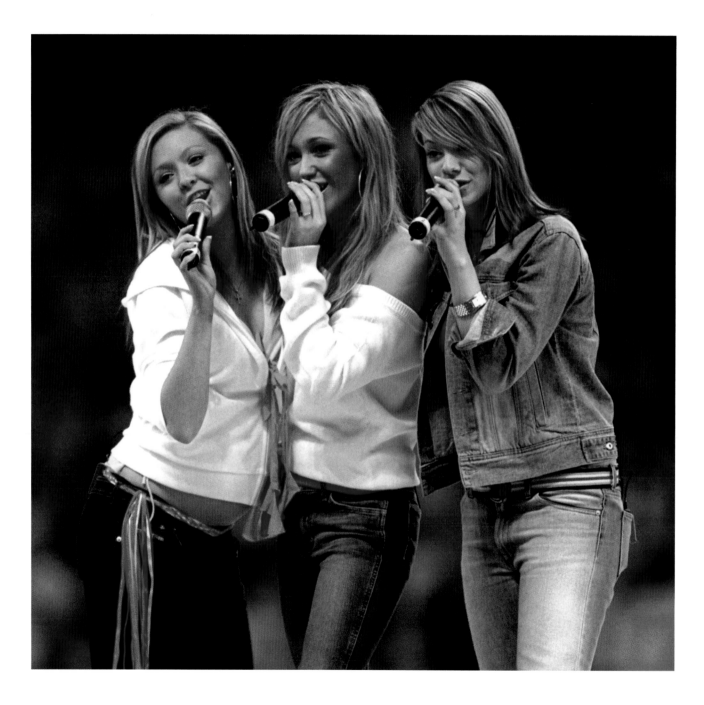

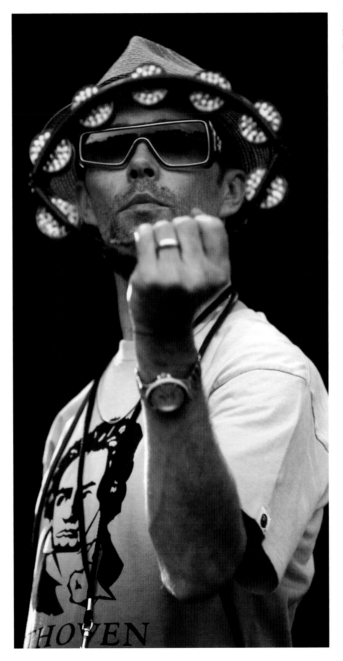

Former Stone Roses' singer Ian Brown at *V2002*, Chelmsford, Essex.
18th August, 2002

Facing page: Atomic Kitten provide pre-match entertainment at the Birmingham v. Norwich First Division playoff Final.
12th May, 2002

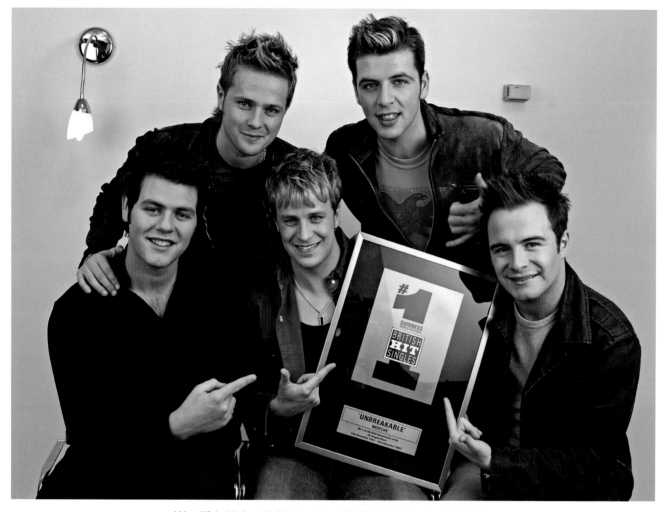

Westlife's *Unbreakable* tops the UK Singles Chart on its 50th anniversary: (front row L–R) Bryan McFadden, Kian Egan and Shane Filan; (back row, L– R) Nicky Byrne and Mark Feehily.

9th November, 2002

Former *Pop Idol* contestant Darius Danesh plays the *Girlguiding UK Big Gig* at Wembley Arena.

9th November, 2002

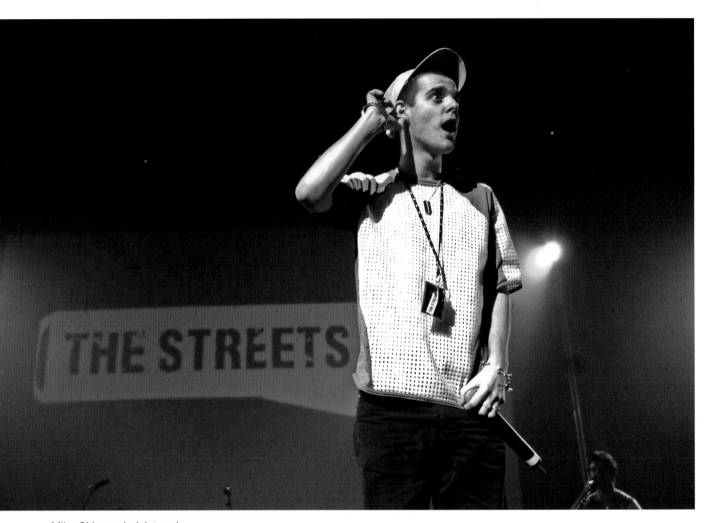

Mike Skinner, lyricist and
vocalist for The Streets,
at the Brixton Academy.
7th February, 2003

Facing page: The *Brit
Awards* crowd listens to
David Gray at Earls Court.
20th February, 2003

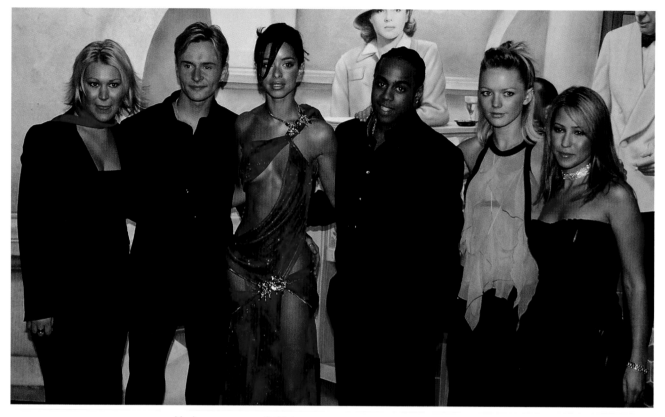

No longer seven: S Club,
(L–R) Jo O'Meara, Jon Lee,
Tina Barrett, Bradley McIntosh,
Hannah Spearritt and Rachel
Stevens, at the Gala Celebrity
premiere of the S Club movie
Seeing Double.
7th April, 2003

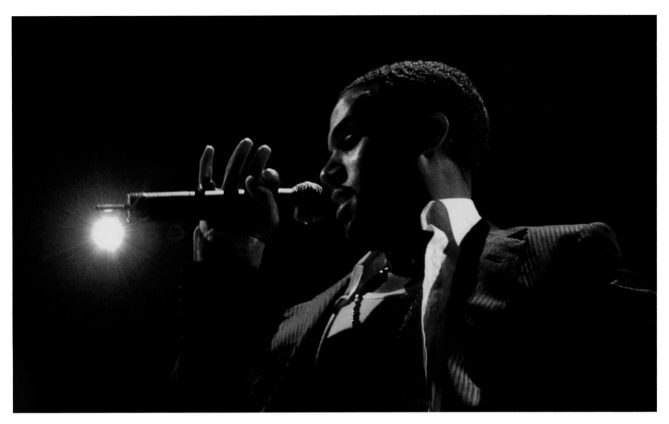

Craig David at London's
Wembley Arena.
30th May, 2003

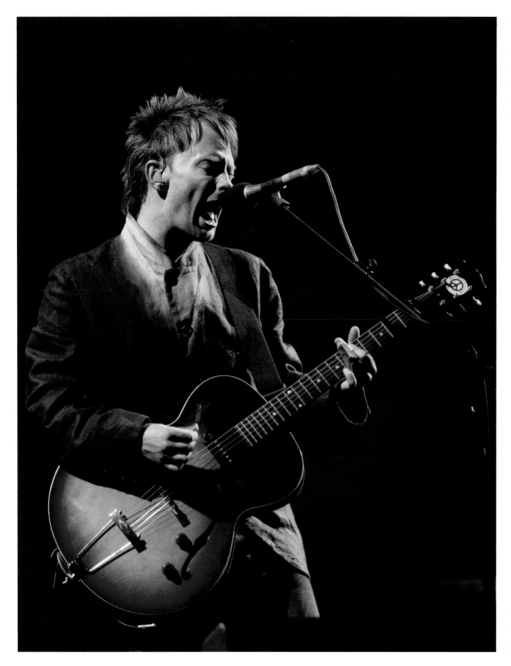

Facing page: *Pop Idol* judges (L–R) Simon Cowell, Pete Waterman, Nicki Chapman and Neil Fox with show hosts Ant and Dec at the launch of a new series of *Pop Idol*.
31st July, 2003

Thom Yorke of Radiohead at the Glastonbury Festival.
28th June, 2003

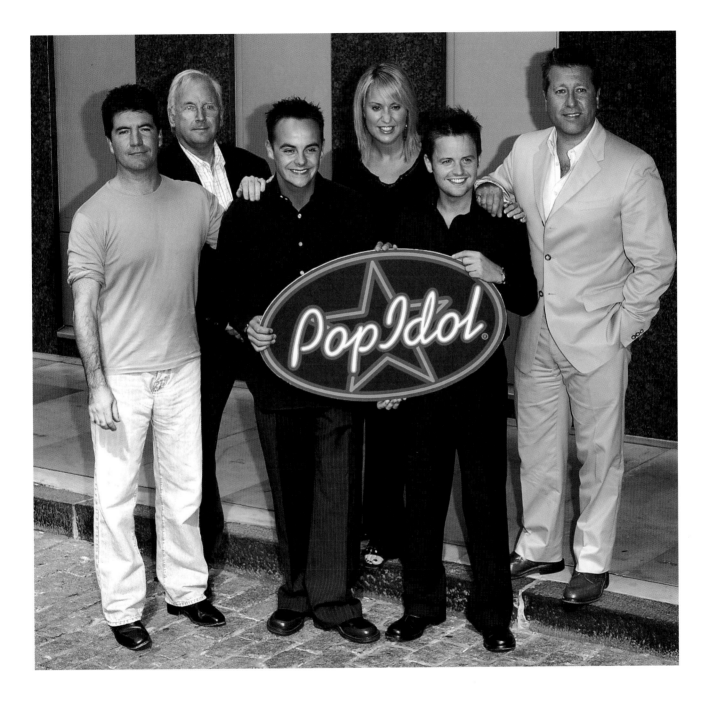

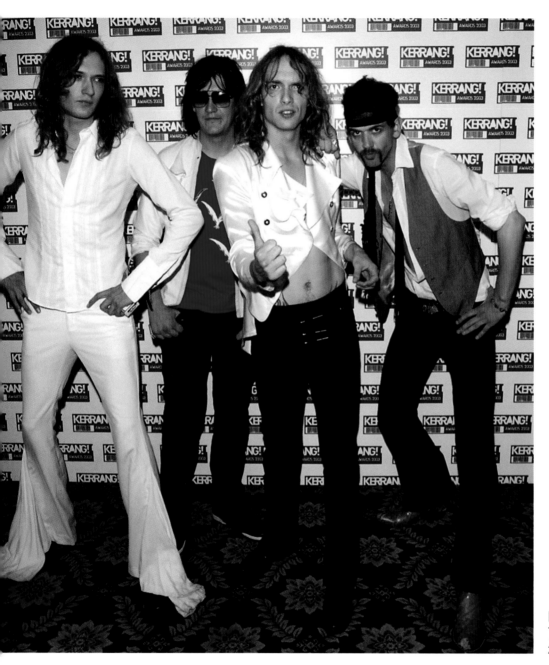

Lowestoft's finest sons,
The Darkness.
21st August, 2003

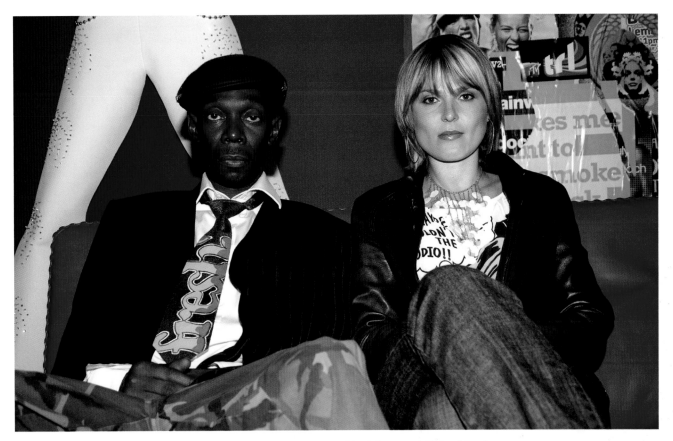

Maxi Jazz and Sister Bliss from
Faithless appear on MTV.
26th July, 2004

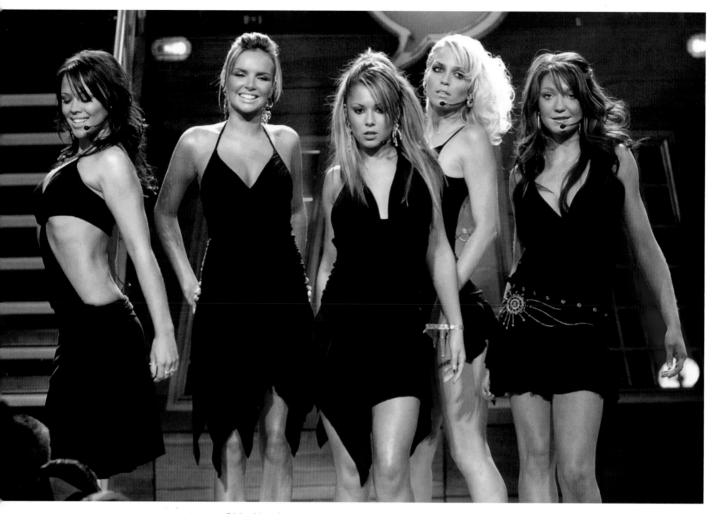

Girls Aloud onstage at
the *Disney Channel* Kids
Awards 2004.
16th September, 2004

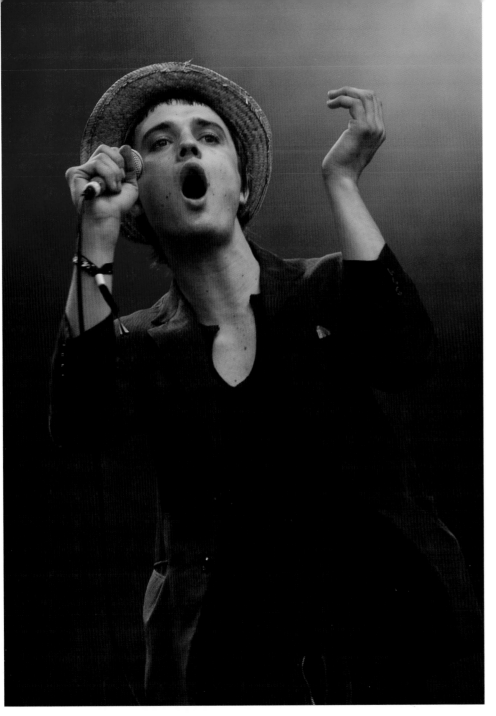

One of the most notorious figures of 21st Century British pop, Pete Doherty, lead singer of Babyshambles, at Glastonbury. Doherty first rose to fame with the Libertines, a name which followed him long after the band ceased to perform.
24th June, 2005

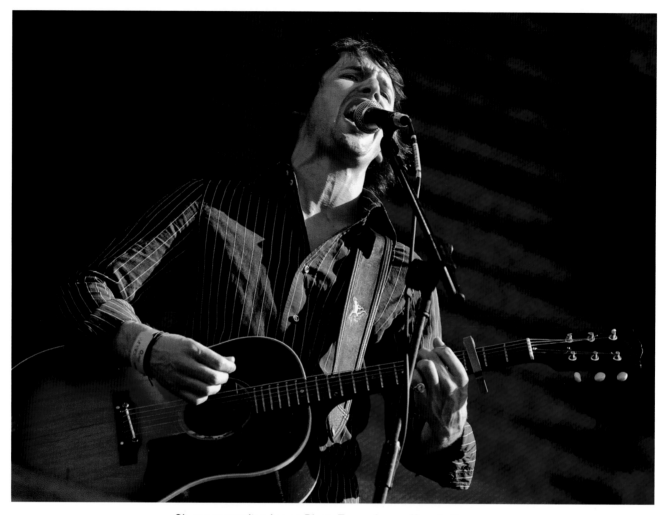

Singer-songwriter James Blunt. Formerly an officer in the
Lifeguards, he stood guard over the coffin of the Queen Mother
before her funeral. He also served in Kosovo in the '90s.
29th June, 2005

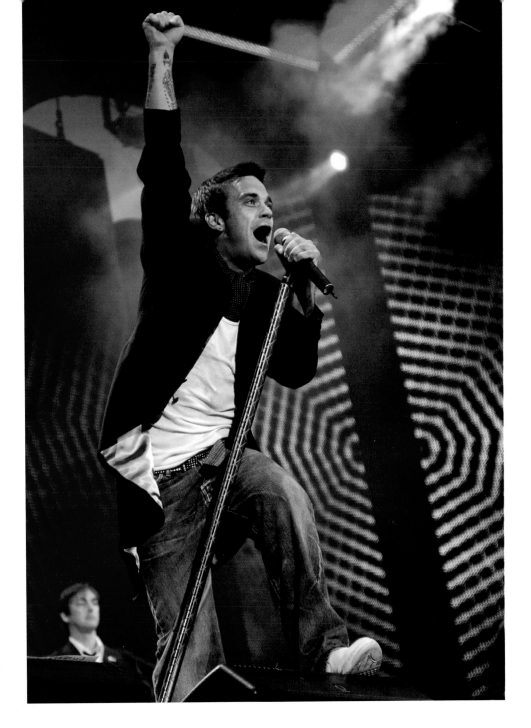

Former Take That singer
turned international solo
superstar, Robbie Williams
at *Live8*.
2nd July, 2005

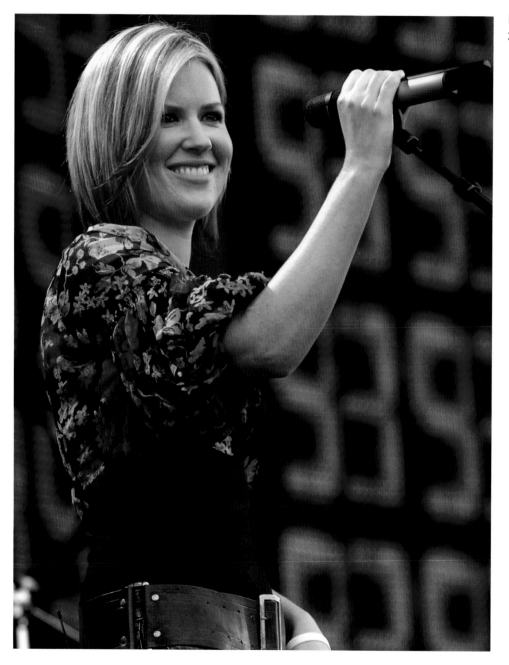

Dido at *Live8*.
2nd July, 2005

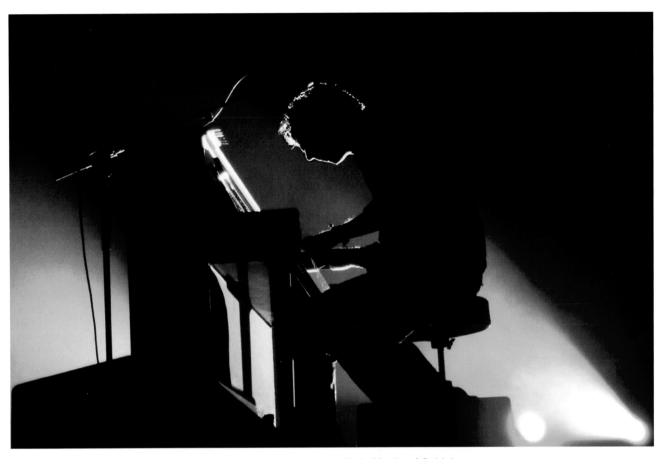

Chris Martin of Coldplay.
14th December, 2005

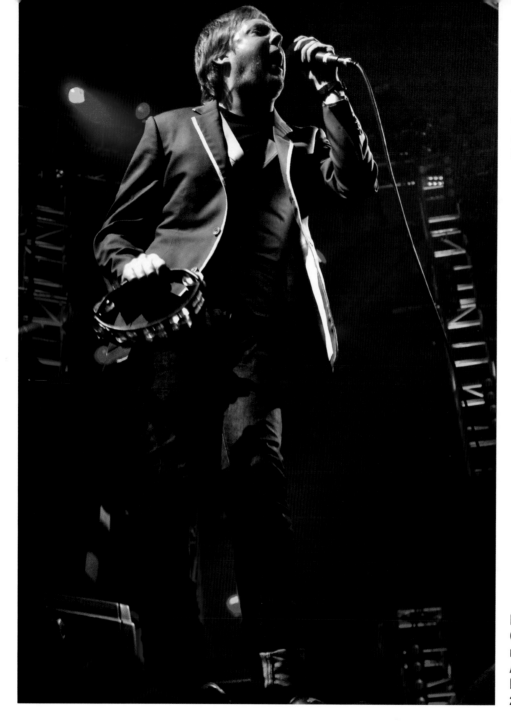

Facing page: Noel Gallagher at the MENCAP *Little Noise Sessions*, at the Union Chapel in Islington, north London.
26th November, 2006

Ricky Wilson of the Kaiser Chiefs. The band were named after the South African football team Kaizer Chiefs.
21st April, 2006

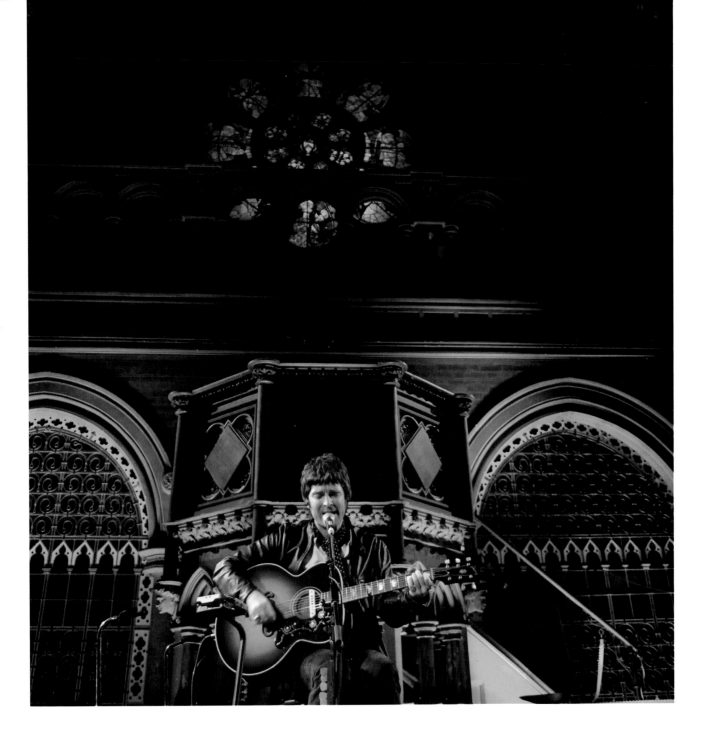

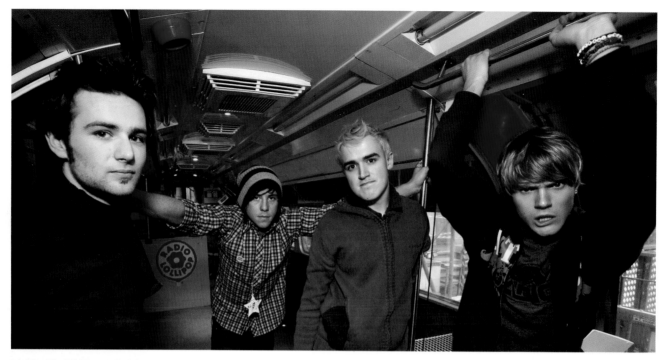

McFly: (L–R) Harry Judd,
Danny Jones, Tom Fletcher
and Dougie Poynter.
29th November, 2006

Facing page: Amy
Winehouse at Circomedia
in Bristol. Winehouse's
very public battle with the
chemical and emotional
pitfalls of her profession
threaten to eclipse her
undoubted original talent.
19th April, 2007

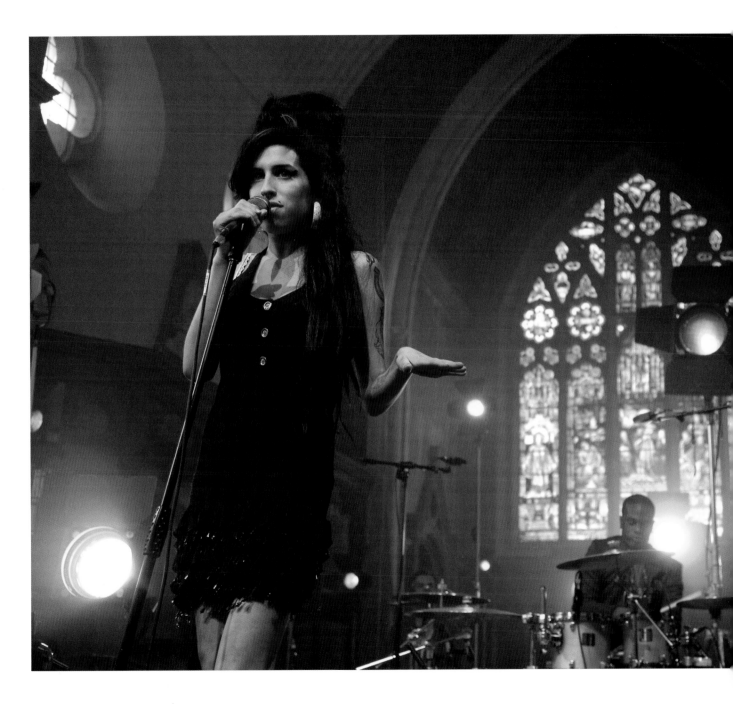

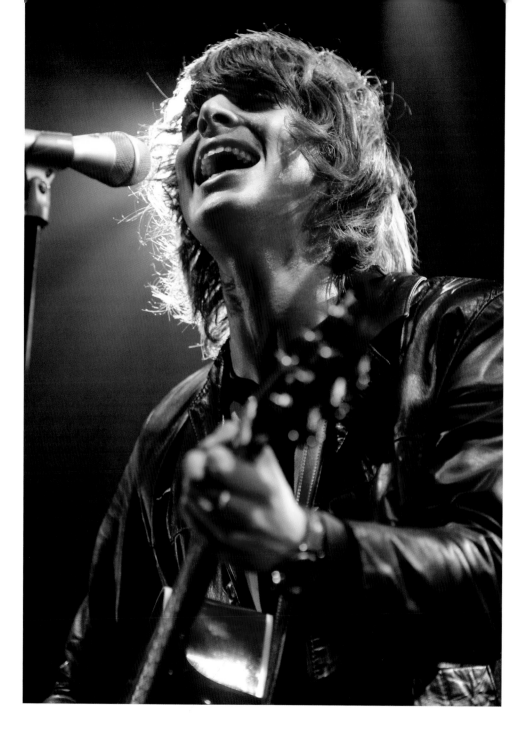

Scottish singer-songwriter
Paolo Nutini at the Brixton
Academy.
24th April, 2007

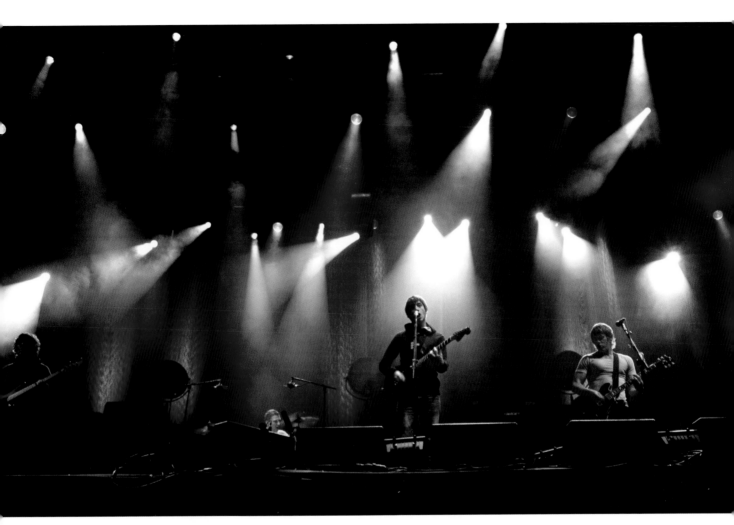

The Arctic Monkeys
on the Pyramid Stage
at Glastonbury.
22nd June, 2007

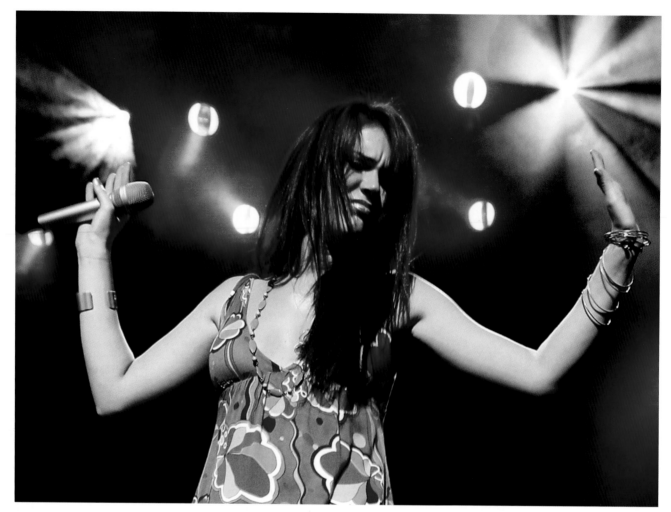

Joss Stone at *Indigo2* in
the O2 Arena in Greenwich,
south-east London.
25th July, 2007

Facing page: *X Factor*
winner Leona Lewis at
the *Brit Awards*.
20th February, 2008

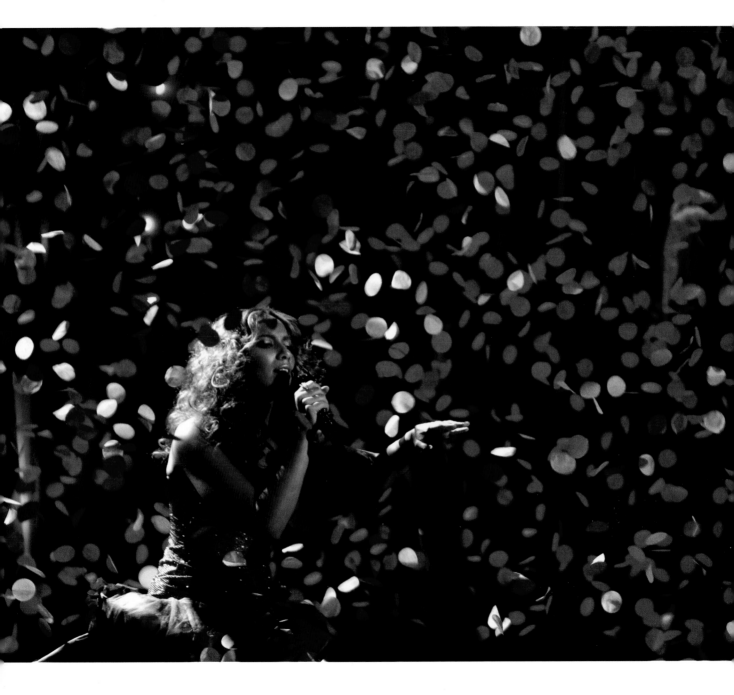

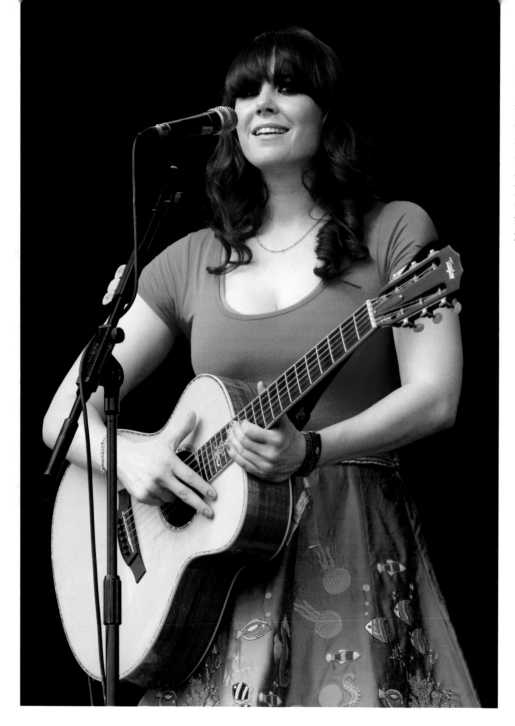

Kate Nash at Glastonbury. Having built her own following largely through online social networking sites, her 2007 album *Made of Bricks* was described as one of the worst of the year by the *Independent* newspaper. It reached the top of the charts.
27th June, 2008

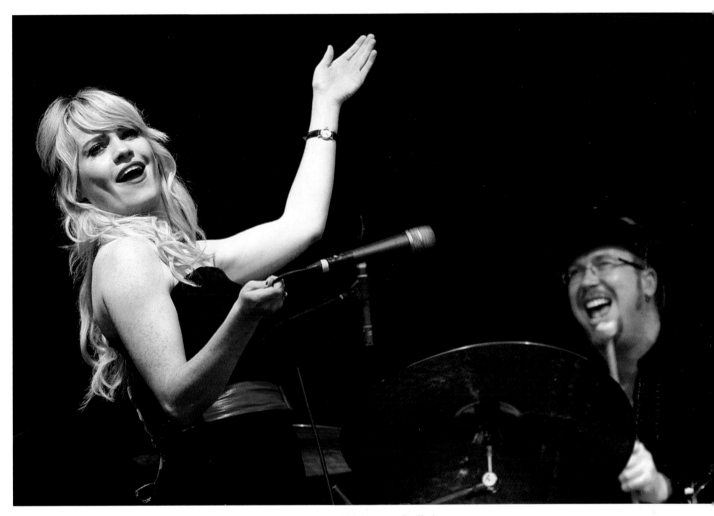

Welsh star Duffy in
microphone-swinging mode.
31st August, 2008

The Publishers gratefully acknowledge Press Association Images, from whose extensive archive the photographs in this book have been selected. Personal copies of the photographs in this book, and many others, may be ordered online at www.prints.paphotos.com

For more information, please contact:
Ammonite Press
AE Publications Ltd. 166 High Street, Lewes, East Sussex, BN7 1XU, United Kingdom
Tel: 01273 488005 Fax: 01273 402866
www.ammonitepress.com